THE COMPLETE ENGRAVINGS, ETCHINGS AND DRYPOINTS OF
Albrecht Dürer

THE COMPLETE ENGRAVINGS, ETCHINGS AND DRYPOINTS OF Albrecht Dürer

Edited by Walter L. Strauss

DOVER PUBLICATIONS · INC.

NEW YORK

Published in Canada by General Publishing Company, Ltd.,
30 Lesmill Road, Don Mills, Toronto, Ontario.
Published in the United Kingdom by Constable and Com-
pany, Ltd.

*The Complete Engravings, Etchings and Drypoints of
Albrecht Dürer* is a new work, first published by Dover Publi-
cations, Inc., in 1972.
Second edition, 1973.

International Standard Book Number: 0-486-22851-7
Library of Congress Catalog Card Number: 75-189347
MANUFACTURED IN THE UNITED STATES OF AMERICA
Dover Publications, Inc.
180 Varick Street
New York, N.Y. 10014

CONTENTS

INTRODUCTION

"The merchants of Italy, France and Spain are purchasing Dürer's engravings
as models for the painters of their homelands"
[Johannes Cochlaeus, *Cosmographia Pomponij Mele*, Nuremberg, 1512].

"The entire world was astonished by his mastery"
[Giorgio Vasari, *Vite de' più eccellenti pittori,
scultori ed architettori*, Florence, 1568].

Dürer's contemporaries were already fascinated by his engravings. The esteem in which they have been held ever since is exemplified by Vasari's remarks, made forty years after Dürer's death by an Italian in Italy, the country which thought it had a monopoly in the arts.

Apart from the mastery of execution, this admiration of Dürer has frequently been attributed to his versatility and to the large number of works in all media which have come down to us. These consist of some 2000 drawings, 250 woodcuts, more than seventy paintings, three books on theoretical subjects and over one hundred engravings.

There are indeed other artists who have left us legacies of similar magnitude, novelty and mastery. The reason for the peculiar fascination exercised by the body of Dürer's work goes beyond this, however, and must be sought elsewhere.

Dürer never stood still. He innovated and experimented to the end of his life. Even during his sojourn at Basel as a journeyman, he introduced an effervescent new element into woodcut book illustration. But only a few years later, at Venice, the center of book publishing, he was engaged in other pursuits.

Upon his return to his native city of Nuremberg, he carried with him a portfolio of watercolor landscapes made at a time when landscape painting was unknown. These sketches strike us even today as thoroughly modern.

In Nuremberg he then established his fame with the publication of a series of extra-large woodcuts illustrating the Revelation of St. John the Divine, known as *The Apocalypse*. It was the

first book both illustrated and published by an artist. The text is therefore subordinate to the pictures, but these are revolutionary and drastically different in concept and execution from anything seen before.

Shortly after this Dürer became interested in the theory of the proportion of the human body. He embarked upon experimentation with constructed faces and figures, culminating in the engraved "Adam and Eve" of 1504. Only three years later, in 1507, in the painted version of the same subject, the constructed system has given way to idealization.

During 1506 Dürer went to Italy a second time. Evidence of the change that came over him is found in the letter of February 7 to his friend Willibald Pirckheimer: "The works which pleased me eleven years ago no longer appeal to me. If I had not seen it for myself, I would not have believed anyone who told me such a thing."

In Italy, Dürer's *Brotherhood of the Rosary* amazed the Venetian painters. Dürer had meticulously alternated numerous layers of color and transparent varnish in order to achieve an unprecedented iridescent effect. Upon his return to Germany he painted a few more commissioned panels, but then abandoned this medium for several years.

In one of his letters Dürer mentions his intention of traveling to Bologna for the purpose of learning more about the "secret art of perspective." In 1509, the publication at Nuremberg of a plagiarized version of Viator's *De Perspectiva* apparently intensified his interest. His lines suddenly become ruler-straight and the near point of sight is clearly indicated in drawings of this period.

Parallel with these developments, Dürer experimented with color. The portrait of Frederick the Wise of Saxony is in sober shades of black and olive, that of Oswald Krell has a bright red background, the St. Onuphrius is in shades of brown and tan, and there are unusual color combinations in the costume studies of Livonian ladies and Irish warriors. But near the end of his life, as

reported by Melanchthon, Dürer abandoned the lively and radiant colors he had favored in his youth. He realized that simplicity was the highest form of art and "no longer admired his own paintings, as had been his wont, but sighed now that he recognized his shortcomings" (P. Melanchthon to Georg von Anhalt, December 17, 1546).

After Dürer's return from the journey to the Netherlands, 1520/21, his works became more sparse, restricted mostly to portrait commissions and printed memorial portraits of his friends. This is perhaps not primarily due to sickness and fatigue, as has frequently been asserted. Dürer was then actively engaged in the preparation of his three theoretical works *On Measurement, On Fortification* and *On Human Proportion*. The four volumes of manuscripts at London and the papers at Dresden give an indication of the immense amount of time and detailed work expended on these projects. He continued experimentation to the very end. Even the final pages of the fourth book on human proportion, which Dürer could no longer edit before his death, comprise an attempt to find a new method of stereometric demonstration of movement. Pirckheimer, who saw to the publication, included these last illustrations without text. Only Dürer could have supplied it.

Viewed against this tapestry of experimentation—so coarsely woven in the preceding paragraphs—experimentation that encompassed technique, color, perspective and proportion, Dürer's engravings represent the quintessence of his efforts and thoughts and most succinctly demonstrate the development of this profoundly intellectual artist.

In the case of woodcuts, Dürer more often than not simply provided sketches which were then cut into the wood block by skilled artisans. These woodcuts, particularly exemplified by the various Passion series, are simple, direct, outspoken and emotional, marked by an economy of line. The engravings, however, by the very nature of the medium, are entirely his own handiwork. The

INTRODUCTION

impression of each fine line is dependent upon the degree of pressure on the burin in the hand of the artist. Dürer's engravings, in spite of their wealth of detail, are erudite and, at the same time, subtle understatements directed toward a more sophisticated audience. It is here that Dürer demonstrates to the world what can be achieved in black and white. These prints are no longer an invitation to add color, like so many of the woodcuts of the fifteenth century.

Engravings, unlike woodcuts, were generally unsuitable as book illustrations. The process of inking and then wiping the plate was too tedious for that purpose. Dürer conceived his engravings as individual works of art. At the same time, he was fully conscious of the advantage, commercial and otherwise, of being able to reproduce them in limited editions.

In a letter to Jacob Heller he stresses the importance of selling a picture to Frankfurt, even if he could obtain a higher price elsewhere, because "more people will be able to see it there." In another communication Dürer asserts that he will no longer accept commissions for paintings with many figures and will return to engraving, "for it is much more profitable."

The subject matter of many of his engravings follows this dictum. A great number of his prints are devotional sheets which his wife Agnes sold at the market square of Nuremberg or at the fairs at Frankfurt and other cities. Others are peasant scenes typical of the quaint outdoor types who attended these events as vendors or as buyers. They may well be engraved "snapshots" of particular individuals who were seen regularly in the marketplace and whom everyone in town recognized.

It must be remembered that there simply was no way of reproducing pictures at that time other than woodcuts and engravings. It was because of their lifelike quality that the majority of Dürer's engravings became famous. His application of rules of perspective made these engravings drastically different from the customary woodcuts then in circulation. We have become so used to this standardization or, as Ivins calls it, "rationalization" of sight that we can hardly visualize its novelty and impact in the early sixteenth century.

This impression was further emphasized, probably unintentionally, by the peculiar method of perspective in many of Dürer's works, marked by the location of the vanishing point far off to the side instead of close to the center.

The earliest engraving bearing Dürer's monogram, the "Virgin with the Dragonfly" (No. 4), executed shortly after his return from his first journey to Italy, already provides a novel feature. The head of the sleeping St. Joseph, whose age stresses the notion of Mary's virginity, is severely foreshortened. In the "Prodigal Son" (No. 32) that follows, Dürer, with a twinkle in his eye, merely pictures the hindquarters of a bull, leaving the observer to imagine the rest. His huge "St. Eustace" (No. 34) presents an unprecedented wealth of detail. The tiny horseman on the road beneath the castle can hardly be discerned without a magnifying glass.

At the same time Dürer produced two series of small engravings, hardly larger than calling cards. The subjects range from the religious and classical to the profane. A high point of purity and effectiveness was reached in 1503. Yet there were difficulties. The copper plates were too soft to permit repeated printing without a weakening of the finer lines.

Therefore, after the interruption occasioned by his second sojourn beyond the Alps, he began experimentation with drypoint (1512). The result did not please him as it pleases his present-day admirers. He continued to search for new ways to achieve his ends.

His most famous engravings, "Knight, Death and Devil" (No. 71), "St. Jerome in His Study" (No. 77) and "Melencolia I" (No. 79), from the years 1513/14, were engraved in a more even manner, so that all the lines would more or less weaken at the same rate. For this reason they are distinguished by a more mellow texture and a silvery tone.

It is in this group of engravings that Dürer

demonstrates the intrinsic meaning of what he calls *Vergleichlichkeit,* i.e. harmonious relationship, or perhaps more properly, allegorical significance. In what measure he succeeded in this endeavor becomes apparent immediately upon viewing "Melencolia I." Even without a title the temperament of the representation is readily understood today as it was in Dürer's time.

Several years followed during which Dürer was intensely occupied with a number of projects for the Emperor Maximilian I. These included the *Triumphal Arch* and illustrations for the *Prayer Book* and for other planned publications. This did not, however, prevent Dürer from experimenting concurrently with etchings (1515/18). Again the result was apparent disappointment and abandonment, notwithstanding the effectiveness of some of the sheets.

In the year 1519 Dürer issued another remarkable engraving—one of only three in horizontal format—picturing St. Anthony, the first Christian monk (No. 89). He is shown in this instance, not beset by creatures of temptation, as was customary, but quietly reading. His stooped silhouette parallels the contours of the cityscape behind him. It seems to overpower the scene in its almost cubistic quality, akin to Dürer's experimentation with faceted heads during the same year.

Dürer's extended stay in the Netherlands, 1520/21, again caused an interruption in his engraving activity. Back in Nuremberg, he took up the burin once more in order to continue the series of Apostles. In these later renderings they appear quite austere, without haloes, simply holding the instruments of their martyrdom. They are Dürer's last statement in this medium, with the exception of one group.

He brought the long series of his engravings to a close with portraits of his friends and patrons: Cardinal Albrecht of Brandenburg, Duke Frederick the Wise of Saxony, Willibald Pirckheimer, Philip Melanchthon and Erasmus of Rotterdam, in that order. Each of these portraits is adorned with a memorial tablet, reminiscent of Roman tombs, describing the virtues of the sitter. Exactly like the printed *Triumphal Arch* for the Emperor Maximilian, these engraved portraits were intended to perpetuate the memory of his friends on paper instead of stone. Even here he could not resist experimentation. In the pupil of the eyes of some of the sitters may be discerned the reflection of a window pane, although in the case of Melanchthon, the clouds above would seem to preclude this reference to an interior.

Is it experimentation, then, that provides the clue to the fascination Dürer exercises upon his audience? The question already troubled earlier commentators. The remarks made by one of these, S. R. Koehler, in his introduction to the catalog of the first exhibition of Dürer's prints in America (Boston, 1888), are still relevant: "But while it must be admitted that the secret of these designs cannot be penetrated without effort, it is true, nevertheless, that they exercise a strong fascination upon the beholder, even so long as they are not in the least understood—a welcome assurance that the admiration expressed for them by those who have not taken the pain to study them is not all lipservice. It is precisely their enigmatical character which proves to be their strength, and this enigmatical character again, is due, in the sense here under consideration, to the curious mixture of allegory and realism, of vague idea and definite form, which characterizes them and invests them with the charm of a vivid dream."

Koehler's suggestion of a vivid dream was not so farfetched. Dürer was indeed influenced in this regard by a book in his possession. It was Francesco Colonna's *Hypnerotomachia* (Venice, 1499), subtitled "in which he teaches that all human beings are nothing but a dream, and records, by the way, many matters worth knowing." The title has been translated to mean "A Striving of Love in a Dream." The action occurs in a dreamland of temples, monuments and theaters, all of which are constructed in numerical proportion, based on the canon of Vitruvius. The

INTRODUCTION

book was published anonymously, but the decorated initials of its chapters reveal the name of the author.

Many parallels can be drawn between this description and Dürer's life and works. Apart from the quality of workmanship, perspective, rationalization of sight, coloring and constant experimentation, there is precisely the same mixture of allegory and realism that is peculiar to his engravings and sets them apart from his other works.

The authors of the early catalogs of Dürer's works were particularly handicapped by the difficulty of providing illustrations. For this reason they were obliged to supply wordy descriptions of the details of each engraving. It was not until 1877 that a volume of reproductions of all of Dürer's engravings became available. This was the catalog issued by Amand-Durand in heliogravure. The cost, however, was prohibitive.

Valentin Scherer's 1904 volume on Dürer in the series *Klassiker der Kunst* finally made reproductions of all of Dürer's engravings accessible to the general public. Friedrich Winkler thoroughly revised the fourth edition of that book in 1928. Nevertheless, the illustrations have a number of shortcomings. They are not always based on prime impressions. Frequently they are unnecessarily reduced in size. Border lines are added where, in fact, they do not exist in the original, and occasionally corners are squared off where they are actually rounded in the plate.

Campbell Dodgson, for many years Keeper of Prints at the British Museum in London, made every effort to select the best possible impressions of the engravings for reproduction in his catalog (1926). Unfortunately these were severely re-duced in size upon publication, negating Dodgson's good intentions.

In the present work all the engravings, with very few exceptions, are pictured in actual size. Every attempt has been made to reproduce superior impressions with full margins and border lines where they exist.

The chronological sequence of the engravings is intended to show the development of the artist. There are some pitfalls to this arrangement. Because Dürer's early plates are not dated, any determination of chronology must be based on circumstantial evidence. The individual plates of the Engraved Passion become separated, since Dürer issued them intermittently over a period of several years. It is nevertheless considerably easier to present the artist's development year by year in the body of the book, and group the subjects in an index, than to do the reverse.

The detailed record kept by Dürer in his diary of the trip to the Netherlands, 1520/21, conveys an idea of the price he placed on his engravings. While at Antwerp he bought a good beret for 2 florins (guilders), paid six stuivers (one florin equalled 24 stuivers) for a doctor's visit and one florin for a pair of boots. One florin was also Dürer's selling price for two sets of the Engraved Passion, or eight whole sheets like "Adam and Even," or twenty "half sheets" like the "Nativity" and "St. Anthony." "Quarter sheets," like the "Peasant," went at the rate of forty-five assorted engravings for one florin. The salary of the mayor of Nuremberg at that time was 600 fl. per annum. Dürer's expenditures for food in one year were 280 fl., as he mentions in his letter to Jacob Heller.

ACKNOWLEDGMENTS

Sincere thanks are due to many friends and colleagues who have given me encouragement, advice and aid in this endeavor; particularly Dr. Fedja Anzelewski, Director of the Kupferstichkabinett at Berlin; Mr. K. G. Boon, Rijksmuseum, Amsterdam; Mr. Fred Cain, Curator of the Alverthorpe Gallery, Jenkintown; Dr. Harold Joachim, The Art Institute, Chicago; Dr. Walter Koschatzky, Director of the Albertina, Vienna; Prof. Colin Eisler, Institute of Fine Arts, New York University; Mr. J. A. Levenson, Institute of Fine Arts, New York University; Prof. Ruth S. Magurn, Fogg Art Museum, Cambridge, Mass.; Mr. Benjamin Rifkin, Institute of Fine Arts, New York University; Mr. Gaillard Ravenel, National Gallery of Art, Washington, D. C.; Mr. Lessing Rosenwald, Jenkintown; Mrs. B. T. Ross, The Art Museum, Princeton; Mr. J. K. Rowlands, British Museum, London; Miss Eleanor Sayre, Museum of Fine Arts, Boston; Mr. Werner Schmidt, Kupferstichkabinett, Dresden; Messrs. Peter Strieder and Fritz Zink, Germanisches Nationalmuseum, Nuremberg.

Special thanks are due to Mr. Theodore Rousseau, Curator in Chief, Miss Janet S. Byrne, Curator, and Mr. A. Hyatt Mayor, Curator Emeritus, Department of Prints and Photographs, Metropolitan Museum of Art, New York City, who have made the superb impressions of the Junius S. Morgan Collection, acquired by the Mr. and Mrs. Isaac D. Fletcher Fund, available for reproduction and have provided facilities for special photography. The photographs were taken (after a great deal of experimentation in order to avoid the use of a screen in the printing process) by Mr. Robert Hagelstein, without whose devotion and meticulous attention to technical details this project would not have succeeded.

NOTE ON THE

REPRODUCTIONS

The illustrations in this volume, with the exception of those listed below, were photographed from the original engravings at the Metropolitan Museum of Art in New York City, and are reproduced with the museum's kind permission and cooperation. Most of these illustrations come from the collection of Junius S. Morgan and were acquired by the museum with the assistance of the Mr. and Mrs. Isaac D. Fletcher Fund in 1919. Mr. Morgan spent several decades in assembling his unique collection while residing at Paris. He continually refined its quality by replacing good prints with more perfect ones, habitually referring to each engraving by its Bartsch number instead of its title.

The reproductions of the engravings at the Metropolitan Museum were photographed directly on offset negative film and then transferred to the printing plates without resort to glossy photographs. Wherever possible, no halftone screen has been used, so that each engraving can be examined under a magnifying glass without dissolving into a pattern of black and white dots. A screen was required only in those cases where a tonal or sfumato effect demanded it. This true line reproduction conforms with the technique of engraving in greater measure than any halftone process, particularly in view of the fact that the burr caused by the burin, resulting in a very slight, ragged edge of the lines in the copper plate, wears off after only very few impressions.

NOTE ON THE REPRODUCTIONS

Engraving No. 29, which was specially photographed at the Metropolitan Museum of Art like those just described, is from the Henry Walters Collection. The following Metropolitan Museum of Art items (all Fletcher Fund) are reproduced from the Museum's own photographs: Nos. 6, 8, 10, 17, 37, 38, 48, 49, 50, 54, 63, 71, 89, 91, 93, 94, 95, 96, 97, 98, 102, 103.

Engravings from collections other than those of the Metropolitan Museum of Art:

Amsterdam, Rijksmuseum: No. 15.

Berlin, Kupferstichkabinett: Nos. 4, 5, 9, 14, 20, 21, 26 (second state), 41, 44, 55, 73 (both states).

Boston, Museum of Fine Arts: Nos. 45 (Harvey Parker Collection), 56, 104.

Cambridge, Mass., Fogg Art Museum: Nos. 34 (gift of Dr. Arnold Knapp), 39, 88, X-2.

Chicago, Art Institute: Nos. 2, 40 (Potter Palmer Collection), 43 (Clarence Buckingham Collec-

tion), 79, 81 (Hugh Dunbar Memorial Fund and John H. Wrenn Collection Fund), 83 (Clarence Buckingham Collection), 101.

Dresden, Kupferstichkabinett: Nos. 1, 3.

Kansas City, Mo., William Rockhill Nelson Gallery of Art: 77.

London, British Museum: Nos. 42, 51 (both states).

New York, Kennedy Galleries, Inc.: No. 31.

New York, New York Public Library: No. X-6.

Princeton, The Art Museum: Nos. 53, 60, 61, 62, 64.

Private collections: Nos. 7, 11, 19, 27, 71, X-4.

St. Louis, City Art Museum: No. 100.

Vienna, Albertina: Nos. 24a, 33, 42a, 42b, 57, 92, X-3, X-5, X-7.

Washington, National Gallery of Art (Lessing J. Rosenwald Collection): No. 105.

LIST OF PLATES

LIST OF PLATES

LIST OF PLATES

ABBREVIATIONS

The following abbreviations are used in the descriptions of the plates:

B = Bartsch, Adam von, *Le Peintre-Graveur*, vol. VII, Vienna, 1808; Leipzig, 1866.

D = Dodgson, Campbell, *Albrecht Dürer, Numbered Catalogue of Engravings, Dry-Points and Etchings with Technical Details*, London, 1926.

K = Koehler, S. R., *A Chronological Catalogue of the Engravings, Dry-Points and Etchings of Albert Dürer*, New York, 1897.

L = Lippmann, Friedrich, *Zeichnungen von A. Dürer in Nachbildungen*, 7 vols., Berlin, 1883-1929.

M = Meder, Joseph, *Dürer-Katalog; ein Hand-buch über Albrecht Dürers Stiche, Radierungen, Holzschnitte, deren Zustände, Ausgaben und Wasserzeichen*, Vienna, 1932.

P = Panofsky, Erwin, *Albrecht Dürer*, 2 vols., Princeton, 1943, 1945 and 1948.

T = Tietze, Hans, and E. Tietze-Conrat, *Kritisches Verzeichnis der Werke Albrecht Dürers*, vol. I, Augsburg, 1928; vol. II, Basel and Leipzig, 1937; vol. III, Basel and Leipzig, 1938.

W = Winkler, Friedrich, *Die Zeichnungen Albrecht Dürers*, 4 vols., Berlin, 1936-1939.

THE PLATES

1. THE GREAT COURIER

No date [1495].[1] A monogram added subsequently. Rounded corners.
100 × 113 mm; 3 7/8 × 4 3/8 in.
Only at Dresden, Melbourne, Paris and Vienna.
B.81; K.103; D.1; T.A19; M.78; P.188. [Abbreviations are explained on p. xviii.]

Earlier doubts have given way to the opinion that this is Dürer's first experimental engraving since a drawing was found at Danzig which apparently served as the model for this subject.[2] This drawing (W.9) is inscribed by Dürer: "Dz hat wofgang pewrer gemacht Jm 1484 Jor" (This was drawn by Wolfgang Peurer in the year 1484). Nothing else is known about Peurer.[3] He may have been an apprentice or an assistant in the goldsmith's shop of Dürer the Elder or in the workshop of Dürer's teacher, the painter Michael Wolgemut.[4]

The watermark of the paper used for the printing of this engraving, "Cardinal's Hat," was used by Dürer infrequently beginning in 1507. It was also used for the posthumous edition of Dürer's book *Unterweisung der Messung* (Instructions on Measurement). The rarity of this print, as well as the watermark, suggests that the remaining impressions are posthumous.

[1] Throughout, dates within square brackets are approximate.
[2] H. Secker, "Der grosse Postreiter," *Zeitschrift für bildende Kunst*, 1918, vol. LIII, p. 256.
[3] Recently Peurer has been tentatively identified as being identical with the Housebook Master. Cf. V. M. Strocka,

"Albrecht Dürer und Wolfgang Peurer," *Festschrift für Kurt Badt*, Cologne, 1970, pp. 249-260.
[4] E. Flechsig, 1928, vol. I, p. 234. [References given by name and date only will be found in Part A of the Bibliography (p. 229), "Chronological List of Prior Catalogs and Commentaries," under the respective data.]

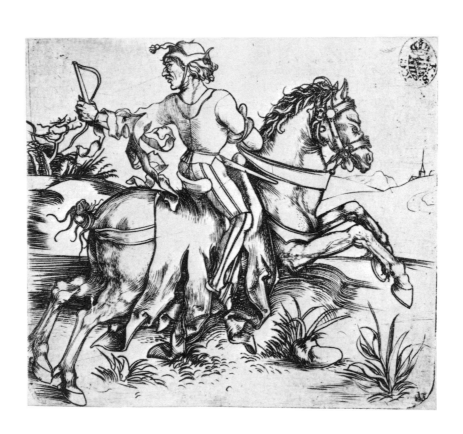

2. YOUNG WOMAN ATTACKED BY DEATH; *or,* THE RAVISHER

Without monogram or date [1495].
113 × 100 mm; 4 3/8 × 3 7/8 in.
Partial border lines at upper left and on the right side.
B.92; K.1; D.3; T.41; M.76; P.199.

This engraving is today generally accepted as being by Dürer, although it is reminiscent of the Housebook Master in several respects. The thistle-like plant in the background, eryngium (sea holly), occurs in several of Dürer's early works. Its reputedly aphrodisiac qualities were, according to Pliny,[1] known already to the ancient Greeks, and apparently fascinated the young Dürer.

Perhaps this print is related to a Nuremberg news item of the year 1489, when a man was hanged for a number of attacks on women.[2]

[1] Pliny, *Natural History,* Book 22, chapter 9; M. Stahlhelm, "Das Liebeskraut Eryngium auf den Bildern Albrecht Dürers," *Nürnberger Hefte,* vol. I, no. 7, 1949.

[2] F. Lippmann, *Kunstgeschichtliche Gesellschaft,* vol. V (cited by Tietze, 1928).

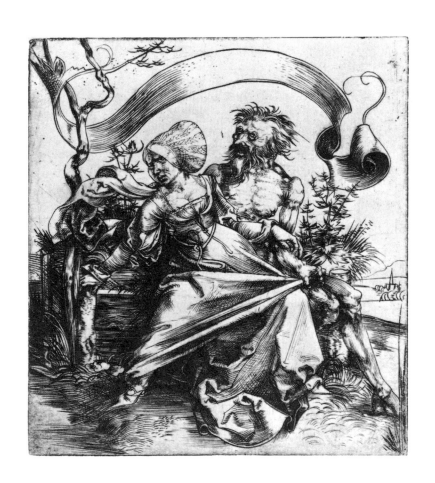

3. THE CONVERSION OF ST. PAUL

Without monogram or date [1495].
295 × 217 mm; 11 1/2 × 8 1/2 in.
Only at Dresden.
D.2; T.A20; M.46; P.217.

The authenticity of this work, which was first described in 1854,[1] is still not fully established. Unquestionably it bears a resemblance to both "The Great Courier" (No. 1) and "The Ravisher" (No. 2). While Panofsky doubts the authenticity because all other early engravings by Dürer are of smaller size and unheroic in character, Winkler[2] insists on the authenticity, asserting that this is the first instance in which Dürer dares to picture a dramatic event, turning away from the style of Schongauer. The lower right-hand corner is missing and has been reconstituted in ink.

[1] J. G. A. Frenzel, *Die Bekehrung des Paulus, ein Dürer zugeeignetes bis jetzt unbekanntes Kupferblatt aus des Meisters frühester Periode*, Leipzig, 1854.
[2] 1957, p. 55.

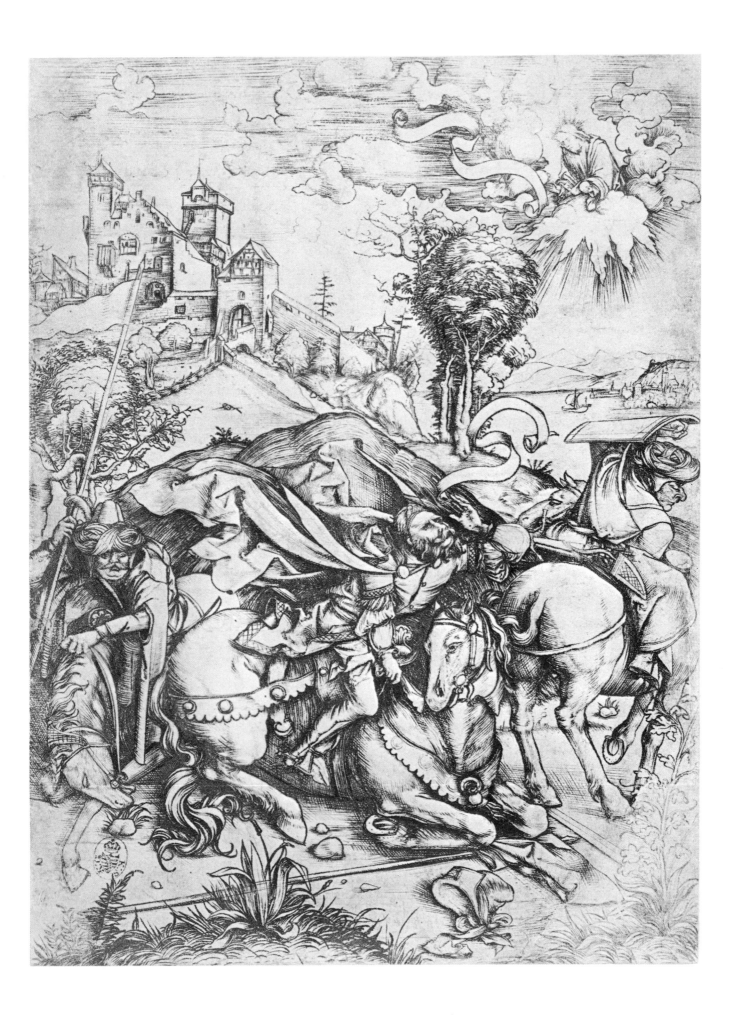

4. THE VIRGIN WITH THE DRAGONFLY

Monogram (capital A, small d); no date [1495].
240 × 186 mm; 9 3/8 × 7 1/4 in.
No border lines. The upper right corner rounded.
B.44; K.2; D.4; T.42; M.42; P.151.

The first of Dürer's engravings bearing a monogram and the only one with this archaic version of it. The dragonfly has been variously identified as a grasshopper, a praying mantis and a butterfly. The composition is still primitive, although the severely foreshortened head of St. Joseph—asleep and old to stress the notion of Mary's virginity—is in marked contrast to earlier still extant drawings by Dürer of this subject (W.23, 24, 30, 35). The face of the Virgin bears a great resemblance to Thalia of the series of drawings by Dürer known as "Tarocchi" (W.122).

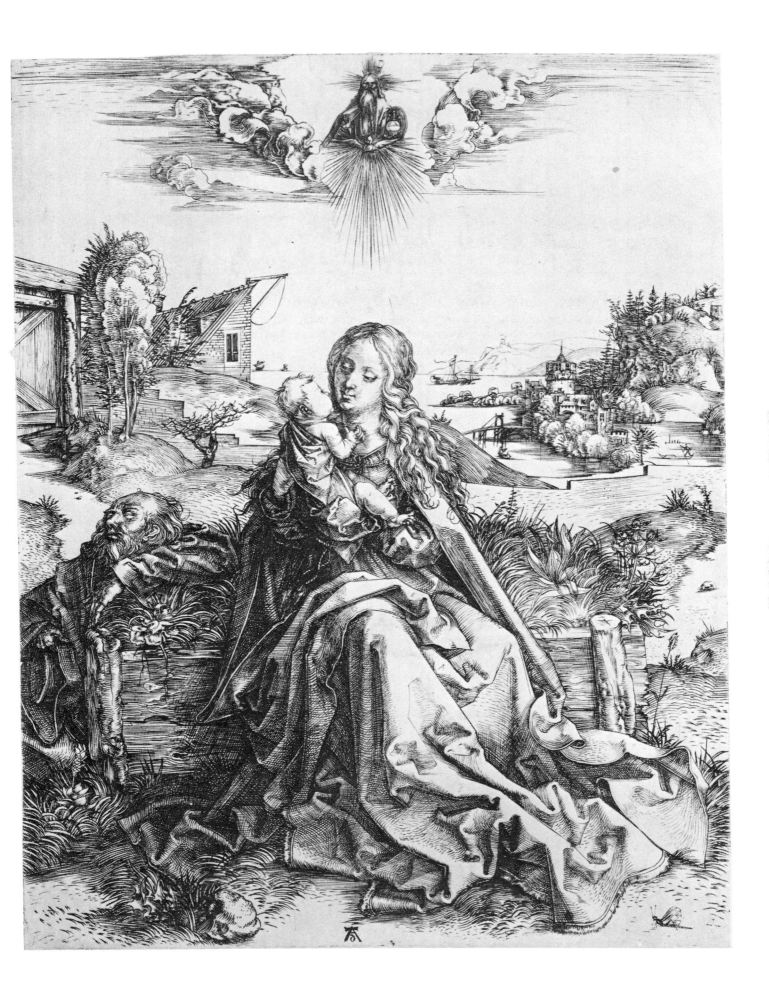

5. THE ILL-ASSORTED COUPLE; *or,* THE OFFER OF LOVE

Monogram; no date [1495].
151 × 139 mm; 5 7/8 × 5 3/8 in.
No border lines.
B.93; K.4; D.5; T.47; M.77; P.200.

The style of the monogram indicates that it is one of Dürer's earliest engravings. The left-handedness of the subjects may be due to Dürer's use of an earlier model.[1] Although a moralizing theme was read into this episode by some early commentators, Dürer probably intended to do no more than to portray purchased love.

[1] Thausing, 1876, vol. I, p. 210.

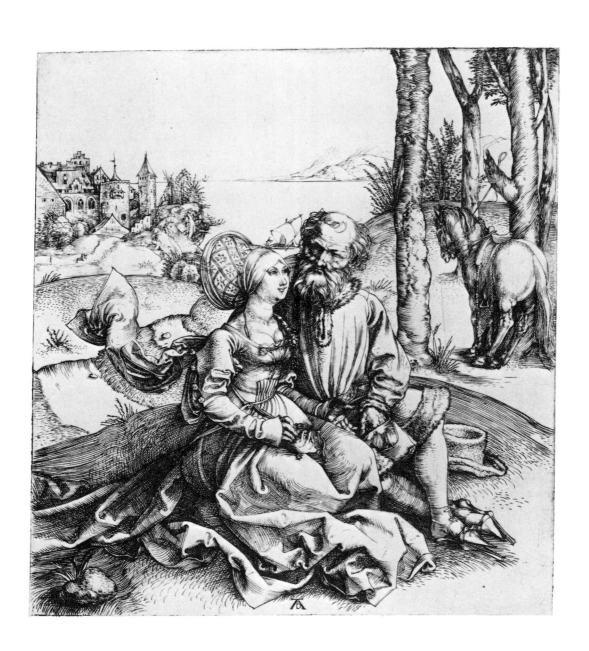

6. FIVE LANSQUENETS AND AN ORIENTAL ON HORSEBACK

Monogram; no date [1495].
132 × 147 mm; 5 1/8 × 5 5/8 in.
Border lines on bottom and sides only.
B.88; K.3; D.6; T.43; M.81; P.195.

In early commentaries the scene was described as a band of robbers attacking Dürer, or as William Tell.[1] More recently it has been suggested that it had originally been intended as a scene beneath the Cross.[2] This, however, is vehemently denied by Panofsky,[3] who terms it an unfounded conjecture. Italian influence is manifest, but the grouping, particularly the position of the Oriental horseman, is a little awkward. Note the scotch plaid pattern of the Turk's saddlecloth.

[1] Hüsgen, 1778, No. 88; Heller, 1827, No. 981.
[2] Flechsig, 1928, vol. I, p. 191; Winkler, 1957, p. 57.
[3] P. 195.

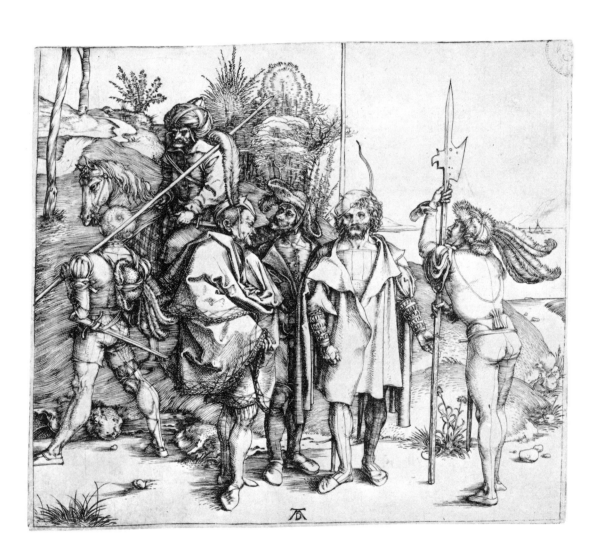

7. FORTUNE (*Das kleine Glück*)

Monogram; no date [1495].
120 × 67 mm; 4 5/8 × 2 5/8 in.
No border lines.
B.78; K.9; D.13; T.120; M.71; P.185.

Fortune is described in the *Tabula Cebetis* (Tablet of Cebes)[1] as a blind woman standing on a globular stone. Dürer's close friend, the humanist Willibald Pirckheimer, owned a manuscript of that work and had translated it.[2] The instability of the sphere is here further emphasized by the thin cane. Fortune is holding the aphrodisiac plant eryngium, denoting luck in love (cf. No. 2). Like "The Virgin with the Dragonfly" (No. 4), this drawing is closely akin in stance and format to Dürer's series of drawings known as "Tarocchi."[3] Perhaps related to the drawing "Nude Seen from Behind" (W.85).

[1] The *Tabula Cebetis* was once attributed to the Stoic philosopher Cebes of Thebes, who lived during the reign of Marcus Aurelius. It was, however, already well known in the time of Lucian.
[2] Erwin Panofsky, "Virgo and Victrix," *Prints,* Thirteen Illustrated Essays on the Art of Prints, selected for the Print Council of America by Carl Zigrosser, New York, 1962, p. 39. E. Reicke, *Willibald Pirckheimers Briefwechsel,* Munich, 1940, vol. I, p. 208. H. Imhoff, *Tugendbüchlein,* Nuremberg, 1606, p. 334.
[3] H. Kaufmann, "Dürers Nemesis," *Tymbos für Wilhelm Ahlmann,* Berlin, 1951, p. 138.

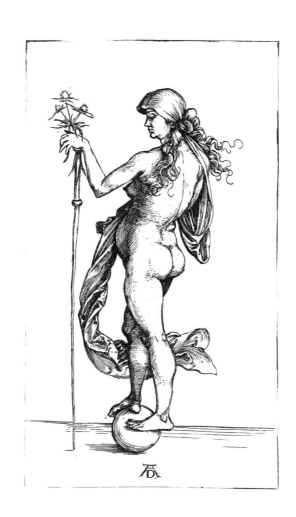

8. ST. JEROME PENITENT IN THE WILDERNESS

Monogram; no date [1496].
324 × 228 mm; 12 5/8 × 8 7/8 in.
No border lines.
B.61; K.6; D.11; T.101; M.57; P.168.

The stone in the saint's right hand serves to strike his chest. In this engraving too Italian influence is manifest. The scenery in the background, however, is based on sketches of quarries in the vicinity of Nuremberg (W.108; W.109). There is a certain lack of cohesion between the various parts of this unusually large plate.

St. Jerome, one of the most learned Fathers of the Church and author of the Vulgate, was born in 331 or 342 in Dalmatia of a well-to-do family. He died in 420. He was one of the favorite saints of Dürer's time, but, curiously, Martin Luther was less than fond of him. "I know of no one among the teachers whom I bear as much enmity as St. Jerome, for he speaks only of fasting, virginity, etc."[1]

[1] *Werke Martin Luthers,* Erlangen Edition, vol. LXII, p. 120.

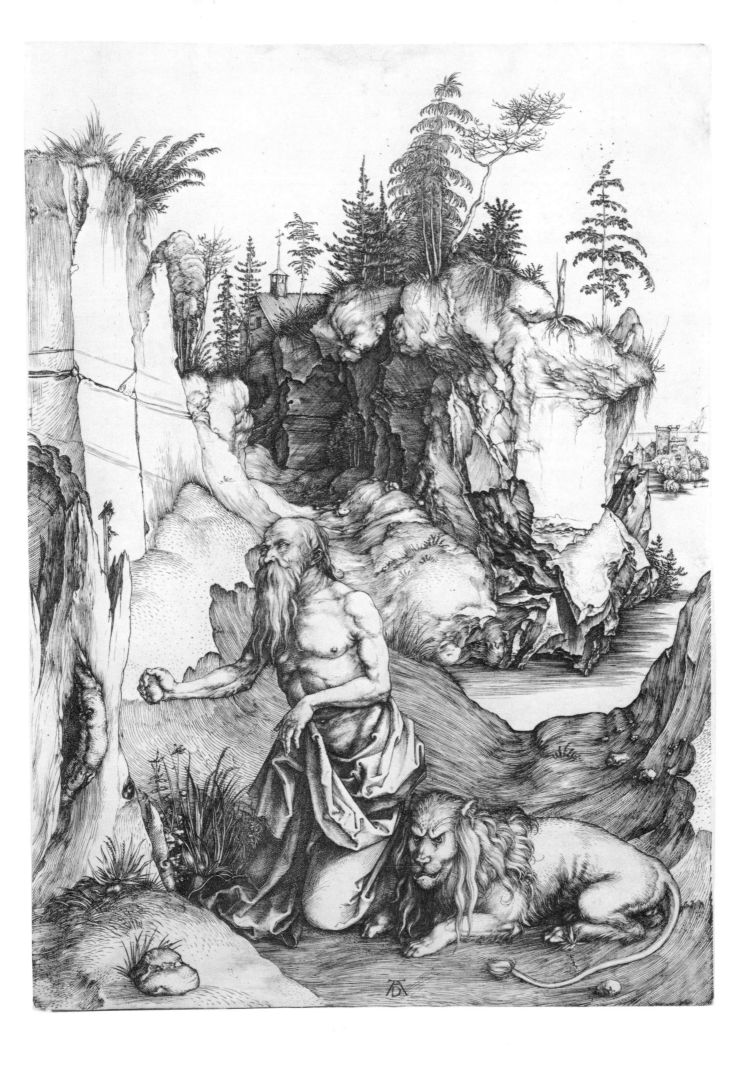

9. THE PENANCE OF ST. JOHN CHRYSOSTOM

Monogram; no date [1496].
180 × 119 mm; 7 × 4 5/8 in.
No border lines.
B.63; K.7; T.93; M.54; P.170.

St. John Chrysostom, a poor student at school, in desperation kissed the image of the Holy Virgin. To the amazement of his fellow students he henceforth wore a golden circle around his mouth and therefore was called "golden-mouthed" (in Greek, *chrysostomos*). The Pope ordained him a priest at the age of sixteen, but St. John Chrysostom felt unworthy of the priesthood and became a hermit in the desert. There the Emperor's daughter, having lost her way one day, sought refuge in his cave. Upon her insistence he admitted her and they sinned. As penance he vowed to walk on all fours until forgiven. Years later the Empress gave birth to another child who refused baptism except from St. John Chrysostom. Everyone despaired of finding him, when some hunters brought a strange wild animal to the festivities.

The child, seeing the animal, said, "You are forgiven." St. John stood up and shed his long moss-covered hair, and the Pope recognized him. The courtiers searched the desert and found the Emperor's daughter, who had also survived the ordeal in the wilderness.[1]

Mrs. Heaton, Dürer's first biographer in English, describes the scene very poignantly: "The princess is quite naked and more graceful in form and more beautiful of face than most of Dürer's female figures. There is a certain tenderness about her that makes us think that perhaps Dürer's sympathies were not entirely with the repentant saint who is seen in the background.[2]

The composition was perhaps suggested to Dürer by Jacopo de Barbari's engraving "Cleopatra" (or vice versa).

[1] As told in *Passional oder der Heiligen Leben*, Nuremberg, 1488, published by Anton Koberger, Dürer's godfather.

[2] Mrs. Heaton, 1869, p. 191.

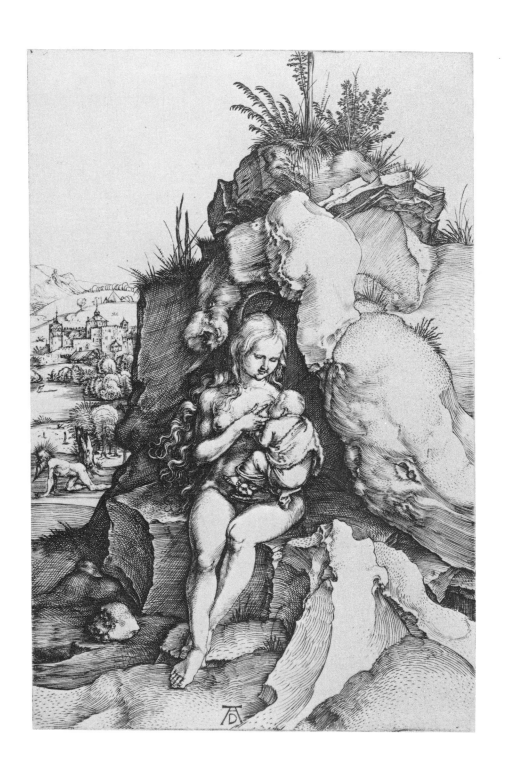

10. THE MONSTROUS SOW OF LANDSER

Monogram; no date [1496].
121 × 127 mm; 4 3/4 × 5 in.
No border lines.
B.95; K.11; D.8; T.110; M.82; P.202.

"In the year 1496 a wondrous sow was born in the village of Landser with one head, four ears, two bodies, eight feet, on six of which it stood, and with two tongues."[1] At Eastertime 1496, a similar animal, perhaps the same that was born at Landser, but now stuffed, was exhibited at Nuremberg.[2] Such quirks of nature, according to ancient belief, were produced by God in order to warn the world of portentous events. The birth of this unusual creature was therefore immediately publicized by a broadsheet issued by Bergmann von Olpe at Basel with a poem by Sebastian Brant, the author of the *Narrenschiff* (Ship of Fools). In Dürer's print the view of the village of Landser is pictured in mirror-image of the Basel print, which therefore obviously served as its model. The engraving was probably hurriedly produced for the occasion. It is somewhat strange that a newly born pig should be shown fully grown. On the other hand, Dürer did picture it standing on six of its eight legs, whereas on Brant's broadsheet the animal is in an upright stance.

[1] Hüsgen, 1778, No. 87.
[2] H. Deichsler, *Chroniken der fränkischen Städte*, vol. V, p. 586.

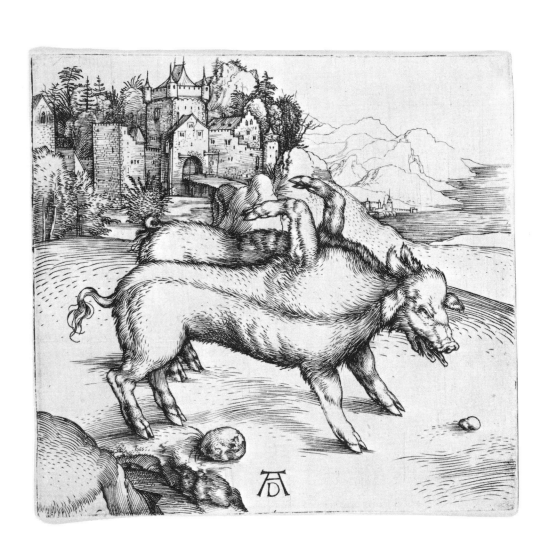

11. THE PRODIGAL SON AMID THE SWINE

Monogram; no date [1496].
248 × 190 mm; 9 3/4 × 7 3/8 in.
No border lines.
B.28; K.5; D.10; T.49; M.28; P.135.

The scenery is here for the first time made part of the composition, not a thing apart. The position of the man's legs is a little awkward; the perspective above his head is not quite correct. The peculiar sleeves, open up to the elbow, occur only in this instance and in two earlier engravings (Nos. 2 and 5).[1] The whimsical hindquarters of the bull at the left leave the viewer to imagine the rest.

Dürer may have been inspired to produce his own version of this legend by an illustrated book published at Basel in 1495, entitled *Quadrigesimale de Filio Prodigo*, reciting fifty sermons on the subject by Johannes Meder delivered during Lent 1495. On the verso of the title page appears a laudatory poem by Sebastian Brant (cf. No. 10).[2]

Dürer apparently forgot to do a part of the tree in the background and at the last minute put it in after the plate had had its burr diminished. As a result early impressions on this plate show a very strong burr on some of the lines of the tree. It would seem to indicate that the artist did his own printing.[3] Preparatory drawings at London (W.145); Boston (W.146); Chicago (W.239).

[1] E. Flechsig, 1928, vol. I, p. 201.
[2] E. Vetter, *Der verlorene Sohn*, Düsseldorf, 1955, p. xxii.

[3] W. M. Ivins, Jr., *Prints and Visual Communication*, Cambridge, Mass., p. 77.

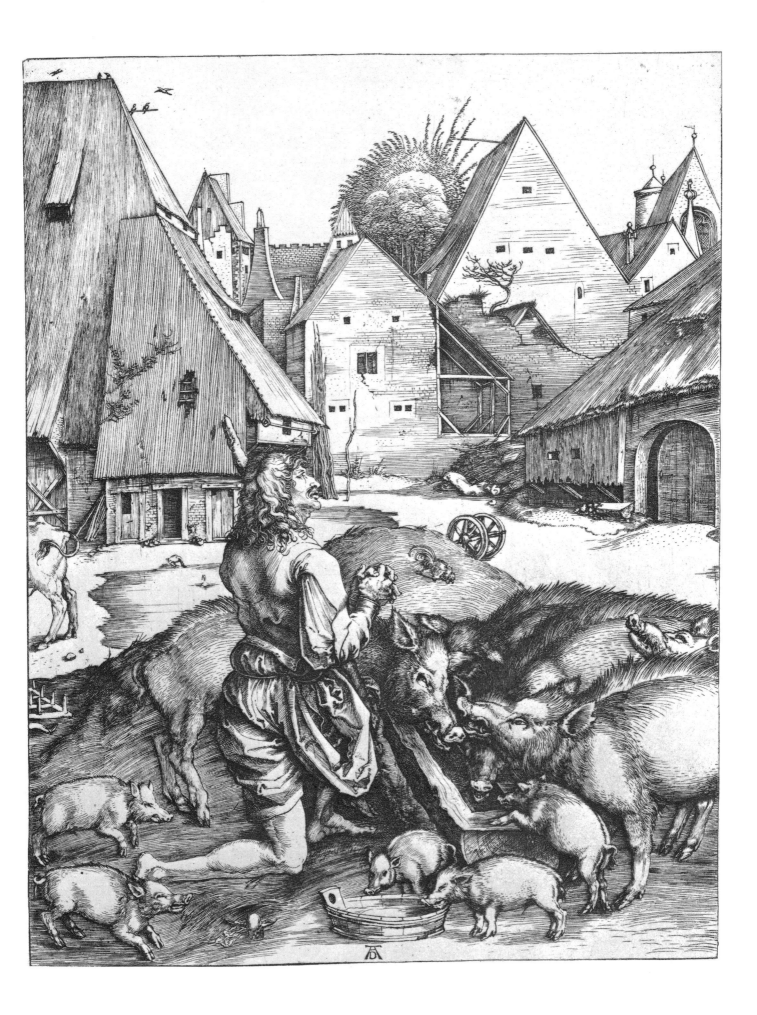

12. THE SMALL COURIER

Monogram; no date [1496]. The A of the monogram is reversed.
108 × 77 mm; 4 1/4 × 3 in.
With border lines.
B.80; K.10; D.7; T.46; M.79; P.187.

The head of the courier is similar to that of one lansquenet on the right of the earlier engraving No. 6, but the relationship of the figures to the landscape represents a considerable improvement.[1] Reminiscent in some respects of the Housebook Master.

This print is the first in a group of small engravings of uniform size. Perhaps a large copper plate was cut into rectangles for this purpose. With the exception of "The Four Witches" (No. 19), Dürer's engravings before the year 1503 are not dated. The chronological sequence of this group is therefore conjectural to some extent. According to Flechsig,[2] it comprises the following engravings:

No. 12 The Small Courier
No. 13 The Cook and His Wife
No. 14 The Oriental Family
No. 16 Rustic Couple
No. 17 Three Peasants in Conversation
No. 18 Lady on Horseback and Lansquenet
No. 25 Sol Justitiae
No. 26 St. Sebastian at the Column
No. 27 The Virgin on the Crescent

A second group of small engravings, of slightly different format, begins with No. 28.

[1] T.46.

[2] E. Flechsig, 1928, vol. I, p. 223.

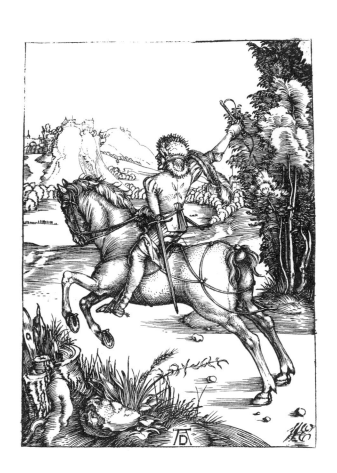

13. THE COOK AND HIS WIFE

Monogram; no date [1496].
108 × 77 mm; 4 1/4 × 3 in.
With border lines.
B.84; K.22; D.1; T.184; M.85; P.191.

By the eighteenth century this print was already catalogued under the title "The Cook and His Wife." Koehler[1] suggested that the man may be Mohammed, for "it has been said that a divine dove often alighted upon Mohammed's shoulders and communicated to him his religious system. Might it be a piece of Düreresque humor, to be interpreted as a caricature of Mohammed, as a man given to worldly lusts, and therefore thinking of nothing but cooking and women, even while listening to the pretended divine message?" This interpretation has since, however, given way to that of Lange,[2] who recounts a tale from *Der Ritter von Thurn*, Basel, 1493, a book Dürer had helped to illustrate during his travels as a journeyman. It tells of the cook's wife who ate an eel meant for a guest. She told a false story to her husband, but the magpie revealed the truth to him. In revenge she plucked all the feathers off the bird's head. Thereafter, whenever the magpie encountered a bald-headed man, it exclaimed: "So you have been telling about the eel!"

The plate of this engraving is mentioned in an inventory of Gommer Spranger of Amsterdam in 1637.[3]

[1] Koehler, 1897, No. 22.
[2] K. Lange, "Die Atzel, die vom Aal schwätzt," *Zeitschrift für bildende Kunst*, 1907, vol. XIII, p. 94.
[3] Hollstein, 1962, No. 85.

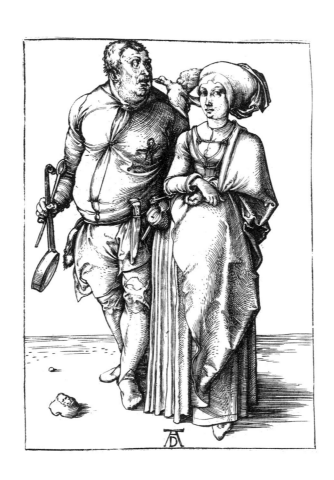

14. ORIENTAL FAMILY

Monogram; no date [1496].
108 × 77 mm; 4 1/4 × 3 in.
With border lines.
B.85; K.21; D.18; T.44; M.80; P.192.

The Turks were a constant and serious threat to the borders of the Empire in Dürer's time. In the year 1493 they attacked Croatia and cut off the noses of their captives. According to Tietze (T.44), this plate, as also Nos. 16 and 17, were made primarily with commercial rather than artistic aspects in mind. The head of the Turk appears again in the drawing of Pilate in the *Green Passion* (W.304).

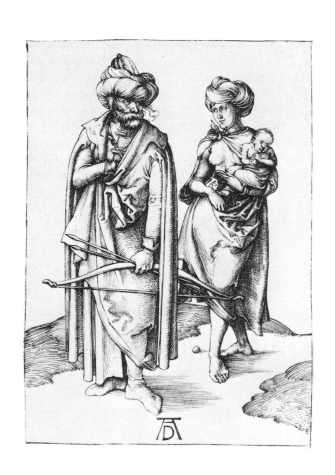

15. ORIENTAL RULER ENTHRONED

Without monogram or date [1497]. Unfinished. Only at Amsterdam.
296 × 234 mm; 11 5/8 × 9 1/8 in.
D.15; T.143a; M.91; P.219.

Originally described as "Charlemagne,"[1] this unfinished engraving was first ascribed to Dürer in 1917.[2] Previously it was attributed to Hans Baldung Grien by Passavant,[3] who was also the first to identify the personage pictured as a "Turkish emperor," on account of his Oriental attire, the sword and the orb. The preparatory drawing, showing how this engraving was to be completed, was rediscovered only recently. It is now at the National Gallery of Art in Washington. On its verso Dürer traced the design in mirror image, preparatory to cutting the plate. This drawing was formerly in the collection of Sir Thomas Lawrence, but after his death disappeared from public view. In the interim it was known only by an old copy.[4] Dürer's interest in Oriental subjects was intensified during his visit to Venice in 1495. It is virtually certain that he visited the Bellini studio while in that city.[5] Gentile Bellini (1429–1507) had spent a year in Constantinople, and portrayed Sultan Mahomet II in 1480. The suggestion that this engraving may have been intended to illustrate the story of this Sultan and his beautiful slave Irene is, however, highly conjectural.[6]

[1] Duchesne, *Voyage d'un iconophile*, Paris, 1834, p. 242.
[2] E. Römer, "Uber einen unvollendeten Stich in Amsterdam," *Repertorium für Kunstwissenschaft*, 1917, vol. XI, p. 17.
[3] 1862, vol. III, p. 320, No. 6.

[4] W.77. Formerly in the collections of Lord Northcliff and Captain H. S. Reitlinger.
[5] W.78.
[6] T.143a; W.76.

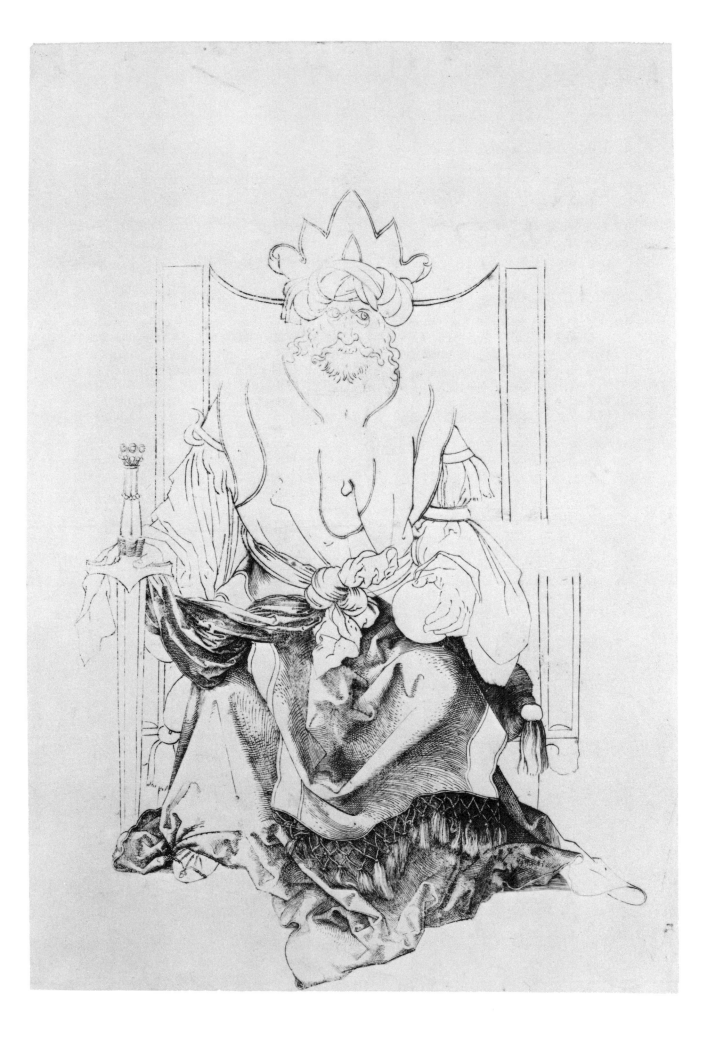

16. RUSTIC COUPLE

Monogram; no date [1497].
108 × 77 mm; 4 1/4 × 3 in.
No border lines.
B.83; K.23; D.19; T.109; M.86: P.190.

Hüsgen, in 1778,[1] described this engraving as "The Intoxicated Lansquenet and his Wife." Bartsch[2] thought the man was menacing the woman by his side. Allihn[3] thought the "pair is about to step up to a dance and the man, far from scolding, is trying to make himself agreeable." The stance of the couple is strikingly similar to the woodcut illustration of the "Star Fool" in Sebastian Brant's *Das Narrenschiff*,[4] which Dürer had helped to illustrate (cf. Nos. 10 and 11). There is a drawing attributed to Dürer (W.164) which Winkler considers preparatory for this engraving. This, however, is disputed by Tietze (T.109).

[1] Hüsgen, 1778, No. 71.
[2] B.83.
[3] M. Allihn, *Dürer Studien*, Leipzig, 1871, p. 79.
[4] J. Meder, 1932, p. 25.

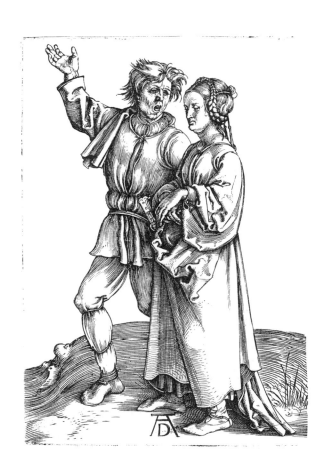

17. THREE PEASANTS IN CONVERSATION

Monogram; no date [1497].
108 × 77 mm; 4 1/4 × 3 in.
No border lines.
B.86; K.24; D.20; T.141; M.87; P.193.

This scene has been connected by a number of commentators to the peasant uprisings of the period. It should be remembered, however, that Dürer's wife Agnes sold her husband's woodcuts and engravings in a stall in the market square of Nuremberg, as well as at the fairs in other cities. Peasants were ever-present at these events, as vendors as well as buyers. The sword which the peasant uses for a cane is similarly used as a satirical accessory in Martin Schongauer's engraving "Peasant Family Going to Market" (B.88).[1]

This engraving is related to the "Sol Justitiae" (No. 25) and to the "Rustic Couple" (No. 16) in technique, especially in the horizontal shading devoid of crosshatching.

The original plate was sold to Prince Dolgorouky, a Russian collector, in 1852. Its present whereabouts is not known.

There is an impression of this engraving on vellum at the Museum of Fine Arts in Boston.

The drawing "Rustic Couple and Three Peasants" (W.164) is described by Winkler as preparatory for this engraving. Panofsky (P.193) denies that assertion, following Tietze (T.141), who considers it a copy after the engraving.

[1] T.141.

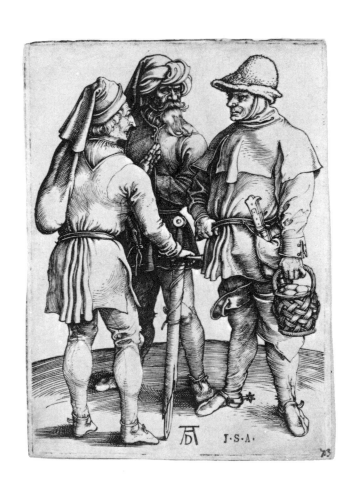

18. LADY ON HORSEBACK AND LANSQUENET

Monogram; no date [1497].
108 × 77 mm; 4 1/4 × 3 in.
No border lines.
B.82; K.27; D.16; T.45; M.84; P.189.

Tietze (T.45) considers this engraving characteristic of Dürer's early, primitive style in which he follows Schongauer, while the motif is akin to the Housebook Master. Allihn[1] states that "the subject itself is quite clear; it is the old story, told hundreds of times, of the lady in love with her squire, but it is also a protest against the views of the nobility which must have secured for Dürer the applause of the bourgeois circles for which he worked."

[1] M. Allihn, *Dürer Studien*, Leipzig, 1871, p. 71.

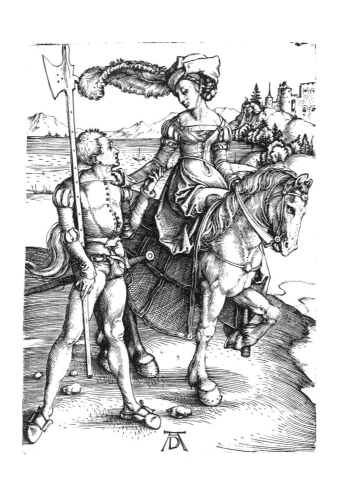

19. THE FOUR WITCHES

Monogram; dated 1497.
190 × 131 mm; 7 3/8 × 5 1/8 in.
Border lines on all sides, separated from the platemark by 3 mm.
B.75; K.14; D.14; T.122; M.69; P.182.

This is the only one of Dürer's engravings before 1503 bearing a date. For this reason it has been presumed to denote an actual event. The devil lurking in the background and the skull and bone on the floor preclude the suggestion that the "Three Graces" or "Discord and the Three Fates"[1] are pictured in this engraving. It seems more likely that the girl wearing the wreath is being initiated by three matrons or witches. In 1484, Pope Innocent VIII had issued his encyclical *Summis Desiderantes*, which described witchcraft in vivid terms, particularly the existence of devils taking the shape of women. Men who had intercourse with these she-devils became afflicted with sickness, pains and impotence. In 1486 in Cologne, Jacob Sprenger had published his vicious book *Malleus maleficarum* (Hammer for Witches), a guide for witch-hunters; women in particular, including midwives and even nuns, were termed susceptible to devilish deeds. This book went through at least sixteen editions in Germany alone, eleven in France and six in England, the last in 1669. Dürer's prints may well be connected with one of these editions.

The letters "OHG" have still not found a satisfactory explanation. They have been variously interpreted to mean "Oh Gott hüte" (Oh God Forbid), "Obsidium Generis Humani" (Ambush against the human race)[2] or "Ordo Graciarum Horarumque" (Order of the Graces and Hours).[3] The fruit is a pomegranate, a symbol of fertility.

[1] E. Dwyer, "The Subject of Dürer's Four Witches," *Art Quarterly*, vol. XXXIV, No. 1, 1972.
[2] Thausing, 1876, vol. I, p. 220.

[3] H. Rupprich, *Willibald Pirckheimer und Dürers erste Reise nach Italien*, Vienna, 1930.

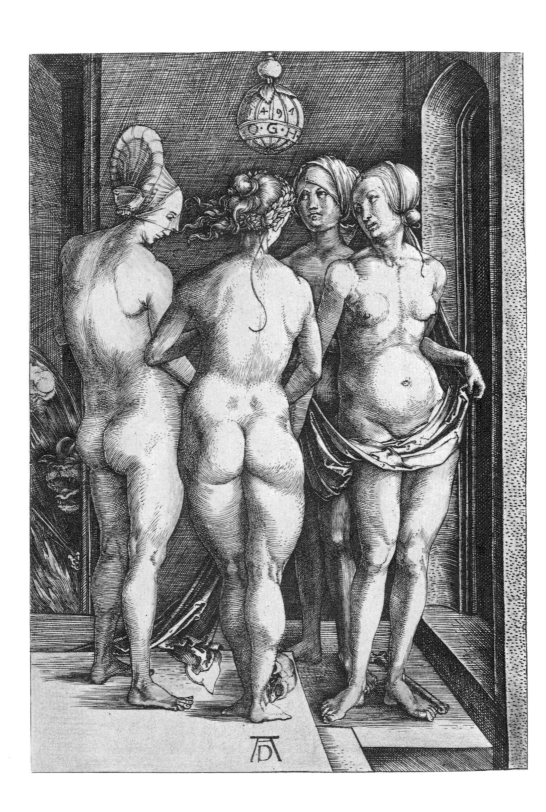

20. YOUNG COUPLE THREATENED BY DEATH; *or*, THE PROMENADE

Monogram; no date [1498].
192 × 120 mm; 7 1/2 × 4 5/8 in.
No border lines.
B.94; K.12; D.9; T.142; M.83; P.201.

The figure of death does not necessarily indicate a warning to lovers, as this was not customary in the fifteenth century. Death was, however, frequently pictured as a reminder that life on earth should not be solely devoted to pleasure and luxury. The cap worn by the man is a precursor of the berets which became popular in the sixteenth century. He has also already discarded the pointed shoes of the type still worn by his companion.[1] This engraving is obviously based on the drawing W.56. The tall grass-like plant in the foreground may be allegorical, related to the quotation from Isaiah in the Basel *Dance of Death* that "all flesh is like hay and grass; grass dries up and flowers wilt."[2] The identical couple, in mirror image, appears in the drawing "Pleasures of the World" (W.163), attributed to Dürer, but, as suggested by the so-called "tossed monogram," perhaps by Hans von Kulmbach after Dürer.

[1] A. Von Eye, *Leben und Wirken Dürers*, Nördlingen, 1860, p. 94.
[2] R. Wustmann, "Von einigen Tieren und Pflanzen bei Dürer," *Zeitschrift für bildende Kunst*, NF, vol. XXII, 1911, p. 112.

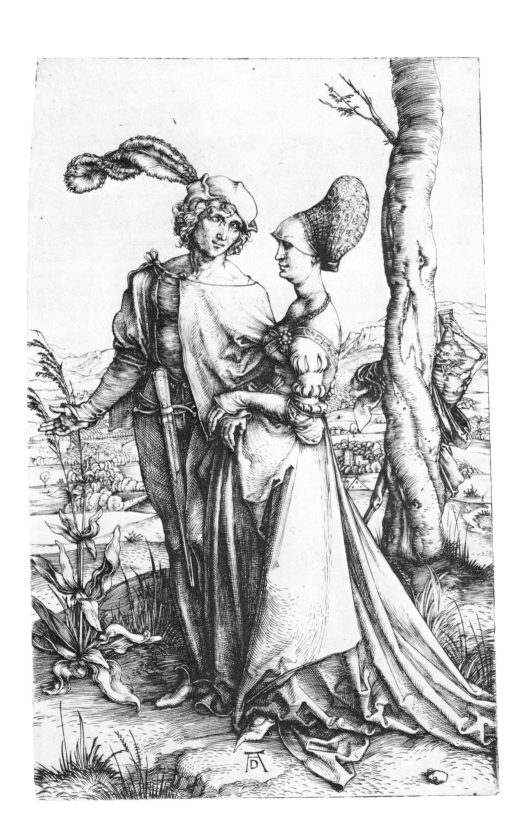

21. MADONNA WITH THE MONKEY

Monogram; no date [1498]. The monogram is the largest on any of Dürer's engravings.
191 × 124 mm; 7 1/2 × 4 7/8 in.
No border lines.
B.42; K.13; D.22; T.146; M.30; P.149.

Italian influence is manifest. This species of monkey was a popular pet in the fifteenth century. It appears also, obviously based on the same lost preparatory drawing, in Dürer's painting *Christ among the Doctors*. The monkey, at the same time, was a symbol of lewdness, greed and gluttony, commonly associated with the Christian concept of the Synagogue and more especially with Eve.[1] The "Island Abode" in the background is based on the drawing W.115. Koehler calls this Madonna "the most beautiful and dignified of all of Dürer's Virgins, of utmost simplicity in handling, although very delicate and skillful, without any attempt at variation of texture, and therefore without even the faintest suggestion of color. In this respect it is worth comparing with 'Adam and Eve' [No. 42] and the 'Madonna by the Wall' [No. 78]." Panofsky points out the advance in technique, compared to the "Virgin with the Dragonfly" (No. 4). The long diagonal lines of the crosshatching, intermingled with short horizontal lines, have given way to a system of parallel curves.

[1] Panofsky, 1943, vol. I, p. 67.

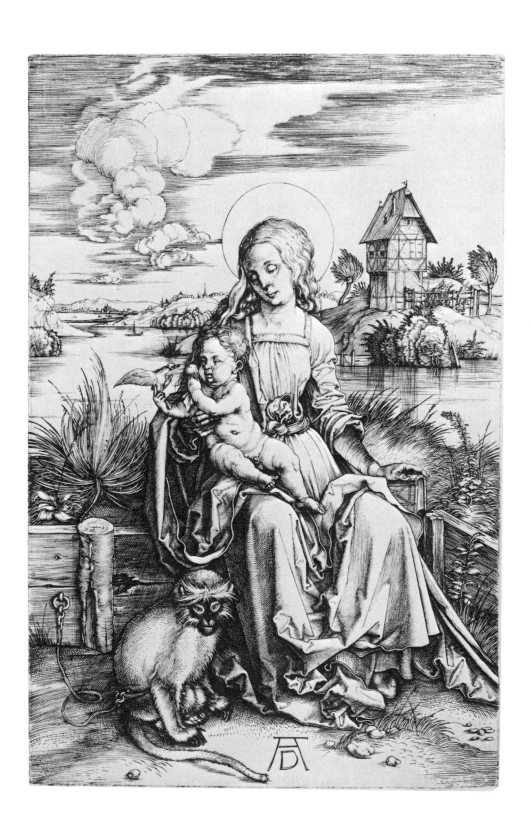

22. THE TEMPTATION OF THE IDLER; *or*, THE DREAM OF THE DOCTOR

Monogram; no date [1498].
188 × 119 mm; 7 3/8 × 4 5/8 in.
Border lines on bottom and sides only.
B.76; K.22; D.28; T.127; M.70; P.183.

The temptress is a typical Italian model[1] and the stove a symbol of rejuvenation,[2] while the pillow stands for laziness, for "idling is the pillow of the Devil."[3] An idler is also described in Sebastian Brant's *Das Narrenschiff*, which Dürer helped to illustrate (cf. Nos. 10 and 11):

No one is fond of a sluggard in his house
Any more than a hibernating mouse.

To sleep by day and sleep by night,
To sit by the stove is his delight.
The Evil One quite soon takes heed
And quickly sows his evil seed.

Thus laziness begets sin, additionally symbolized by the "warmed-over" apple of temptation lying on the stove.

[1] Wölfflin, 1905, p. 122.
[2] G. F. Hartlaub, "Albrecht Dürers Aberglaube," *Zeitschrift des deutschen Vereins für Kunstwissenschaft*, vol. VII, 1940, p. 167.
[3] Panofsky, 1943, vol. I, p. 71.

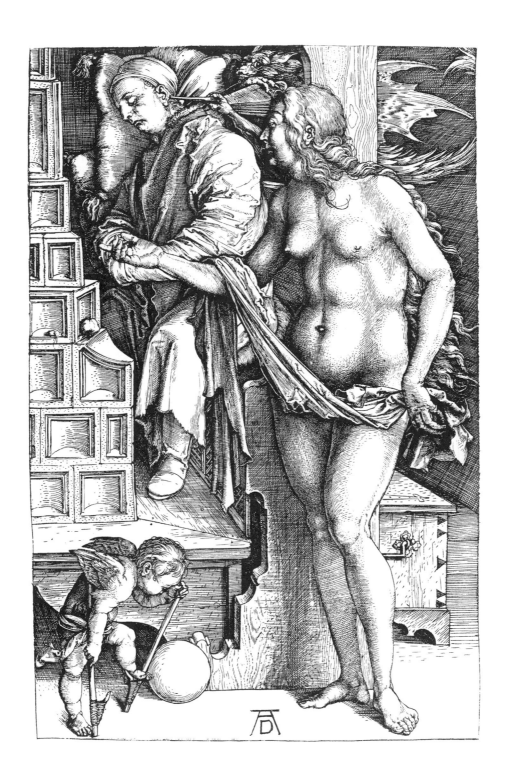

23. THE SEA MONSTER

Monogram; no date [1498].
246 × 187 mm; 9 5/8 × 7 1/4 in.
With border lines.
B.71; K.16; D.30; T.128; M.66; P.178.

This print is mentioned by Dürer in his diary under the date November 24, 1520: "At Antwerp I sold two 'Adam and Eve,' one 'Sea Monster,' one 'St. Jerome,' one 'Knight,' etc." It has been variously described as "Abduction of Amymone" (Bartsch), "Glaucus and Scylla," "Nessus and Deianira," "The Rape of Theolinda"[1] and "Perimele and Achelous."[2] The suggestion made by Lange[1] that the subject is probably a folk tale of the Adriatic coast of Italy seems the most plausible. Panofsky[3] agrees and quotes a tale told by Poggio Bracciolini which conforms to the illustration. According to Poggio a wooden replica of this sea monster was on display at Ferrara.

Dürer, according to Wölfflin,[4] "seems unable to desist from treating erotic subjects. The female figure is the core of the composition. The maritime abduction simply serves to legitimize her nudity. Surely based on an Italian model. The surrounding fairy tale was obviously tailored to serve Dürer's purpose. The audacious, diagonally descending line of the background is unprecedented." Winkler[5] asserts that no other engraving of this time has the decorative beauty of this one or the effectiveness of its black and white; "although the artist cares little about content in this instance, it is his first true masterpiece." A counterproof is at the Museum of Fine Arts in Boston.

[1] K. Lange, "Dürers Meerwunder," *Zeitschrift für bildende Kunst*, vol. XI, 1900, pp. 195-204.
[2] E. Tietze-Conrat, *Zeitschrift für bildende Kunst*, vol. XXVII, 1906, p. 265; based on Ovid's *Metamorphoses*.

[3] 1943, vol. I, p. 73.
[4] 1905, p. 124.
[5] 1957, p. 93.

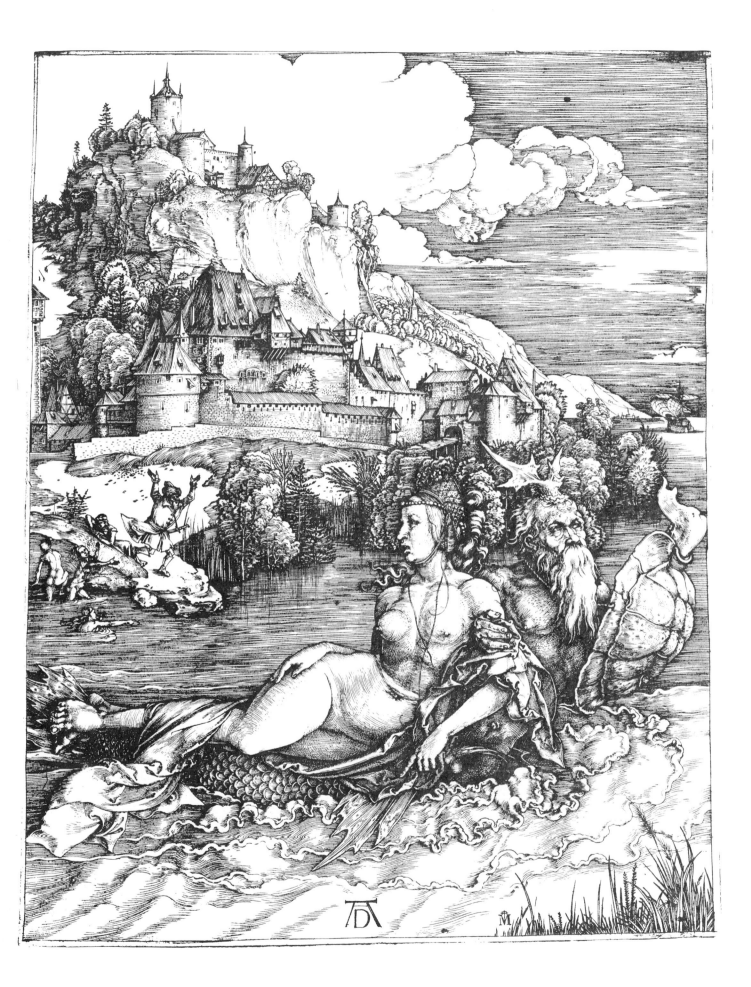

24. HERCULES AT THE CROSSROADS

Monogram; no date [1498].
323 × 223 mm; 12 5/8 × 8 3/4 in.
Border lines on all sides except for the top.
B.73; K.17; D.29; T.117; M.63; P.180.

Mentioned by Dürer in his diary entry of August 20, 1520: "At Antwerp, I also gave the factor of Portugal a Herculum." Vasari[1] already refers to this print as "engraved with the greatest mastery; Diana is striking a nymph seated on the lap of a satyr. Its perfection is the ultimate that can be achieved in this medium." Technically more advanced than the "Sea Monster," this print sums up Dürer's Italian experience. It represents a story related by Xenophon about the young Hercules deciding between Virtue and Pleasure.[2] The helmet of the man wielding the club is similar to that pictured in the woodcut "Beast with Lamb's Horns" (B.74). His wreath is identical to that of the woman seen from behind in "The Four Witches" (No. 19). Winkler[3] cites the fine details and the magnificence of the workmanship but finds the rendering of the figures undramatic: "The two sinners seem like spectators, astonished by the exertions of the others, as in a theatrical rehearsal." Dürer appears to have used the same antique model which also served as the basis for the woodcut by another artist in Benedictus Chelidonius' *Voluptatis cum Virtute Disceptatio Heroicis Lusu Versibus* (Dispute between Pleasure and Virtue in Heroic Verse; Vienna, 1515).[4] The central group is based on Dürer's drawing W.58.

[1] In the chapter on Marcantonio Raimondi.
[2] Panofsky, 1943, vol. I, p. 73.
[3] 1957, p. 95.

[4] H. Gollob, "Der Herkules des Wiener Chelidonius von 1515," *Gutenberg Jahrbuch*, 1966, pp. 284-286.

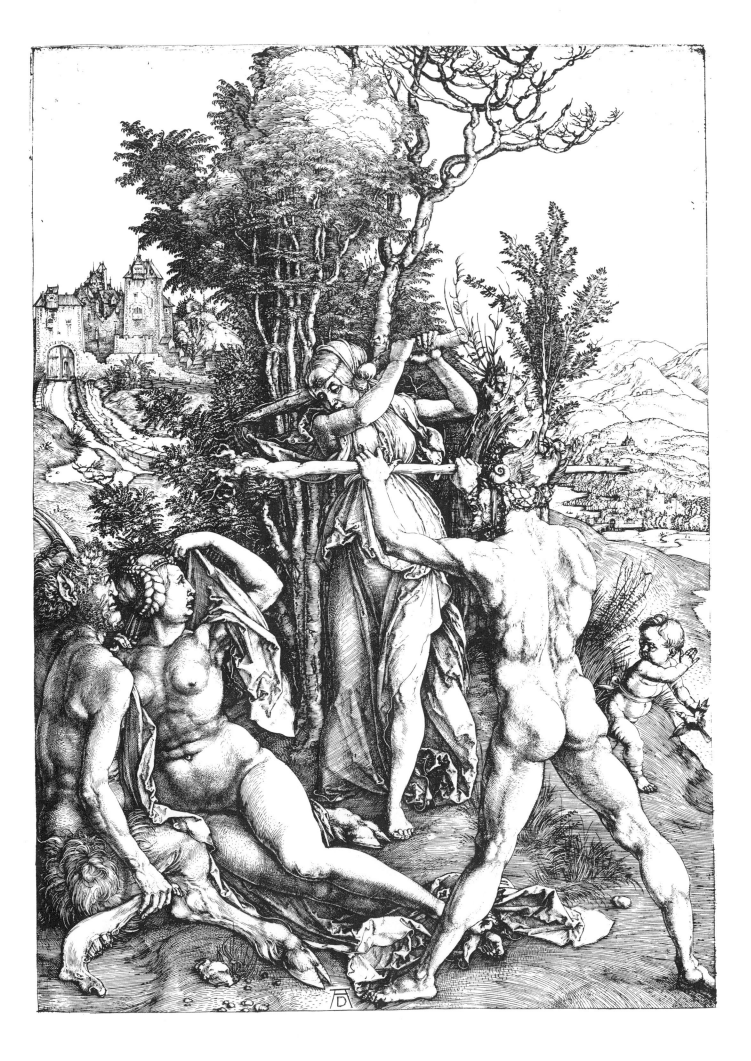

24a. HERCULES AT THE CROSSROADS

Trial impression before completion of the plate.
Vienna, Albertina; also at Berlin, Kupferstichkabinett.

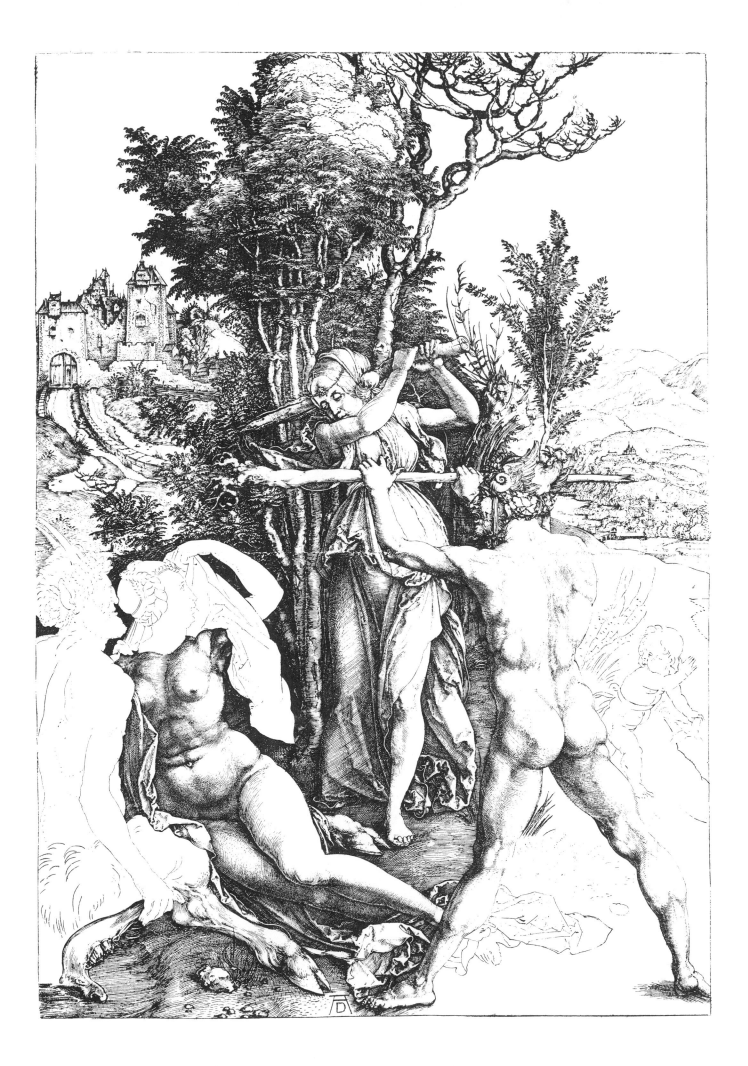

25. SOL JUSTITIAE; *or*, THE JUDGE

Monogram; no date [1499].
108 × 77 mm; 4 1/4 × 3 in.
No border lines.
B.79; K.28; D.31; T.178; M.73; P.186.

The literary source of this print is Petrus Berchorius' *Repertorium Morale*, issued by Dürer's godfather Anton Koberger at Nuremberg in 1480 and 1499:[1] "The Sun of Righteousness shall appear ablaze when he will judge mankind on the day of doom, and he shall be burning and grim. For, as the sun burns herbs and flowers in summertime when he is in the Lion, so Christ shall appear as a fierce and lion-like man in the heat of Judgment and shall wither the sinners." Panofsky[2] calls this engraving one of Dürer's most impressive creations in spite of its small size. Only his extravagant imagination "was capable of charging the form of an insignificant astrological image with the content of this apocalyptic vision." Crossed legs were prescribed for judges in ancient law books.

The subject of "Sol Justitiae" was appropriate for the year 1499. Many people were expecting the end of the world or the Last Judgment to occur at the end of the century. Astrologers predicted a new deluge, and many families moved to high ground or into the upper stories of their dwellings. The Jews were expelled from Nuremberg in March. There were portentous events: the Emperor's army was defeated in the Swiss War, and Ludovico Sforza was deposed in Milan. This engraving is based on the preliminary drawings W.173 and W.166.

[1] E. Panofsky, *Dürers Stellung zur Antike*, Vienna, 1922.

[2] 1943, vol. I, p. 78.

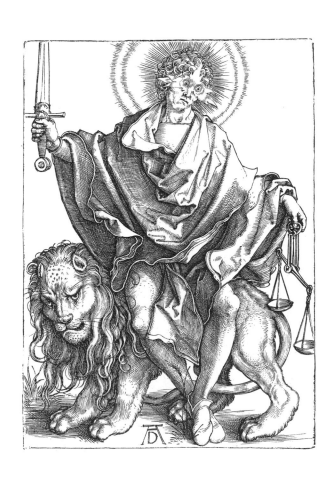

26 . ST. SEBASTIAN AT THE COLUMN

Monogram on a paper attached to the wall; no date [1499].
108 × 77 mm; 4 1/4 × 3 in.
With border lines.
B.56; K.20; D.23; T.145; M.61; P.163.

St. Sebastian was considered to be a protector from the plague. The saint's head bears a great resemblance to that of St. John in Dürer's wood-cut "Apocalypse" (B.61). It is perhaps modeled on a work by Cima da Conegliano, who was in turn dependent on Perugino.[1] Panofsky[2] calls it a "minor engraving." This is quite in contrast to the comments of Wölfflin,[3] who noted its "magic, almost overpowering nature," and Winkler,[4] who remarks that it has "even greater vitality than the 'Temptation of the Idler' [No. 22]." The stippled effect of the wall is identical to that in "The Four Witches" (No. 19).

The second state of the plate, also illustrated, can be distinguished by two added lines, making a total of five lines, in the blade of the uppermost arrow.

[1] Wölfflin, 1905, p. 119.
[2] 1943, Vol. I, p. 83.
[3] 1905, p. 120.
[4] 1957, p. 98.

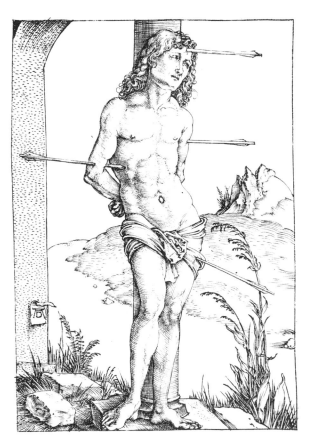 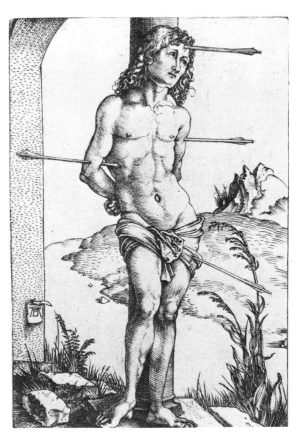

First state *Second state*

27. THE VIRGIN ON THE CRESCENT

Monogram; no date [1499].
108 × 77 mm; 4 1/4 × 3 in.
No border lines.
B.30; K.8; D.21; T.144; M.29; P.137.

A delicately and skillfully engraved little plate, it vividly recalls in its placid beauty Schongauer's "Small Standing Madonna" (B.27). An unpleasant feature, however, is the face in the crescent, the "Man in the Moon," a detail abandoned by Dürer in two of his later representations of this subject.[1] Panofsky[2] calls this print too "a minor engraving," but Winkler[3] considers it "more than precious; despite its small size it must be counted among Dürer's most perfect works."

[1] K.8. (Compare Nos. 51, 74 and 85).
[2] 1943, vol. I, p. 85.

[3] 1957, p. 98.

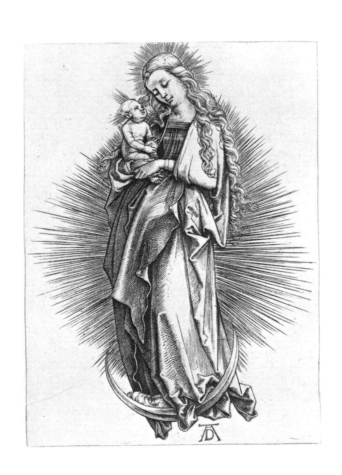

28. MAN OF SORROWS WITH HANDS RAISED

Monogram; no date [1500].
115 × 70 mm; 4 1/2 × 2 3/4 in.
No border lines.
B.20; K.18; D.25; T.183; M.20; P.127.

Based on an Italian model, perhaps Signorelli[1] or Bellini,[2] it is the earliest of the second series of small engravings.[3] The gesture of the arms is known as *ostentatio vulnerum* (display of the wounds). Winkler[4] calls it "beautifully modeled and brilliantly engraved, superior to 'St. Sebastian' [No. 26]"; he says it is based on a Venetian woodcut illustration of 1493.

[1] H. Grimm, "Bemerkungen über den Zusammenhang von Werken Albrecht Dürers mit der Antike," *Preussisches Jahrbuch*, vol. II, 1881, p. 190.
[2] P.127.
[3] E. Flechsig, 1928, vol. II, p. 230, lists this second series as follows:

No. 28 Man of Sorrows with Hands Raised
No. 29 Witch Riding Backwards on a Goat
No. 30 Three Putti with Shield and Helmet
No. 32 The Virgin with the Infant Christ and St. Anne
No. 33 St. Sebastian at the Tree
No. 35 The Standard Bearer
No. 36 St. George on Foot
No. 38 Apollo and Diana

[4] 1957, p. 137.

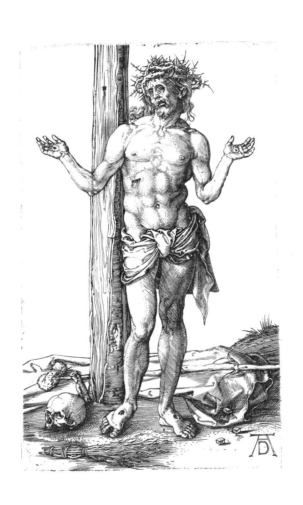

29. WITCH RIDING BACKWARDS ON A GOAT

Monogram with the D reversed; no date [1500].
115 × 70 mm; 4 1/2 × 2 3/4 in.
No border lines.
B.67; K.41; D.41; T.179; M.68; P.174.

This engraving too is evidently based on an Italian model. It is reminiscent of Mantegna.[1] No satisfactory explanation has yet been found of this subject. Tietze[2] suggests that at least the putti may be related to Mantegna's lost painting *Melancholia.*

[1] Thausing, 1876, vol. I, p. 230.

[2] T.179.

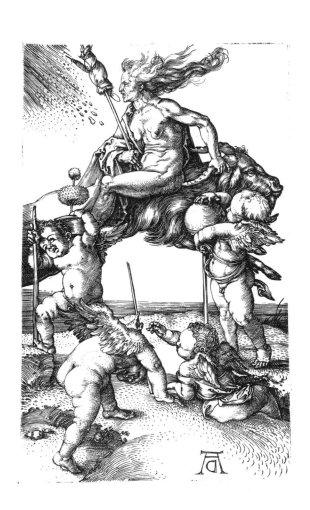

30. THREE PUTTI WITH SHIELD AND HELMET

Monogram; no date [1500].
115 × 70 mm; 4 1/2 × 2 3/4 in.
No border lines.
B.66; K.40; D.40; T.180; M.99; P.173.

Retberg[1] considers this print a sample of Dürer's humor. The putti already announce his name while holding an empty escutcheon of nobility (which he so much desired to possess). Panofsky[2] calls this a minor engraving. Winkler[3] observes that in this instance earlier heraldic showpieces, usually staid and dry, have given way to an "animated" approach.

[1] Retberg, 1871, No. 114.
[2] 1943, vol. I, p. 83.
[3] 1957, p. 137.

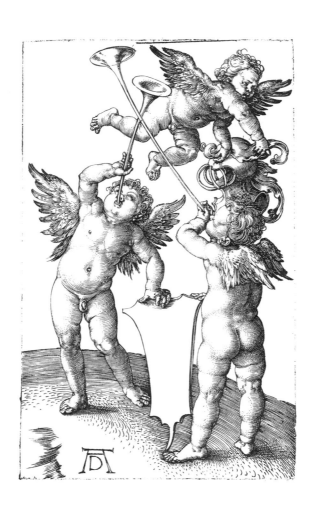

31. COAT-OF-ARMS WITH LION AND ROOSTER

Monogram; no date [1500].
187 × 122 mm; 7 1/4 × 4 3/4 in.
With border lines.
B.100; K.31; D.37; T.212; M.97; P.207.

As early as 1778, Hüsgen termed this engraving "rare and expensive." Bartsch praised the "intelligence and excellence of the workmanship." It was, by consensus of most scholars, not intended as the crest of a particular family but "purely a creation of fancy."[1] This print was usually dated close to the "Coat-of-Arms with a Skull" (No. 40) until Flechsig[2] pointed out that the style of the monogram indicates a slightly earlier time. Dürer began placing a date on all of his engravings beginning in 1503. Panofsky[3] comments that the rooster was considered the only animal capable of frightening the lion. Based on the drawings W.177 and W.257.

[1] K.31.
[2] 1928, vol. I, pp. 195, 222, 445.
[3] 1943, vol. I, p. 83; P.207.

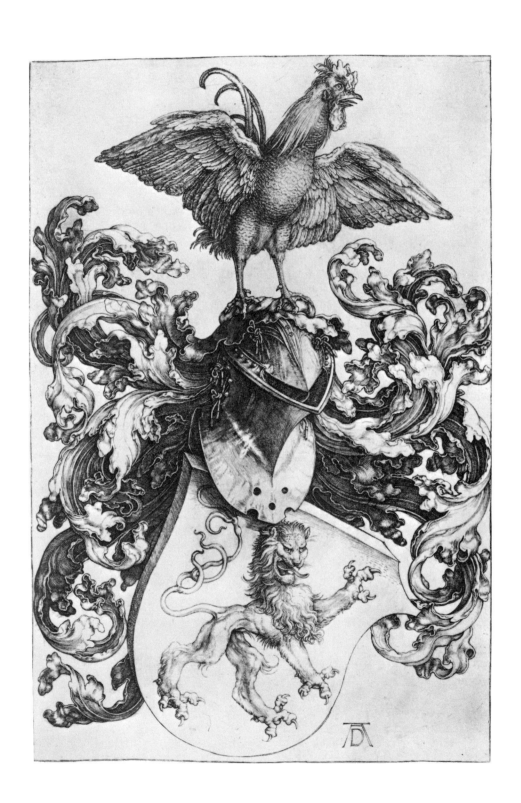

32. THE VIRGIN WITH THE INFANT CHRIST AND ST. ANNE

Monogram; no date [1501].
115 × 70 mm; 4 1/2 × 2 3/4 in.
No border lines.
B.29; K.25; D.26; T.W27; M.43; P.136.

Opinion has been greatly divided concerning the merits of this engraving. Hausmann[1] called it "charming." Retberg[2] found the Virgin "so wanting in nobility of form and pose that one is tempted to take her for a low-grade servant, and the child in her arms for the infant Virgin." Tietze[3] denies the authenticity altogether and calls it a workshop production. He finds the position of the Virgin's legs awkward and the tablet bearing the monogram too severe and insensitive to be by Dürer. Panofsky's comment: "Rather indifferent." There is a remarkable resemblance between this engraving and Dürer's woodcut B.84.

[1] 1861, p. 17.
[2] 1871, No. 44.
[3] T.W27.

33. ST. SEBASTIAN AT THE TREE

Monogram on a tablet; no date [1501].
115 × 70 mm; 4 1/2 × 2 3/4 in.
No border lines.
B.55; K.19; D.24; T.W50; M.62; P.162.

Thausing[1] saw a relationship to the series of captives engraved by Jacopo de Barbari. The monogram may be a later addition.[2] The rough outline of the hirsute legs is unusual for Dürer. Tietze[3] considers this print to be a workshop production, perhaps by Hans Baldung Grien. Hagen[4] asserts that Dürer based the figure on the antique Marsyas in the Della Valle Palace at Rome. According to Panofsky,[5] this is a minor engraving, although authentic. Perhaps this print was originally intended to represent Marsyas bound to a tree, because the arrows do not at any point intersect the contours of the figure; the conversion to a St. Sebastian may have been an afterthought (Talbot, 1971, No. 20).

[1] 1876, vol. I, p. 318.
[2] K.19.
[3] T.W50.

[4] O. Hagen, "War Dürer in Rom?," *Zeitschrift für bildende Kunst, vol. LII, 1917, p. 255.*
[5] 1943, vol. I, p. 83.

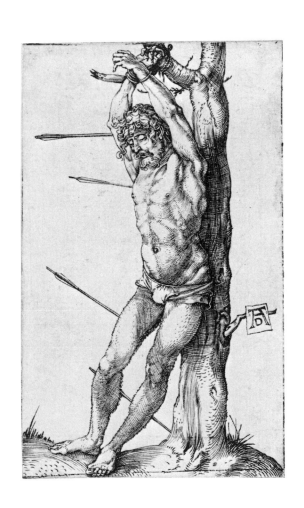

34. ST. EUSTACE (*Often erroneously called "St. Hubert"*)

Monogram on a tablet; no date [1501].
355 × 259 mm; 13 7/8 × 10 1/8 in.
Border line on the bottom only.
B.57; K.32; D.32; T.182; M.60; P.164.

This is the largest of Dürer's engravings. He frequently sold impressions of it or gave them away as presents during his journey to the Netherlands.[1] St. Eustace was a general under the Emperor Trajan. While hunting he was suddenly confronted by a stag bearing a crucifix. After his conversion to Christianity on account of that incident, he was burnt to death in a fiery oven. Thausing[2] points out that the minute detail and the careful execution of this engraving surpass its inventiveness and composition. Wölfflin[3] remarks that Dürer neglects to tell the story of the saint and seems more interested in the horse than in the stag. The horse is not a proportional construction but a schematic application of geometric shapes.[4] Dürer carefully avoided any overlapping of the animals. In this end and other details this print is closely related to Pisanello's painting of the same subject (London, National Gallery). Those who examine this print very carefully will discern a tiny knight on horseback above the right arm of the saint.[5] The unusually large size of the plate appears to have caused some difficulty in printing. Even some of the best impressions have some squeezed lines near the edges. There are impressions on satin, all posthumous, at Coburg, Boston, Vienna, Gotha and Frankfurt.

[1] At Antwerp, August 19 and 20, September 9, November 12 and 24, according to his diary.
[2] 1876, vol. I, p. 228.
[3] 1905, p. 130.
[4] H. David, "Zum Problem der Dürerschen Pferdekonstruktion," *Repertorium für Kunstwissenschaft*, vol. XXXIII, 1910, p. 310.
[5] Retberg, 1871, No. 127.

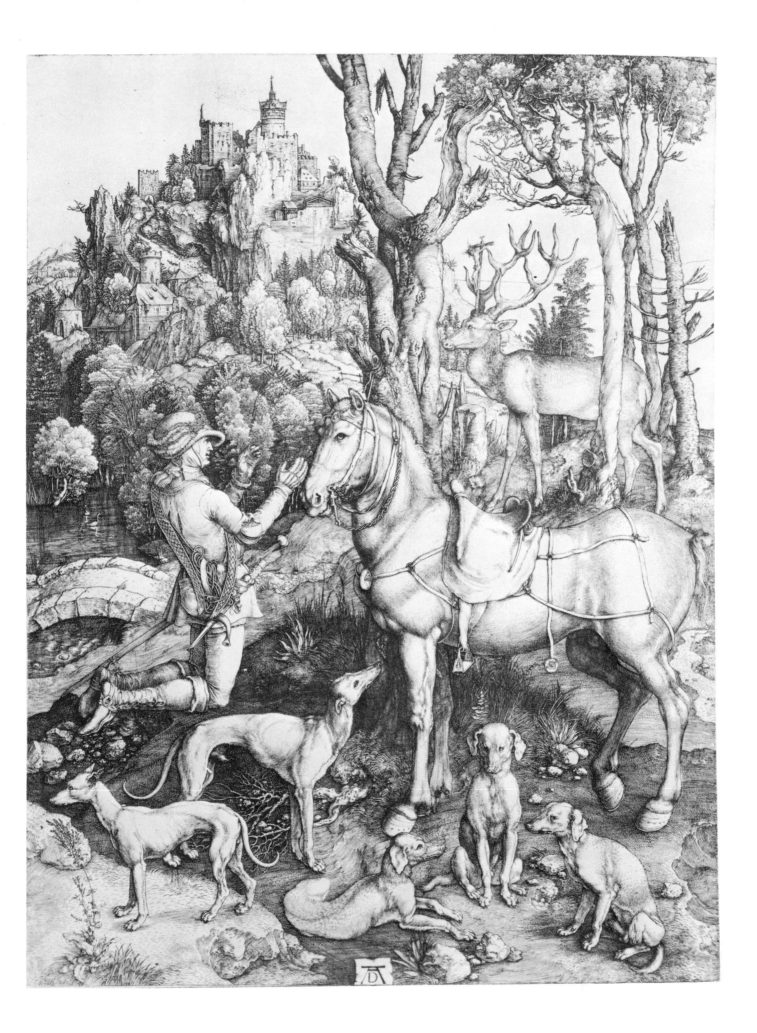

35. THE STANDARD BEARER

Monogram on a tablet; no date [1502].
115 × 70 mm; 4 1/2 × 2 3/4 in.
No border lines.
B.87; K.26; D.27; T.239; M.92; P.194.

The banner with the St. Andrew's Cross of the Order of the Holy Fleece, as used by Maximilian I in his capacity as Duke of Burgundy, relates this print to the Swiss War of 1499.[1] Koehler[2] remarks that the incongruities this engraving offers in design and workmanship, the poor drawing of the mouth in its first state, the correction in its second state and the changes made in the upper left corner are quite foreign to Dürer and might point to its being a forgery: "Certainly Dürer's oeuvre would lose nothing if this plate were thrown out."

This is in marked contrast to the comments of other scholars, however. Hausmann[3] calls it "a lovely print." Panofsky[4] sees in it "a by-product of the process of arriving at a more elastic posture which was to lead up to the 'Adam and Eve' of 1504 [No. 42]." This first use of a tablet with hanger for the monogram coincides with the use of this device on the woodcuts of the *Life of the Virgin* series (B.76–95). The background is remarkably similar to that of "St. George on Foot" (No. 36).

[1] Thausing, 1876, vol. I, p. 239.
[2] K.26.

[3] 1861, p. 33.
[4] 1943, vol. I, p. 92.

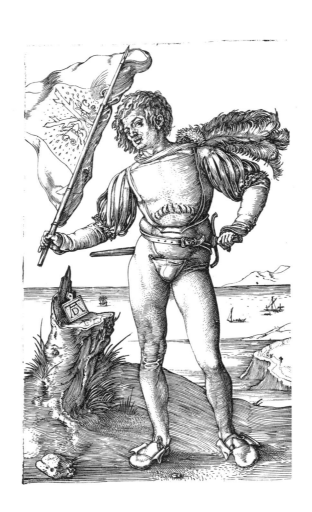

36. ST. GEORGE ON FOOT

Monogram on a tablet; no date [1502].
115 × 70 mm; 4 1/2 × 2 3/4 in.
No border lines.
B.53; K.43; D.46; T.240; M.55; P.160.

The emblem on the banner is here that of the Order of St. George, a cross within a circle. The Emperor Maximilian I always took great interest in this order, founded by his father, and in the extension of it into confraternities with whose aid he hoped to enlist forces for a march to Rome and a crusade against the Turks. This print is often dated somewhat later, in the vicinity of the "St. George on Horseback" (No. 46), but Tietze[1] suggests an earlier date on account of the traditional bearded face (which subsequently was replaced by a beardless version), the tablet with a tab, the uncommon circular halo (which otherwise appears only in the "Madonna with the Monkey," No. 21) and the severe profile of the somewhat awkward figure. Furthermore, as mentioned earlier, Dürer consistently placed a date on all of his engravings beginning in 1503.

[1] T.240.

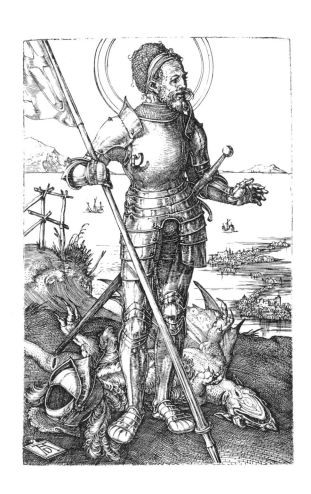

37. NEMESIS; *or*, FORTUNA (*Das grosse Glück*)

Monogram on a tablet; no date [1502].
329 × 224 mm; 12 7/8 × 8 3/4 in.
No border lines.
B.77; K.33; D.33; T.196; M.72; P.184.

Copies of this print were frequently given as presents by Dürer during his trip to the Netherlands during 1520/21.[1] Vasari[2] describes it as "a nude figure floating in the clouds, representing Temperance, with magnificent wings, a golden cup and reins in her hands." The reins signify restraint from temptation that should be exercised by man; the sphere, uncertainty. The subject is based[3] on the poem *Manto* by Angelo Poliziano, first published in 1482. Nemesis was credited with transferring Greek knowledge to Rome—perhaps a tribute to many translations from Greek into Latin by Dürer's close friend and mentor, Willibald Pirckheimer. The figure is proportioned according to the canon of Vitruvius.[4] The landscape below has been identified as the village of Klausen (Chiusa) in the Valle d'Isarco in the Tyrol, which lay on Dürer's route of travel to Venice. Although there is some variance between Dürer's Nemesis and the attributes described by Poliziano, he has created an image that places her among the matriarchs.[5]

A preparatory drawing survives (W.266). On it a faint grid used for the construction can be discerned.

[1] At Antwerp, August 19 and 20, November 24; At Cologne, November 12, 1520.
[2] 1568, in the chapter on Marcantonio Raimondi.
[3] K. Giehlow, "Poliziano und Dürer," *Mitteilungen der Gesellschaft für vervielfältigende Kunst*, vol. XXV, 1902, p. 25.
[4] Panofsky, 1943, vol. I, p. 81.
[5] H. Kauffmann, "Dürers Nemesis," *Tymbos für Wilhelm Ahlmann*, Berlin, 1951, p. 135.

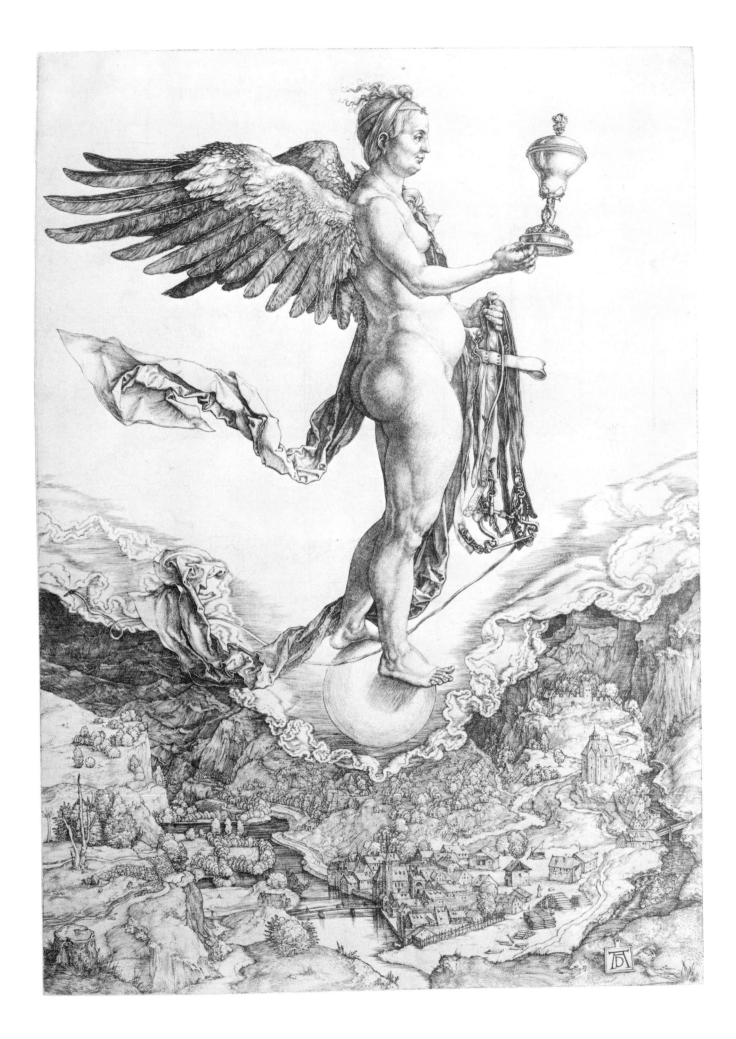

38. APOLLO AND DIANA

Monogram on a scroll; no date [1502].
115 × 70 mm; 4 1/2 × 2 3/4 in.
No border lines.
B.68; K.36; D.34; T.233; M.64; P.175.

Closely related to the very similar engraving by Jacopo de Barbari. In no other plate, except "Adam and Eve" (No. 42) is there such delicate modelling of the flesh.[1] The contrast of male and female is emphasized by the introduction of movement.[2] The head of Diana is almost identical to the one in the drawing "Woman Riding a Dolphin" (W.330), dated 1503. Winkler[3] calls this print "a masterpiece." The D of the monogram shows a correction. Based on the drawing W.261. Closely related to the drawing "Head of a Stag" (W.362).

[1] K.36.
[2] Wölfflin, 1905, p. 143.

[3] 1957, p. 137.

39. MADONNA ON A GRASSY BENCH

Monogram; dated 1503.
115 × 70 mm; 4 1/2 × 2 3/4 in.
No border lines.
B.34; K.29; D.35; T.242; M.31; P.141.

Except for "The Four Witches" (No. 19), this is the first of Dürer's engravings to bear a date. Henceforth he dated them consistently.[1] Vasari remarks that Dürer here "surpassed Martin Schongauer, as well as himself." But Koehler[2] finds it less satisfactory from an artistic point of view and archaic in feeling: "the most satisfactory way to dispose of it would be to reject it as a forgery, together with 'St. Sebastian Tied to a Column' (No. 26), but it would require courage to do that!" In marked contrast, Wölfflin[3] calls it "the most sensitive of the early Madonnas, quite in the convivial style of the *Life of the Virgin* [woodcut] series." The play of hands is charmingly natural. Panofsky[4] sees it as a compromise between miniature-like delicacy and definiteness of line. Winkler[5] remarks that "no greater monument could have been devised in honor of motherly activity. The Virgin is here mature. Everything is simple and definite." Based on the preparatory drawing W.290.

[1] Except for No. 92, a niello in miniature, and No. 100, an unfinished engraving.
[2] K.29.
[3] 1905, p. 115.

[4] 1943, vo. I, p. 83.
[5] 1957, p. 163.

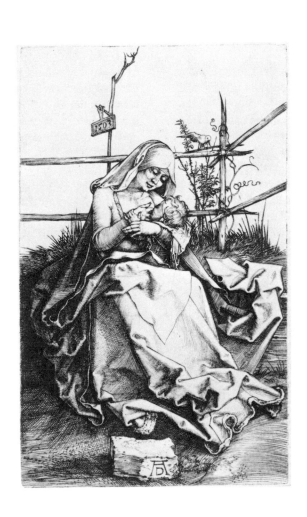

40. COAT-OF-ARMS WITH A SKULL

Monogram on a tablet; dated 1503.
220 × 156 mm; 8 5/8 × 6 1/8 in.
With border lines.
B.101; K.30; D.36; T.211; M.98; P.208.

This engraving is not mentioned in Dürer's diary of his trip to the Low Countries in 1520/21. Panofsky[1] considers it a masterly engraving and a heraldic version of the Love and Death theme of "The Promenade" (No. 20). Bernheimer[2] asserts that it is, in fact, a marriage print, connected with the wedding feast and visits expected at the festive time; therefore the crown is a bridal crown and "the print is an allegory of the eternal polarity of love and death." The subject seems, however, to be more reasonably connected with the Bavarian War of 1503. Duke George the Rich had died that year without male issue. Contrary to Imperial law, he left his lands to his daughter. This led to the War of the Bavarian Succession, in which the city of Nuremberg was deeply involved. Her army captured much of the surrounding territory and Nuremberg became the largest of the "free cities" of the Empire. This engraving appears to be an allegory of this war, which ended badly for the ill-advised titled lady. The Emperor deprived her of her lands, while Nuremberg was permitted to retain the conquered territory. Based on the drawings W.227 and W.177.

[1] 1943, vol. I, p. 83.
[2] R. Bernheimer, *Wild Men of the Middle Ages*, Cambridge, Mass., 1952, p. 183.

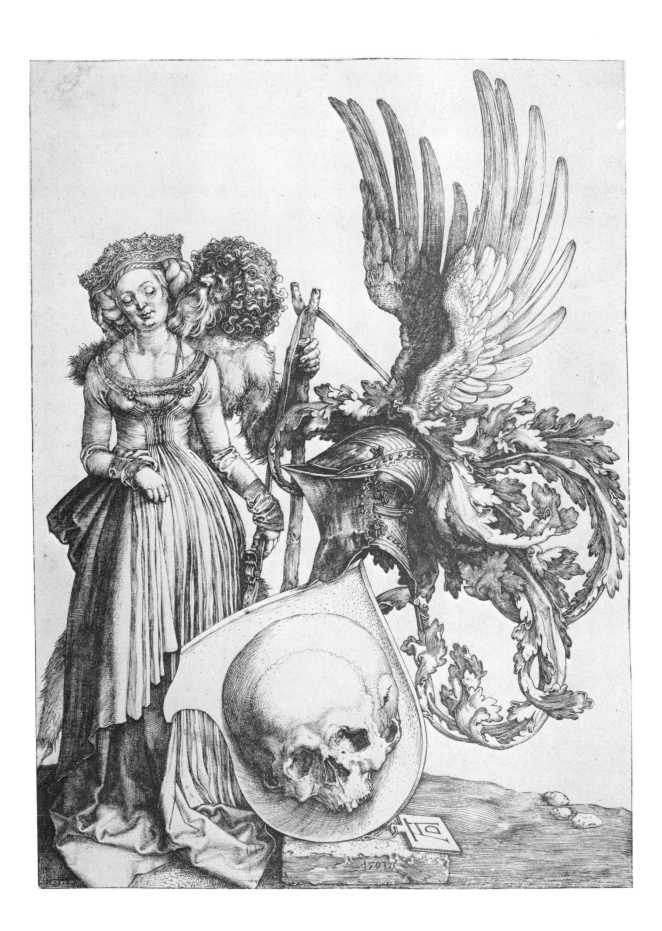

41. NATIVITY (*Weihnachten*)

Monogram on a tablet; dated 1504.
183 × 120; 7 1/8 × 4 5/8 in.
With border lines.
B.2; K.35; D.38; T.250; M.2; P.109.

On August 20, 1520, Dürer recorded in his diary: "I also gave the factor of Portugal a 'St. Anthony,' 'Weÿnachten' and 'The Cross.' " This is the only time the present print is mentioned by Dürer. It is, in fact, an architectural study; the figures seem quite subordinate to the structures, as has been noted by previous writers. Wölfflin[1] remarks that the windows are perhaps a little too black, but "a convivial mood is achieved, although one cannot expect the interplay of black and white to be more than decorative at this stage of Dürer's development." Tietze[2] observes that "although it is clearly designed with a single vanishing point, the eye of the beholder is retarded by the overabundance of detail from following the lines of perspective. The result is a mood of movement in quietude. The scene is not so much a 'presentation' to the observer, as it is an opportunity to 'eavesdrop' on what is taking place." The eye is drawn to the light area beyond the archway where an angel descends to deliver the good tidings of a new time. This engraving is a restatement of the center panel of Dürer's *Paumgartner Altarpiece*, finished shortly before. The prominent location of the date is quite similar to the way the tablet is suspended in the "Madonna on a Grassy Bench" (No. 39). It suggests that both of these prints may also have served as New Year's greetings; this has also been asserted in connection with the drawing "Infant Savior" in Vienna.[3] In Dürer's time the first day of the year was celebrated on Christmas Day.

[1] 1905, p. 147.
[2] T.250.

[3] P.628; Flechsig, 1928, vol. II, p. 356; P. Heitz, *Neujahrswünsche des 15. Jahrhunderts*, Strassburg, 1899.

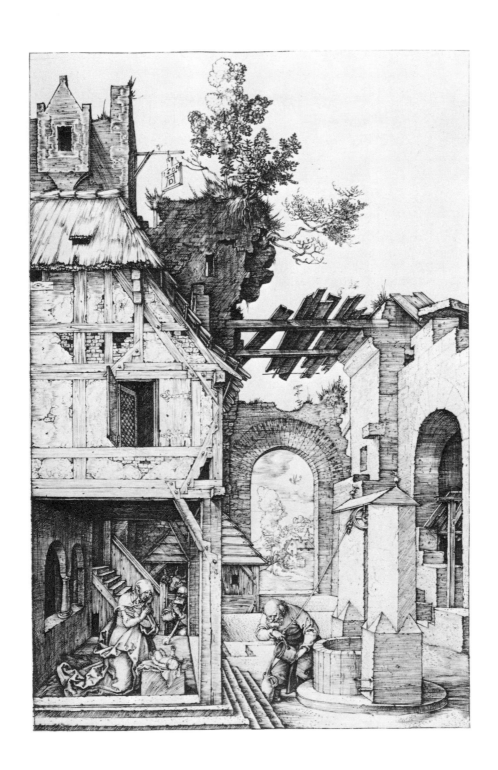

42. ADAM AND EVE

Monogram and date, 1504, on a tablet.
252 × 194 mm; 9 7/8 × 7 5/8 in.
Border lines on right upper corner only.
B.1; K.34; D.39; T.258; M.1; P.108.

Mentioned in Dürer's diary of his trip to the Netherlands, 1520/21, on three occasions.[1] According to Zahn,[2] the conscious application for the first time of a set of rules of proportion explains why these figures have a rigid pose, contradictory to the essence of Dürer's concept of nature. The disagreeable impression is compensated only by the mastery of technique. Thausing[3] asserts that "this engraving brought Dürer before the world in the full consciousness of his power, as indisputably the greatest master of the burin"; while Koehler[4] remarks that "it is equally certain that the biblical story served the artist only as a pretext for representing the nude, both male and female, according to the best lights he then had, based on Apollo Belvedere and on Venus. Nowhere else has Dürer treated the flesh with such caressing care, using much fine dotting in the modeling, and in no previous plate has he used such a variety of textures in the conscious striving for color. It is instructive to compare this with the pure black and white of the 'Virgin with the Monkey' [No. 21]. This Adam and Eve are quite unconscious of their nakedness, they proclaim to the peoples north of the Alps the emancipation of the flesh under the influence of the antique and its release from the curse which for fifteen hundred years had rested upon it." Heller[5] already noted that the animals pictured in this engraving represent the characters of man. Panofsky[6] explains that the four temperaments of man, the sanguine, phlegmatic, choleric and melancholic, "before Adam bit into the apple had been in perfect equilibrium, he was immortal and sinless. According to Hildegard of Bingen, had man remained in Paradise he would have no noxious fluids in his body. The wise, benevolent parrot is contrasted with the diabolical serpent. Adam is holding on to a branch of mountain ash that signifies the Tree of Life to contrast it with the forbidden fig tree." Later impressions are distinguished by a cleft of the tree trunk beneath Adam's left armpit.

Preparatory and related drawings: W.333, 334, 335, 336, 244, 242, 359, 287.

[1] At Antwerp, August 20, September 9 and November 24, 1520.
[2] 1866, p. 44.
[3] 1876, vol. I. p. 304.
[4] K.34.
[5] 1827, No. 116.
[6] 1943, vol. I, p. 84.

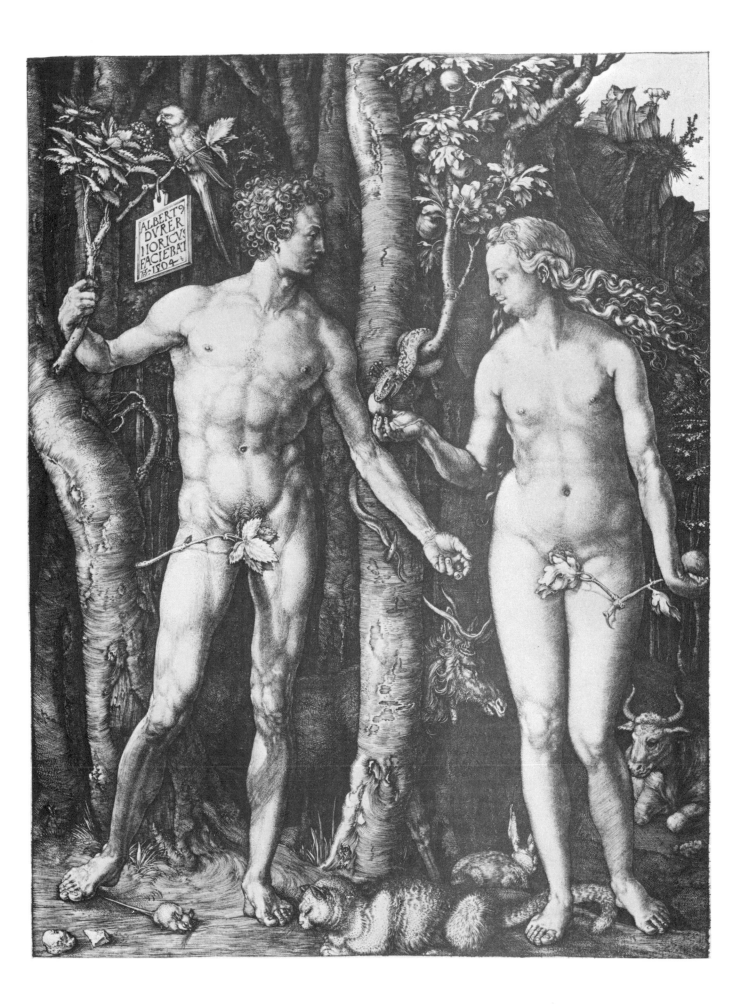

42a. ADAM AND EVE

Trial impression before the completion of the plate, first stage.
Vienna, Albertina; also at London, British Museum.

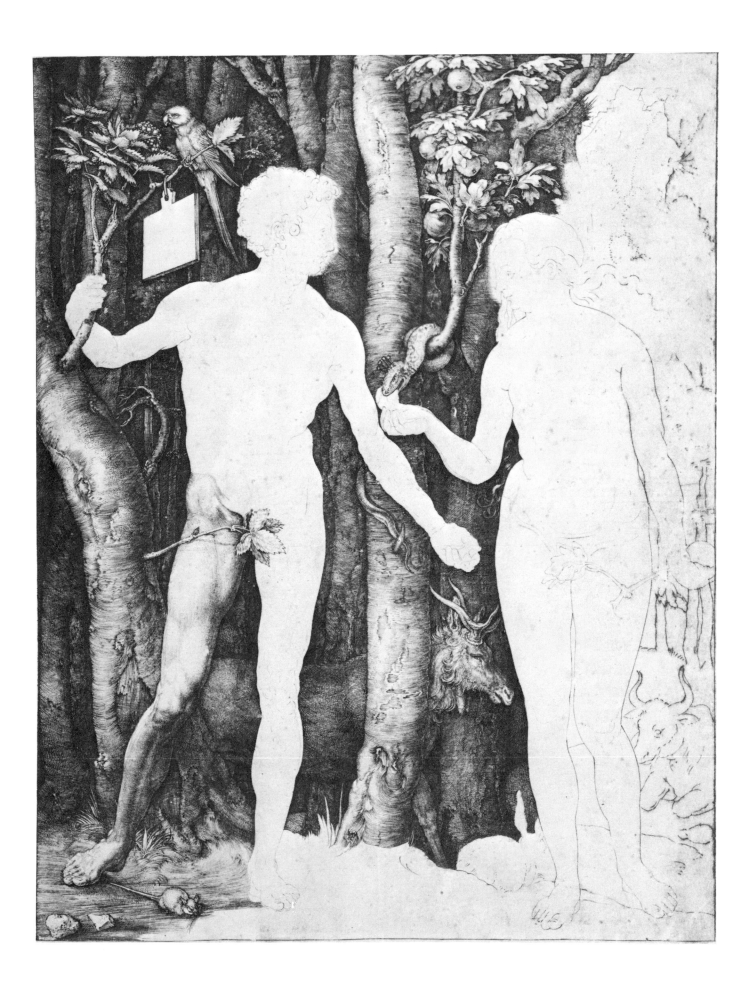

42b. ADAM AND EVE

Trial impression before the completion of the plate, second stage.
Vienna, Albertina.

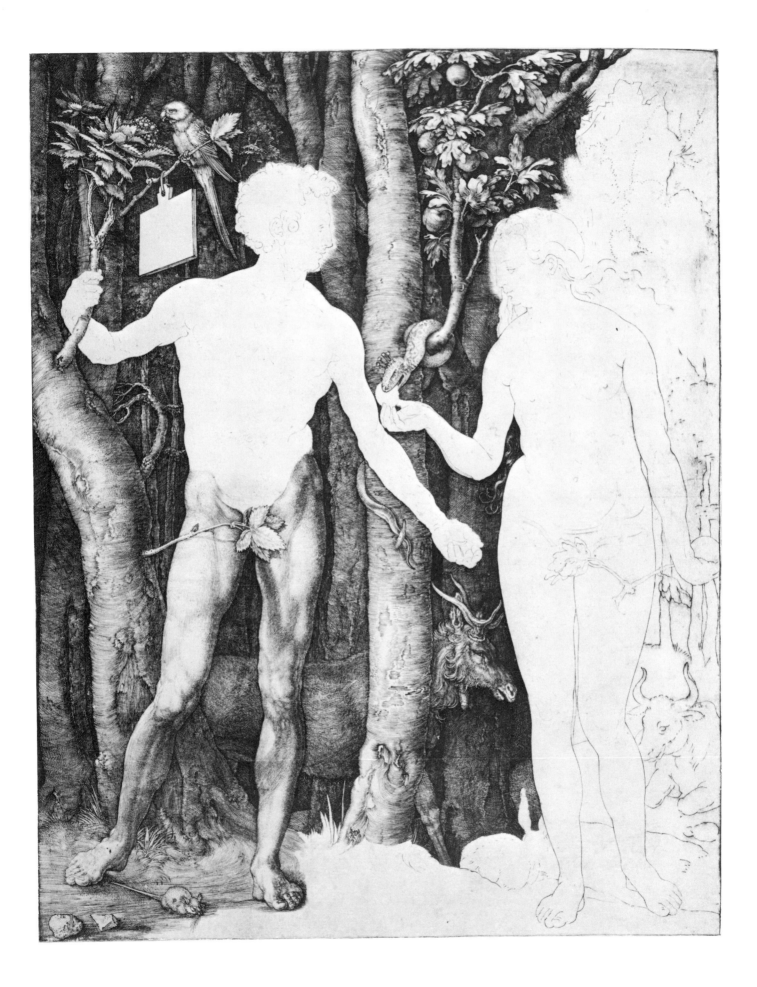

43. SATYR FAMILY

Monogram and date, 1505, on a tablet.
115 × 70 mm; 4 1/2 × 2 3/4 in.
No border lines.
B.69; K.37; D.42; T.275; M.65; P.176.

Formerly erroneously called "Pan and Syrinx" or "Birth of Adonis," this print is based on Lucian's description of a painting by Zeuxis. It was probably conceived as a companion piece to "Apollo and Diana" (No. 38). The engraving is developed from the drawing "Centauress Nursing her Young" (W.344).[1] According to Panofsky[2] the instrument played by the satyr is a *Platterspiel,* a reed instrument equipped with a bladder similar to that of a bagpipe. The scene is staged in a forest even denser than that of "Adam and Eve" (No. 42).

[1] Based on a description by Philostratus, Book II, chapter 3, *Philostratus' Imagines,* London, 1931, p. 139.

[2] 1943, vol. I, p. 87.

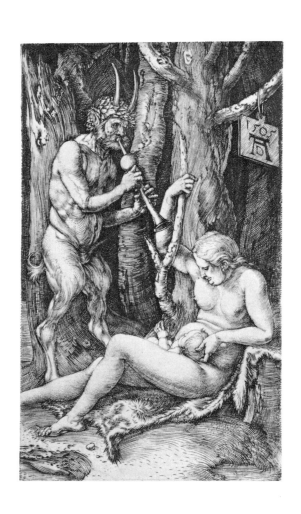

44. THE SMALL HORSE

Monogram and date, 1505.
165 × 108 mm; 6 3/8 × 4 1/4 in.
No border lines.
B.96; K.38; D.43; T.281; M.93; P.203.

Older commentators thought that Perseus or Mercury was pictured in this engraving, but, as Thausing[1] rightly asks, what has Mercury to do with a horse? According to Tietze,[2] this print is solely intended to demonstrate the proportion of a horse based on theoretical construction. Kurthen[3] determined that it is based on a drawing of 1503 (W.360) but constructed on the basis of nine squares in a strictly geometrical system. Panofsky[4] explains that the "Small Horse" is "presented in pure side elevation to reveal its exquisite proportions, set out against a heavy and receding barrel vault, and therefore looks all the more slender and elegant in comparison. Compared to the 'Large Horse' [No. 45] it may well be meant to signify animal sensuality restrained by the higher powers of the intellect and the flame bursting forth from the vase is no less a symbol of illuminating reason. The proportions, and the pig-snouted head are unmistakably Leonardesque." Leonardo da Vinci had made extensive studies of horses in the Milan stables of Galeazzo da San Severino. His manuscripts were lost when the French occupied the city in 1499. Yet some of the material must have reached Dürer, perhaps in 1502 when Galeazzo visited Nuremberg, where he spent many weeks at the house of Dürer's friend Willibald Pirckheimer. Dürer too planned to publish a book on the proportions of the horse. His notes disappeared under mysterious circumstances mentioned by Camerarius in the introduction to the posthumous Latin edition of Dürer's *Four Books on Human Proportion,* 1532.

[1] 1876, vol I, p. 322.
[2] T.281.
[3] J. Kurthen, "Zum Problem der Dürerschen Pferdekonstruktion," *Repertorium für Kunstwissenschaft,* vol. XLIV, 1923, p.94.
[4] 1943, vol. I, p. 88.

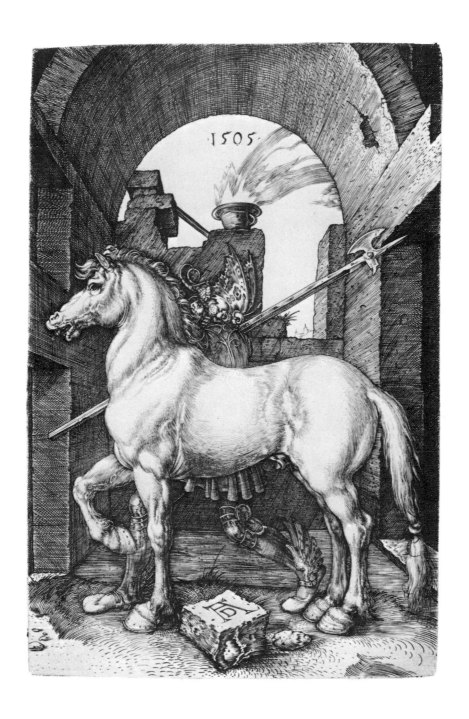

45. THE LARGE HORSE

Monogram and date, 1505.
167 × 119 mm; 6 1/2 × 4 5/8 in.
No border lines.
B.97; K.39; D.44; T.282; M.94; P.204.

Formerly thought to represent Hercules with one of the horses of Diomedes.[1] The fantastically attired groom seems to be stepping up to higher ground. Tietze[2] notes that the knee ornaments of his armor are divergent. The horse may be patterned after a drawing in the sketchbook of Jacopo Bellini. Wickhoff[3] notes a resemblance to a horse drawn by Pisanello in the *Codex Vallardi*.

Panofsky[4] calls attention to the violent foreshortening of the horse to about half its natural length. The title is therefore not based on the actual size of the print, but on the relative scale of the animal as compared to "The Small Horse" (No. 44). It is obviously not constructed proportionally, but after a model from nature.[5]

[1] Thausing, 1876, vol. I, p. 322; K.39.
[2] T.282.
[3] F. Wickhoff, "Dürer Studien," *Kunstgeschichtliches*

Jahrbuch, vol. I, p. 10, 1907.
[4] 1943, vol. I, p. 87.
[5] Winkler, 1957, p. 162.

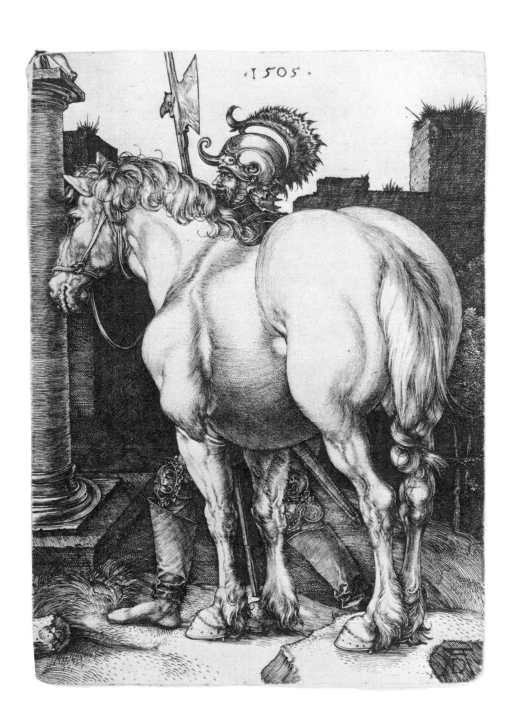

46. ST. GEORGE ON HORSEBACK

Monogram and date on a tablet; 1505 (completed 1508).
110 × 86 mm; 4 1/4 × 3 3/8 in.
No border lines.
B.54; K.42; D.49; T.280; M.56; P.161.

The last work before Dürer's sudden departure on a second trip to Venice in order to escape the Great Plague. This engraving was probably almost complete because the date 1505 had already been engraved in the plate. It was subsequently corrected to read 1508. The background is deliberately reduced in scale for sake of contrast[1] and any indication of a landscape is omitted. Panofsky notes that Dürer in this engraving sought to combine the monumentality of "The Large Horse" (No. 45) with the elegance of "The Small Horse" (No. 44). Pictured from behind, this unusual stance effectively conveys a feeling of pause before the saintly warrior forges ahead to further defend the Faith. It was also used in the *Ober St. Veit Altarpiece*, which was completed in Dürer's workshop during his absence in Italy.

[1] Panofsky, 1943, vol. I, p. 89.

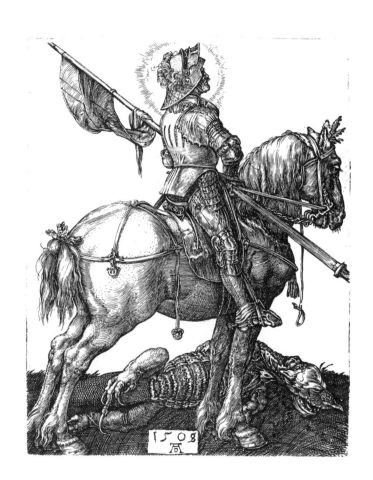

THE ENGRAVED

PASSION

In conformity with the chronological arrangement of Dürer's engravings in this catalog, the sixteen subjects of the Engraved Passion become separated. They are not as uniform in character as Dürer's two woodcut Passions because their development is spread over a longer period of time. Wölfflin[1] remarks that they are more intimate, however—the most sensitive criterion of artistic development. He points out the more Italianate, three-dimensional character of the "Lamentation" (No. 47) of 1507, as compared with the subjects of 1512, which are conceived like two-dimensional paintings. Dürer seeks out difficult problems, extreme foreshortenings, details of heads and bodies, effects of costumes, all

features which are omitted from the woodcut versions. He is working for a different audience, for the intelligentsia. These engravings have an air of artificiality but are nevertheless quite powerful.

Without doubt, Dürer sold these sheets singly before the entire series was completed.[2] The "Man of Sorrows," the "Bearing of the Cross" and the "Resurrection" are particularly suitable for insertion into prayerbooks. For that reason these three subjects seem a little more dull in most complete sets. All sheets lack border lines. Dürer refers to the Engraved Passion on many occasions in the Diary of his trip to the Netherlands, 1520/21, as quoted opposite.[3]

Sequence of Subjects of the Series in Bound Editions

1.	Man of Sorrows[4]	No. 52	9.	Pilate Washing His Hands	No. 63
2.	Agony in the Garden	48	10.	Bearing of the Cross	64
3.	Betrayal	49	11.	Crucifixion	53
4.	Christ before Caiaphas	58	12.	Lamentation	47
5.	Christ before Pilate	59	13.	Deposition	65
6.	Flagellation	60	14.	Harrowing of Hell	66
7.	Christ Crowned with Thorns	61	15.	Resurrection	67
8.	Ecce Homo	62	16.	St. Peter and St. John	68

[1] 1905, p. 225.
[2] Hausmann, 1861, p. 12.
[3] For Dürer's Diary refer to Rupprich, vol. I, pp. 146-202 (German, with extensive footnotes); or Martin W. Conway, *Literary Remains of Albrecht Dürer*, Cambridge, 1889; 2nd ed., London, 1958. The best translation into English, however, is *Record of Journeys to Venice and the Low*

Countries by Albrecht Dürer, edited by Roger Fry, Boston, 1913 (translated by Rudolph Tombo).
[4] In the bound copy at Princeton, formerly owned by Frederick the Wise of Saxony (from the collection of Junius S. Morgan), the "Man of Sorrows" is inserted as the last page.

1520. *Antwerp, August:*

Sebald Fischer bought from me 16 small Passions for four guilders, also 32 of the large books for eight guilders and six engraved Passions for three guilders.

I gave the factor of Portugal the small Passion and the Passion engraved on copper.

Brussels, August:

I also dined once with Mr. Bonysius [Jacob Banisius, secretary of the Emperor Maximilian I] and presented him with a Passion engraved on copper.

I handed my letter of recommendation, given to me by my Lord the Bishop of Bamberg, to the Margrave Hanns [of Brandenburg]. I gave him a Passion engraved on copper as a remembrance.

Lady Margaret [the Regent of the Netherlands] sent for me at Brussels and assured me she would be my advocate in the matter before King Charles [concerning the confirmation of Dürer's annuity]. She was very kind to me. I gave her my engraved Passion, likewise to her Treasurer, named Jan Marnix.

I gave a Passion engraved on copper to the City Treasurer Puscleidis [Busleyden]. In return he presented me with a black Spanish bag worth three guilders. Furthermore, I gave an engraved Passion to Erasmus of Rotterdam.

I also gave an engraved Passion to Erasmus [Strenberger], the secretary of Mr. Bonysius.

Antwerp, September:

I gave an engraved Passion to Marx the goldsmith [Marc de Glasere of Bruges].

Felix, the captain and lute player, has bought from me an entire set of engravings, a woodcut Passion, an engraved Passion, two half-sheets, and two quarter-sheets, all for eight gold guilders. I then gave him an entire set of engravings for a present.

Antwerp, November:

I gave a Passion engraved on copper to Jan the servant of Jobst's [Jobst Planckfeld, Dürer's innkeeper] brother-in-law.

1521 *Antwerp, January:*

I gave one engraved Passion and a woodcut Passion to Wolff von Roggendorff.

Antwerp, March:

I sent a small piece of porphyry and one engraved Passion to Master Hugo [van der Goes] at Brussels.

Antwerp, June:

I gave Master Jacob [probably Dürer's physician] a Passion on copper and a woodcut Passion together with five other prints.

Brussels, July:

I gave an engraved Passion to the wife of Master Jan the goldsmith after having dined with him three times.

47. LAMENTATION OVER CHRIST (*Engraved Passion*)

Monogram and date, 1507, on a stone in the foreground.
115 × 71 mm; 4 1/2 × 2 3/4 in.
No border lines.
B.14; K.57; D.45; T.351; M.14; P.121.

Also called "Descent from the Cross," this is the first of Dürer's engravings after his return from Italy. It is not yet appreciably different in style from those of 1504/05.[1] The "Lamentation over Christ" is the earliest of the plates of the *Engraved Passion* and, according to Hausmann,[2] considerably weaker than the other subjects of that series. Wölfflin[3] notes that it suffers from Dürer's preoccupation during this period with the arrangement of limbs. The position of Christ's legs is similar to that of the Infant Christ's in the painting *The Brotherhood of the Rosary.* Flechsig[4] points out that Dürer could not have thought of an entire series of Passion subjects at that time, otherwise he would have begun with the "Agony in the Garden." In contrast to the other subjects which were to follow, the background of this engraving is white.

[1] Panofsky, 1943, vol. I, p. 145.
[2] 1861, p. 12.
[3] 1905, p. 234.
[4] 1928, vol. I, p. 241.

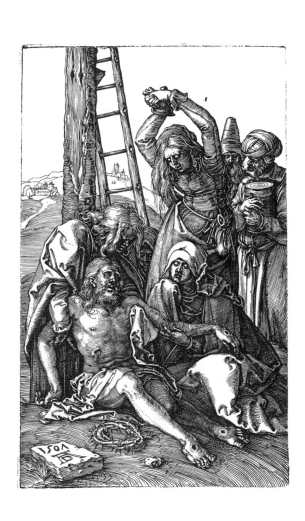

48. AGONY IN THE GARDEN (*Engraved Passion*)

Monogram and date, 1508, on a tablet.
115 × 71 mm; 4 1/2 × 2 3/4 in.
No border lines.
B.4; K.47; D.50; T.361; M.4; P.111.

The saints Peter, James and John are shown asleep. Wölfflin[1] stresses that this engraving is hardly comparable in effectiveness with the woodcut version (B.26). St. Peter appears somewhat labored, pressed toward the margin. Panofsky[2] remarks that the full force of technical and stylistic reorientation is felt in this engraving, as in the one that follows; both are in the new *clairobscur* manner, although printed from a single plate. The suggestion that this new style derives from a meeting with or the influence of Matthias Grünewald[3] is, however, highly speculative, as no evidence of such a meeting has ever been found. This engraving is closely related to the corresponding drawing from the *Green Passion* (W.298). However, that drawing is not in mirror image of the engraving and may postdate it.[4]

[1] 1905, p. 227.
[2] 1943, vol. I, p. 145.
[3] *Ibid.*, p. 246.

[4] T.361; L. Oehler, "Die Grüne Passion, ein Werk Dürers?," *Anzeiger des Germanischen Museums*, Nuremberg, 1960, p. 91.

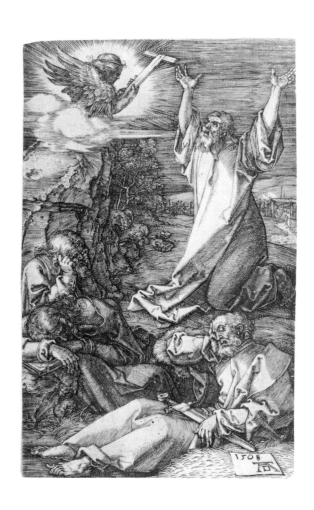

49. BETRAYAL OF CHRIST (*Engraved Passion*)

Monogram and date, 1508, on a tablet.
118 × 75 mm; 4 5/8 × 2 7/8 in.
No border lines.
B.5; K.48; D.51; T.362; M.5; P.112.

St. Peter, striking Malchus, seems to take the spotlight away from Christ.[1] The head of Malchus is strongly reminiscent of that in Schongauer's engraving B.10. Tietze[2] points out that the episode in the background, showing a fleeing youth, represents the rarely illustrated passage Mark 14:51–52, perhaps transmitted by Passion plays. The object underneath Malchus is a lantern, which he customarily carries in Passion plays. According to Panofsky,[3] the emphasis is here shifted from the commotion of the arrest to the tragedy of the betrayal. Physical violence is limited to the duel between St. Peter and Malchus. Christ, unconscious of the noose which threatens his neck, bends his head and closes his eyes to receive the kiss, as though Judas and he were alone in the universe. Closely related to the corresponding subject in the *Green Passion* (W.299 and W.300). (Cf. No. 48.)

[1] Wölfflin, 1905, p. 228.
[2] T.362.

[3] 1943, vol. I, p. 146.

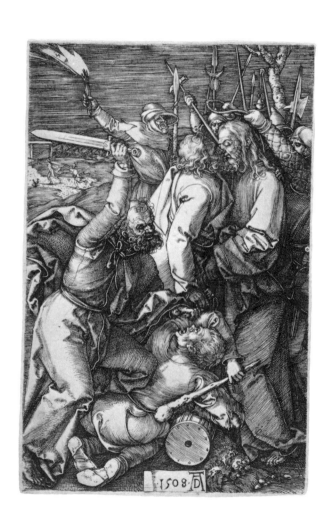

50. CRUCIFIXION

Monogram and date, 1508, on a tablet.
133 × 98 mm; 5 1/8 × 3 3/4 in.
No border lines. The upper corners are rounded.
B.24; K.45; D.47; T.363; M.23; P.131.

Dürer mentions in the diary of his trip to the Netherlands that he gave the factor of Portugal an impression of this engraving at Antwerp on August 20, 1520. St. John, on the right, is clearly reminiscent of the corresponding figure in Mantegna's engraved "Deposition."[1] Flechsig[2] points out that this engraving was conceived as a single sheet, as evidenced by the format, slightly larger than that of the *Engraved Passion*. The figures are, in this case, not placed in front of a black backdrop, as in "Adam and Eve" (No. 42), but actually set into the darkened surroundings.[3] Panofsky[4] calls this print "a nocturne, the most striking feature of which is the expressive figure of St. John, reminiscent of Matthias Grünewald." The women, strictly placed into a triangle, counterbalance St. John's figure.[5]

[1] Thausing, 1876, vol. I, p. 116.
[2] 1928, vol. I, p. 242.
[3] T.363.

[4] 1943, vol. I, p. 145.
[5] Winkler, 1957, p. 232.

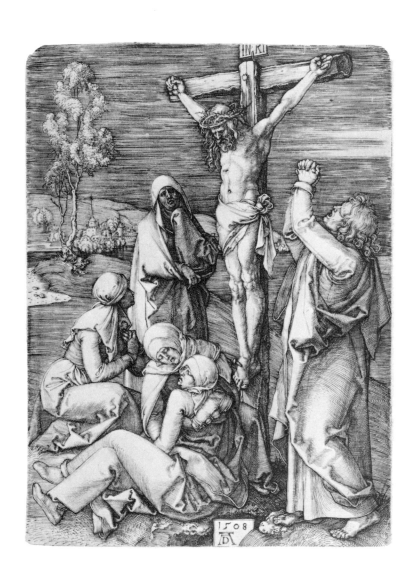

51. THE VIRGIN ON THE CRESCENT WITH A CROWN OF STARS

Monogram; dated 1508.
118 × 75 mm; 4 5/8 × 2 7/8 in.
No border lines.
B.31; K.44; D.48; T.365; M.32; P.138.

The "man in the moon" still appears on the crescent in this version. The separation of the halo from the figure occurs here for the first time in Dürer's works; the stance of the Infant Christ is Leonardesque.[1] Koehler[2] points out that Dürer here shows himself free of the influence of Schongauer. Wölfflin[3] finds this Madonna "gay but a little indifferent." There are impressions of this print at London (illustration at left) and at Berlin showing a state before the halo was completed. In contrast to other engravings of this year, this is not a "nocturne."[4] (Compare Nos. 27, 74 and 85.)

[1] T.365.
[2] K.44.

[3] 1905, p. 279.
[4] Panofsky, 1943, vol. I, p. 145.

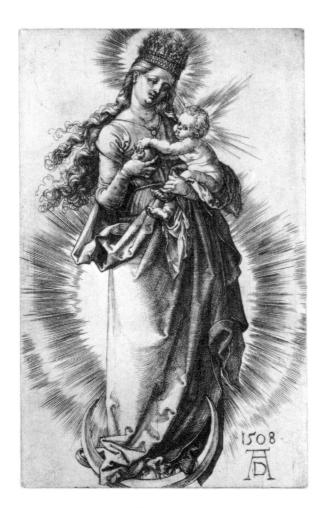

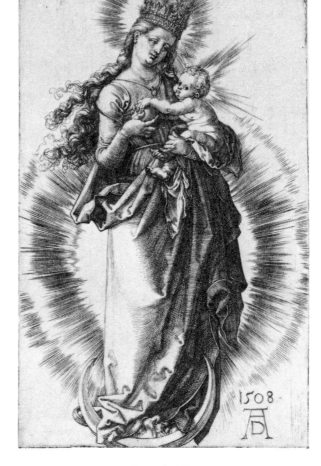

First state *Second state*

52. MAN OF SORROWS BY THE COLUMN (*Engraved Passion*)

Monogram; dated 1509.
116 × 75 mm; 4 1/2 × 2 7/8 in.
No border lines.
B.3; K.46; D.52; T.399; M.3; P.110.

Generally considered the frontispiece of the *Engraved Passion*.[1] This print opens the Passion series, although it is not historical but a representation outside the Gospels. As such, it probably derives from Passion plays. In this version Christ is shown standing. Later, Dürer found the sitting position preferable and used it for the frontispieces of his woodcut Passions. The combination of the Man of Sorrows with the Virgin and St. John was already used by Schongauer (B.69).[2] According to Panofsky,[3] the iconography is based on a vision experienced by St. Bridget. The arrangement of the bystanders in half-length is quite new and remarkable.[4]

After this work Dürer suspended his engraving activity until 1511 and suddenly returned to producing a series of woodcuts after a lapse of more than five years. He issued more than thirty of the thirty-seven subjects of the *Small Woodcut Passion* during this period. The complete series was published in 1511. At the same time Dürer finally completed the *Heller Altarpiece*. In 1510 Dürer also prepared the additional sheets of the *Large Woodcut Passion* and the [woodcut] *Life of the Virgin*.

[1] In the personal bound copy of the Engraved Passion which belonged to Dürer's great patron, the Elector Frederick the Wise of Saxony (now at Princeton), this "Man of Sorrows" is inserted at the end instead of the beginning.

[2] T.399.
[3] P.110: Cf. E. Breitenbach and Th. Hillmann, *Die Christliche Kunst*, vol. XXXIII, 1937, p. 268 ss.
[4] Winkler, 1957, p. 232.

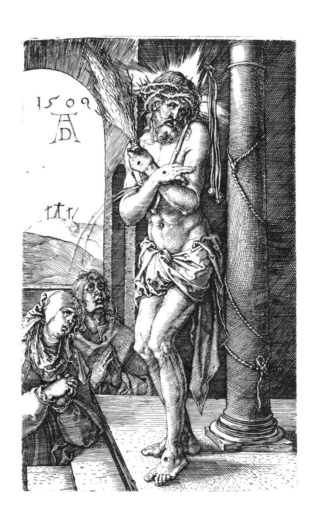

53. CRUCIFIXION (*Engraved Passion*)

Monogram and date, 1511, on separate sheets of paper.
118 × 74 mm; 4 5/8 × 2 7/8 in.
No border lines.
B.13; K.56; D.53; T.478; M.13; P.120.

Wölfflin[1] suggests that probably the moment is pictured when Christ commends his mother to St. John. The feeling of this engraving is statuesque rather than passionate. According to Tietze,[2] the principals are here joined in a triad, almost like a restful pause in the flow of the series. Dürer's rendering, in this instance, is considerably more restrained than the version of 1508 (No. 50). Winkler[3] is critical of the draperies. He finds them restless, almost mannerist, and so abundant as to be incongruous for a Crucifixion. Based on the preparatory drawing W.588.

[1] 1905, p. 232.
[2] T.478.

[3] 1957, p. 232.

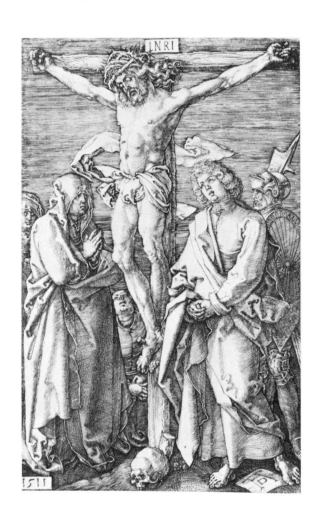

54. MADONNA WITH THE PEAR

Monogram on a tablet; dated 1511.
158 × 106 mm; 6 1/8 × 4 1/8 in.
Border lines on the bottom and partly on the sides. Upper corners rounded.
B.41; K.63; D.54; T.477; M.33; P.148.

The right hand of the Infant Christ is raised as if in benediction. As early as 1827 Heller observed that "this beautifully executed sheet is not accorded its proper due, for there are prints by Dürer which are inferior to it but held in greater esteem. It fetches only modest prices at auction."[1] Thausing[2] also considered it, together with the "Madonna by the Tree" (No. 70), the most beautiful of Dürer's engraved Madonnas. Lippmann, however,[3] noted that "all the magnificence of execution and especially the purity and sharpness of line easily lead to a cold and metallic effect that is notable, for example, in the 'Madonna with the Pear'." Winkler[4] finds the gesture of the Infant Christ not very convincing, "and neither is it the desire of the Virgin that he should appear as the Redeemer at this early age." The pear as pacifier, as opposed to the "apple of discord" or temptation, already occurs as an attribute of the Virgin in a sculpture of the Cathedral of Chartres (completed A.D. 1240).[5] The pear appears on no less than five of Dürer's works; perhaps this was inspired by Bellini. Probably based on the drawing W.516.

[1] No. 621.
[2] 1876, vol. II, p. 62.
[3] F. Lippmann, *Der Kupferstich*, Berlin, 1893, p. 53.

[4] 1957, p. 235.
[5] Drake, *Saints and their Symbols*, London, 1916.

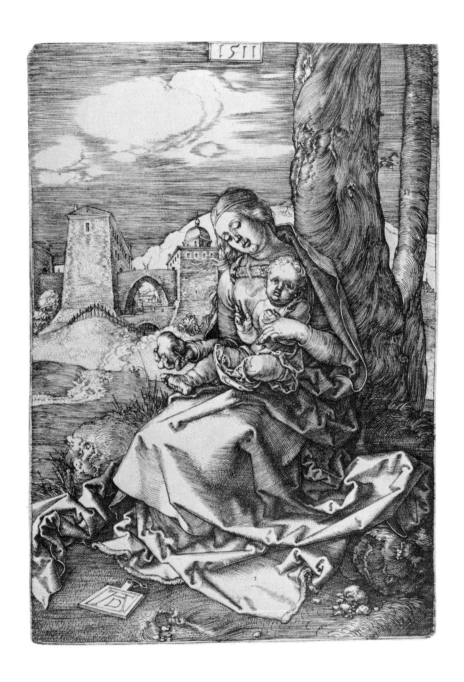

55. THE HOLY FAMILY WITH ST. JOHN, THE MAGDALEN AND NICODEMUS (*Drypoint*)

Without monogram or date [1512].
216 × 190 mm; 8 1/2 × 7 3/8 in.
No border lines. A horizontal line near the bottom margin.
B.43; K.66; D.67; T.547; M.44; P.150.

Koehler[1] and Meder[2] consider this the last of Dürer's experimental drypoints. Flechsig[3] observes that "it is Dürer's earliest one because it is not as carefully planned as usual. The three persons behind the Virgin appear squeezed between bench and wall; the infant is quite unsatisfactory. It almost seems as if Dürer resorted to old designs to test a new technique." Panofsky[4] finds this print "perhaps not by accident somewhat reminiscent of the 'Virgin with the Dragonfly' [No. 4], which in turn was influenced by Dürer's only forerunner in the use of drypoint, the Housebook Master. A gentle play of light and shade enlivens the faces of the bystanders, while the Virgin, built of tiny flicks and scratches, has no particular contours at all. Here Dürer, for once, approaches the Leonardesque ideal of sfumato." Winkler[5] calls this "technically the most successful of Dürer's drypoints, but it is remarkable how carelessly he has handled the composition in this instance." Except in a few limited impressions, the face of the Virgin is crossed out. It has been assumed that Dürer himself did this out of dissatisfaction with the plate. There remains some doubt in this regard, however. Some of the impressions before the face was obliterated are on paper with the "City Gate" watermark, which, as far as can be determined, was not used during Dürer's lifetime. The diagonally ascending line of the composition also occurs in the engravings No. 23 and 89.

[1] K.66.
[2] M.44.
[3] 1928, vol. I, p. 247.

[4] 1943, vol. I, p. 149.
[5] 1957, p. 255.

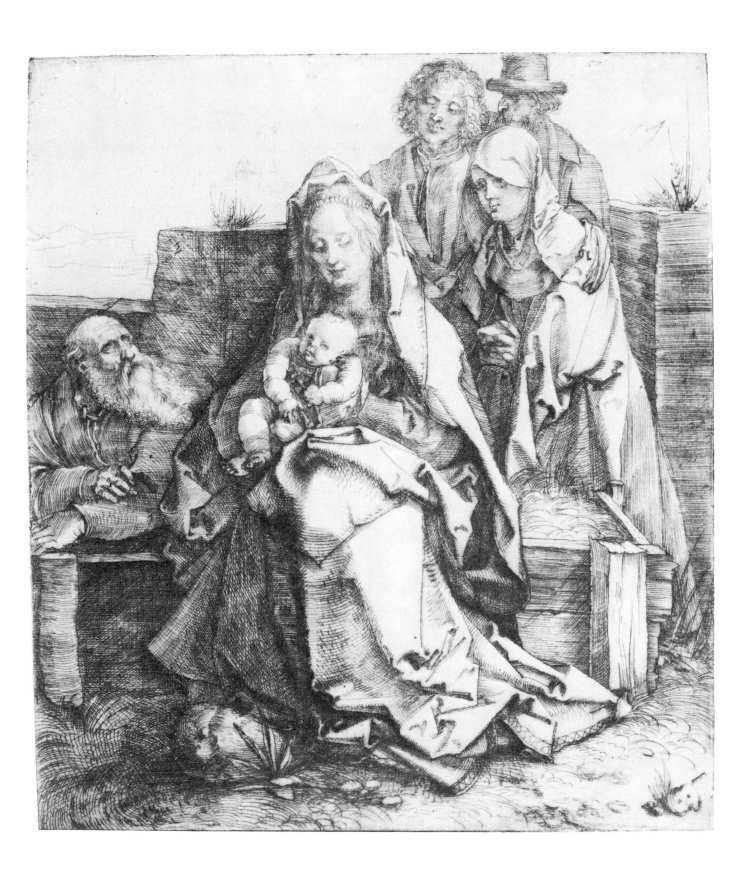

56. ST. JEROME BY THE POLLARD WILLOW (*Drypoint*)

Monogram; dated 1512.
208 × 185 mm; 8 1/8 × 7 1/4 in.
No border lines.
B.59; K.65; D.66; T.501; M.58; P.166.

Hausmann[1] already noted that this is "the most picturesque of Dürer's prints. Its strength, clarity and lighting remain unsurpassed. Unquestionably it served Rembrandt as a model." Wölfflin[2] remarks that Dürer here "seems to break through the barriers of the sixteenth century." Panofsky[3] says very succinctly: "One of only three drypoints by Dürer. The possibilities of the new medium are fully exploited. The elements are interpreted in terms of tonal values rather than plastic form."

Tietze[4] asserts that the date may have been added later by someone else. However, this date is placed on the engraving in very similar fashion to that of the "Madonna with the Pear" (No. 54). There are some impressions of this print before the monogram; also a few where a portion of the upper left corner is inexplicably screened off, shearing off the blades of grass on the top of the rock.[5]

[1] 1861, p. 24.
[2] 1905, p. 258.
[3] 1943, vol. I, p. 148.
[4] T.501.

[5] D.66; H. P. Rossiter, "Two Drypoints by Dürer," *Bulletin of the Museum of Fine Arts*, Boston, vol. XXXVI, 1938, No. 215, p. 36.

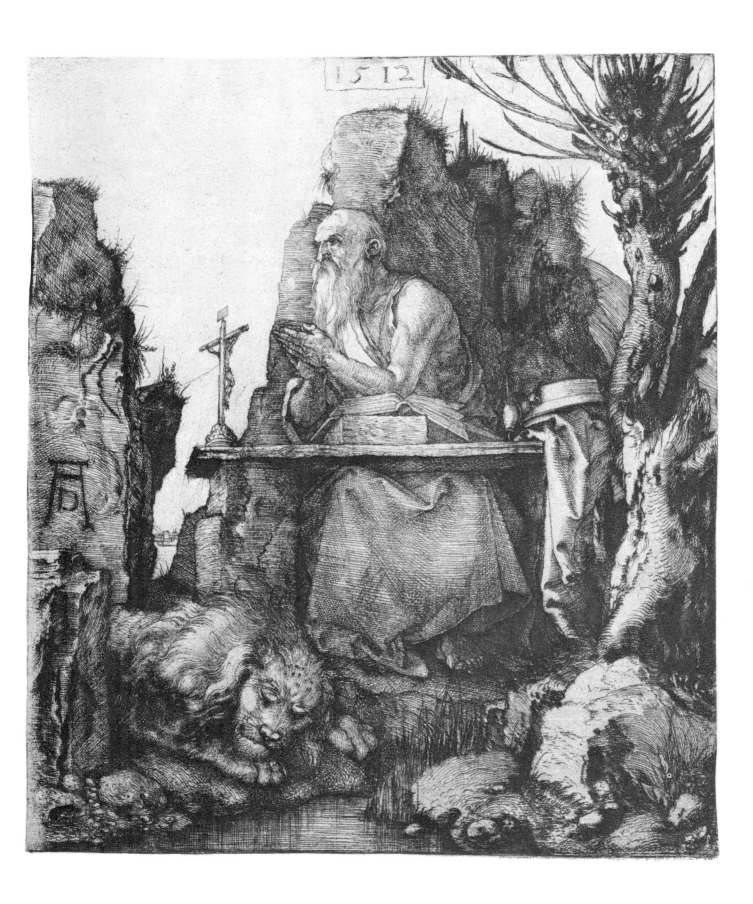

57. MAN OF SORROWS WITH HANDS BOUND (*Drypoint*)

Monogram; dated 1512.
117 × 75 mm; 4 1/2 × 2 7/8 in.
No border lines.
B.21; K.64; D.65; T.500; M.21; P.128.

The measurements are similar to those of the *Engraved Passion,* but the suggestion that this drypoint may have been intended as its frontispiece is not convincing.[1] Panofsky[2] considers it to be Dürer's earliest drypoint, simple in composition, small in size and timid in treatment. Even in good impressions it is a little pale. Winkler[3] points out that this is the only one of Dürer's three drypoints with both a date and a monogram. The monogram of "St. Jerome by the Pollard Willow" (No. 56) was added only in the second state. After only three experiments, therefore, Dürer ceased to work in this medium. Probably based on the drawing W.606.

[1] T.500.
[2] 1943, vol. I, p. 148.

[3] 1957, p. 255.

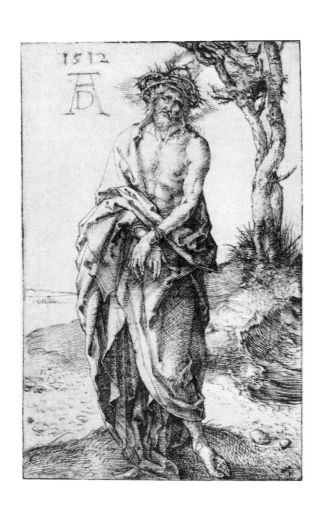

58. CHRIST BEFORE CAIAPHAS (*Engraved Passion*)

Monogram and date, 1512, on a tablet.
117 × 74 mm; 4 5/8 × 2 7/8 in.
No border lines.
B.6; K.49; D.55; T.534; M.6; P.113.

The ceiling, in this instance, gives the engraving a feeling of architectural enclosure, quite in contrast to other subjects of the series. The ceiling beams are directed toward the vanishing point on the left. This serves to emphasize the dialogue between Christ and Caiaphas, which is further enhanced by the lighting. The guardsman on the right seems Leonardesque.[1] Winkler[2] asserts that this engraving is based on the corresponding subject in the *Green Passion* (cf. No. 48). He points out that the main figures, especially the deceitful Caiaphas, are drawn in a masterly manner.

[1] T.534.

[2] 1957, p. 233.

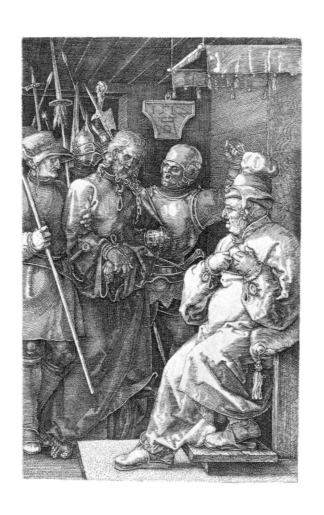

59. CHRIST BEFORE PILATE (*Engraved Passion*)

Monogram; dated 1512.
117 × 75 mm; 4 5/8 × 2 7/8 in.
No border lines.
B.7; K.50; D.56; T.535; M.7; P.114.

The false witness is pointing at Christ.[1] The close relationship of this engraving to the *Green Passion* has been noted by most commentators. Nevertheless, it has recently been asserted that the *Green Passion* sheets may have been based on the engravings and executed by Hans von Kulmbach. Lisa Oehler points out[2] that this high degree of similarity of the two renderings casts great doubt on the authenticity of the *Green Passion* sheet. She asks, "Is there a single case in Dürer's entire work where details are repeated to this extent?"

There is no such evidence, as Flechsig also points out.[3] In view of these remarks, the drawings which have heretofore been considered preparatory for the engraving may in fact not be. Caiaphas is shown standing next to Christ, perhaps due to the influence of Passion Plays, as this is not recorded in the Gospels.[4] Winkler[5] points to the masterly rendering of the hypocritical Pilate.

Related drawings: W.303, W.304, W.vol. III, pl. IX; W.vol. III, pl. X.

[1] Hüsgen, 1778, No. 7.
[2] Cf. No. 48.
[3] 1928, vol. II, p. 449.

[4] T.535.
[5] 1957, p. 235.

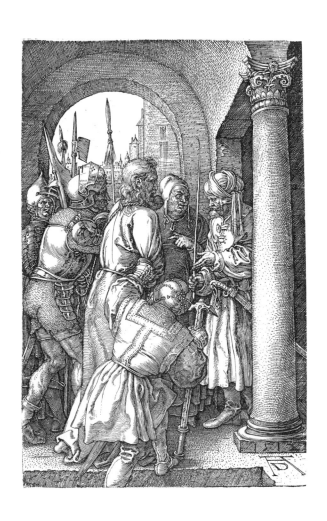

60. FLAGELLATION (*Engraved Passion*)

Monogram and date, 1512, on a tablet.
118 × 74 mm; 4 5/8 × 2 7/8 in.
No border lines.
B.8; K.51; D.57; T.536; M.8; P.115.

Hüsgen[1] points out that Dürer himself is seen standing in the doorway. Wölfflin points especially to the masterly drawing of Christ's body, the predominant profile and its quivering movement.[2] The device of cutting off the column suggests the true expanse of the chamber.[3] The bearded guard appears also in "Christ Crowned with Thorns" (No. 61). According to Winkler[4], the rendering is superior to that of the same subject in the *Small Woodcut Passion*.

[1] 1778, No. 10.
[2] 1905, p. 230.
[3] T.536.
[4] 1957, p. 233.

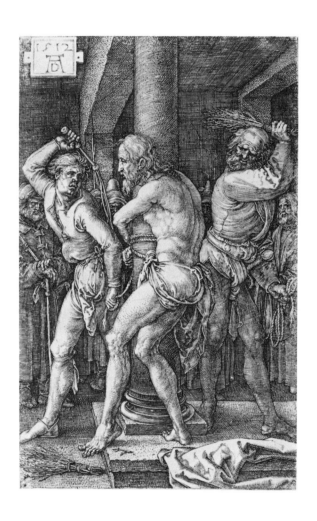

61. CHRIST CROWNED WITH THORNS (*Engraved Passion*)

Monogram and date, 1512, on separate tablets.
118 × 74 mm; 4 5/8 × 2 7/8 in.
No border lines.
B.9; K.52; D.58; T.537; M.9; P.116.

Wölfflin[1] notes that Christ is shown in profile, yet quite differently from the woodcut versions of this subject. This is richer and more picturesque. Nevertheless, greater clarity is not quite achieved. Tietze[2] points to the similarity of the spatial arrangement to the "Flagellation" (No. 60). Pilate is seen in the background, standing next to Caiaphas. The bald bearded man is reminiscent of Italian model heads. The kneeling youth may derive from the "Tarocchi" drawings (W.122–141).

[1] 1905, p. 230.

[2] T.537.

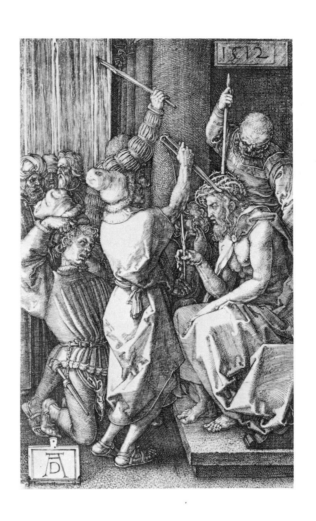

62. ECCE HOMO (*Engraved Passion*)

Monogram and date, 1512.
117 × 75 mm; 4 5/8 × 2 7/8 in.
No border lines.
B.10; K.53; D.59; T.538; M.10; P.116.

According to Wölfflin,[1] "nothing can compare to this engraving. Two opposites are here presented with the greatest economy and limitation. Suffering is contrasted with compassion. Although the expression of suffering is subdued, it is unmistakable. The uninterrupted contour of the stoic observer is likewise characteristic and striking in expressing the contrast of feeling. The public, in the background, is barely shown, but its presence is felt." Winkler[2] also calls this "a new high point. The concept as pictured in the *The Large Woodcut Passion* has here been brought to its ultimate conclusion. It can be seen that the older, experimental rendering of the *Small Woodcut Passion* was misguided."

[1] 1905, p. 231.

[2] 1957, p. 233.

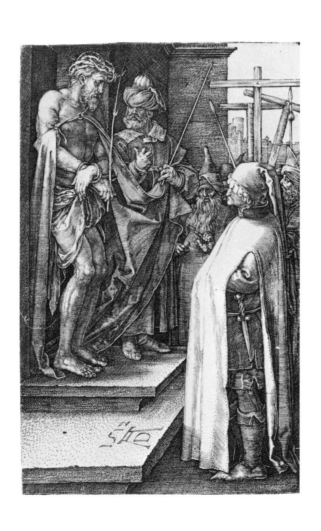

63. PILATE WASHING HIS HANDS (*Engraved Passion*)

Monogram; dated 1512.
117 × 75 mm; 4 5/8 × 2 7/8 in.
No border lines.
B.11; K.54; D.60; T.539; M.11; P.118.

Golgotha is shown in the background. Wölfflin[1] calls this scene "psychologically ineffective, almost like a surgeon washing his hands before an operation. The attention is drawn primarily to the young man pouring water and clad in a most peculiar costume. It is he who is in the limelight." The Moorish features of this young man are akin to some examples in Dürer's *Dresden Sketchbook.*[2]

[1] 1905, p. 231.

[2] T.539; cf. Dürer, *Dresden Sketchbook,* edited by Walter L. Strauss, Dover Publications, 1972, Plates 115 and 118.

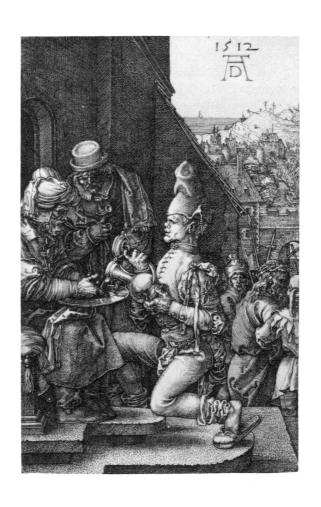

64. BEARING OF THE CROSS (*Engraved Passion*)

Monogram and date, 1512, on a tablet.
117 × 74 mm; 4 1/2 × 2 7/8 in.
No border lines.
B.12; K.55; D.61; T.540; M.12; P.119.

St. Veronica is shown kneeling in front of Christ. Wölfflin asserts that this engraved version cannot compare to the triumphant one of the woodcut.[1] In this instance, Christ is pictured standing, turned toward the women. The rendering of this scene as a "nocturne" is unprecedented.[2] Winkler calls this print "Schongaueresque" in concept. The guardsman shouting at the people is, in fact, found in Schongauer's version (B.16), perhaps based on Passion plays.[3] There is an impression without the hanger of the tablet bearing the monogram at the Museum of Fine Arts in Boston.[4]

[1] 1905, p. 231.
[2] Panofsky, 1943, vol. I, p. 145.
[3] 1957, p. 234.
[4] Hollstein, 1962, No. 12.

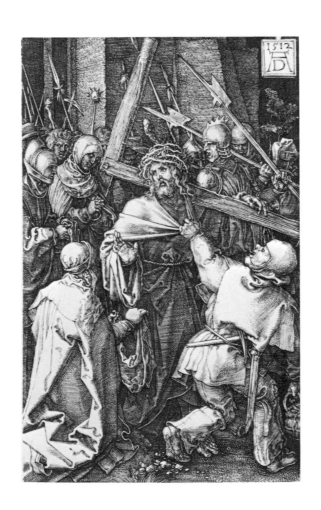

65. DEPOSITION (*Engraved Passion*)

Monogram and date, 1512, on a tablet.
117 × 74 mm; 4 1/2 × 2 7/8 in.
No border lines.
B.15; K.58; D.62; T.541; M.15; P.122.

Wölfflin[1] remarks that in this case the engraved and woodcut version can be easily compared. Both were executed at about the same time. One is the most complicated, the other the simplest solution. In the engraving some of the dignity is sacrificed by the complicated overlappings, as in the case of Christ's body. Winkler[2] asserts that the woodcut version of the *Small Passion* was difficult to surpass in the engraving. Dürer decided to use the tomb as seen from the front, making for the interesting overlappings. The gentle dignity of the woodcut version was, however, lost. Tietze[3] points out that it is not quite clear which one of the praying women is the Virgin Mary.

[1] 1905, p. 236.
[2] 1957, p. 234.

[3] T.541.

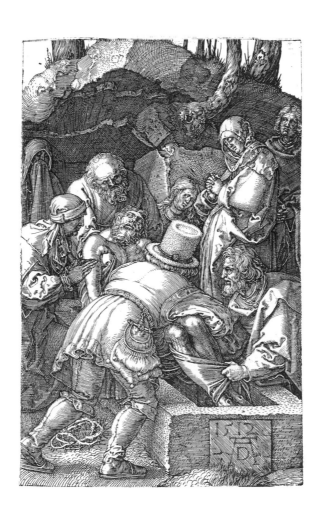

66. HARROWING OF HELL; *or,* CHRIST IN LIMBO (*Engraved Passion*)

Monogram and date, 1512.
117 × 73 mm; 4 1/2 × 2 7/8 in.
No border lines.
B.16; K.59; D.63; T.542; M.16; P.123.

Adam and Eve are on the left, Moses is behind them, Cerberus above. Wölfflin remarks that the contrast between engraved and woodcut versions is similar to that described for the "Deposition" (No. 65). According to Tietze,[2] the man whose arm Christ is touching is probably St. John the Baptist. Winkler[3] calls this print a "new and felicitous rendering, bearing witness to Dürer's inventiveness and imagination. Eve looks charming next to the aged Adam. There is a touch of the merry narrator, as can be seen in his treatment of Eve."

[1] 1905, p. 236.
[2] T.542.
[3] 1957, p. 234.

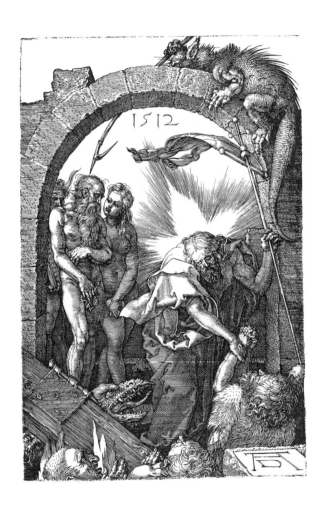

67. RESURRECTION (*Engraved Passion*)

Monogram and date, 1512.
119 × 75 mm; 4 5/8 × 2 7/8 in.
No border lines.
B.17; K.60; D.64; T.543; M.17; P.124.

Christ is seen holding the Flag of Peace in his left hand. In both the woodcut versions and in the *Engraved Passion* Christ is shown in a triumphant stance, Italianate in manner, and contrasted with the sleeping guards.[1] Panofsky[2] points out that in this instance Christ is standing on his sarcophagus, while in the *Large Woodcut Passion* he is shown suspended in the air above it. Winkler[3] is critical of this representation and asserts that Dürer hardly comes to grips with his subject; only in the *Large Woodcut* version does he reach some measure of satisfaction.

[1] Wölfflin, 1905, p. 236.
[2] 1943, vol. I, p. 137.

[3] Winkler, 1957, p. 234.

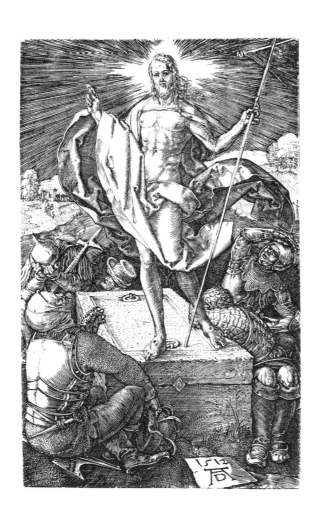

68. ST. PETER AND ST. JOHN HEALING THE CRIPPLE

Monogram and date, 1513.
118 × 74 mm; 4 5/8 × 2 7/8 in.
No border lines.
B.18; K.61; D.68; T.545; M.18; P.125.

Thausing[1] already noted that this engraving, considered as the last sheet of the *Engraved Passion*, is, in fact, outside the scope of a Passion series. Dürer cannot possibly have intended it as the final sheet. It may therefore be presumed that he planned to add further subjects which were never completed. It has been left out of most of the old bound copies of the *Engraved Passion*,[2] and may have been intended as the first sheet of a projected series of the Apostles.[3] Winkler[4] notes the contrast of the statuesque greatness of the Apostle and the merciless condition of the cripple.

According to Beenken,[5] this engraving is perhaps derived from Masaccio's fresco *The Tribute Money* in the Brancacci Chapel in Florence. Tietze[6] notes that the composition is similar to that of "Christ Crowned with Thorns" (No. 61), and that the figure of St. John is similar to that of the "Crucifixion" (No. 53). St. Peter is based on a drawing for the *Heller Altarpiece* (W.453); the man on the far left is inspired by a medal of John Paleologus. The ailment of the cripple has been identified as leprosy.

[1] 1876, vol. II, p. 62.
[2] P.125.
[3] Flechsig, 1928, vol. I, p. 242.
[4] 1957, p. 236.

[5] H. Beenken, "Zu Dürers Italienreise im Jahre 1505," *Zeitschrift des Deutschen Vereins für Kunstwissenschaft*, vol. III, p. 91.
[6] T.545.

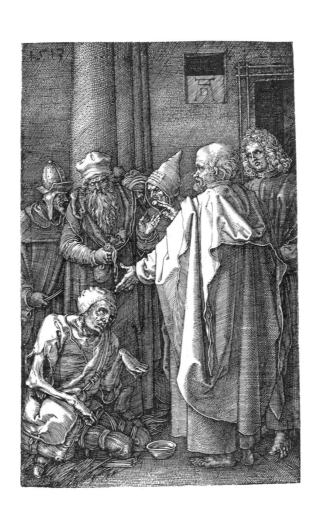

69. SUDARIUM DISPLAYED BY TWO ANGELS

Monogram and date, 1513, on a tablet.
102 × 140 mm; 4 × 5 1/2 in.
No border lines; the corners are rounded.
B.25; K.68; D.71; T.562; M.26; P.132.

Dürer mentions this engraving in his diary of the journey to the Netherlands on two occasions, August 19 and August 20, 1520, when he gave copies away as presents. He refers to it as "Veronicam." It is one of the very few Dürer engravings in horizontal format. Thausing[1] remarks that "both chronologically and ideally, in its magnificence, it could serve as the concluding subject of the *Engraved Passion*." Wölfflin[2] too considers it "the crowning representation of the Passion series. The new face of Christ, created by Dürer, appears here in its purest form. Its effectiveness remains undiminished to this day." Panofsky[3] notes that "the features of the Saviour bear an unmistakable resemblance to Dürer's own. Definitely heraldic in character, the angels are balanced with almost perfect symmetry, yet subtly differentiated in pose and gesture. The Holy Face fastens its eyes on the beholder with hypnotic intensity." The likeness of Christ served as the basis for a large woodcut[4] sometimes attributed to Hans Sebald Beham.

[1] 1876, vol. II, p. 62.
[2] 1905, p. 238.
[3] 1943, vol. I, p. 150.
[4] Bartsch, app. 26; Hollstein, 1962, vol. III, p. 84.

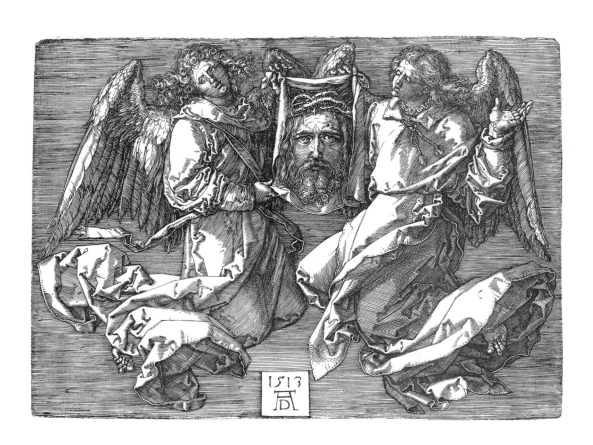

70. MADONNA BY THE TREE

Monogram and date, 1513.
118 × 75 mm; 4 5/8 × 2 7/8 in.
No border lines.
B.35; K.67; D.69; T.546; M.34; P.142.

The Infant Christ is holding a pear in his left hand. Thausing[1] calls this, together with the "Madonna with the Pear" (No. 54), the most beautiful of Dürer's engraved Madonnas. Wölfflin[2] finds it "modest in expression and standing midway between the 'Madonna with the Pear' and the 'Madonna by the Wall' [No. 78]; simple and communicative as some of the old Florentine renderings." Panofsky[3] terms it "unambitious in content." Both Hausmann[4] and Tietze[5] remark on its relationship to Raphael. Winkler[6] notes that "the Virgin, her eyes closed, presses the Infant Christ close to herself, but the child does not quite understand the caressing and turns to look at the beholder. A comparison with earlier representations of the subject reveals in what a masterly fashion Dürer now works."

[1] 1876, vol. II, p. 62.
[2] 1905, p. 273.
[3] 1943, vol. I, p. 151.
[4] 1861, p. 18.
[5] T.546.
[6] 1957, p. 235.

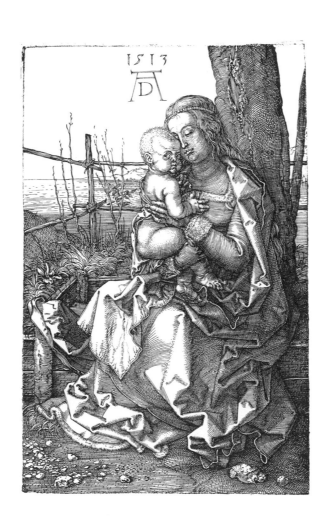

71. KNIGHT, DEATH AND DEVIL

Monogram and date, 1513, on a tablet.
250 × 190 mm; 9 3/4 × 7 3/8 in.
Border line only on the bottom.
B.98; K.69; D.70; T.574; M.74; P.205.

According to Dürer's diary of his journey to the Netherlands in 1520/21, he sold one impression of this print on November 24, 1520, and gave one away on February 11, 1521. In both instances he refers to it as "Reuter" (rider). Vasari was already greatly impressed by this print.[1] He mentions it among "several sheets of such excellence that nothing finer can be achieved. In order to depict human fortitude, he engraved an armored knight on horseback with such perfection that even the glitter of his weapons and the skin of his steed can be discerned."

The meaning of this engraving has been debated since Sandrart, in 1675, called it "the Great Christian Knight." Hüsgen,[2] one hundred years later, calls it "symbolic of the knight's impiety." Heller[3] states that it may picture the famous war-like knight Franz von Sickingen, who was feared in Germany as early as 1510, or else may be based on a painting in the Burtin collection at Brussels (now at the Albertina in Vienna), which bears the legend: "Let all hell break loose and fight—I'll ride down the devil with might."

Thausing[4] suggests that the S before the date indicates that the sanguine temperament is here personified, in contrast to melancholy in the engraving "Melencolia I" (No. 79). Weber[5] calls this print "inspired by Erasmus' *Enchiridion militis christiani* (Handbook of the Christian Knight; 1502, 1509, 1515), which stipulates that every Christian must be a soldier in the service of God, traversing the rough path of life on earth, fortified by weapons given him by Faith. Wölfflin[6] notes that the constructed horse seems almost anachronistic, reminiscent of "Adam and Eve" (No. 42), but perhaps a normal animal would have lacked meaning in this instance. According to Dodgson,[7] the S before the date simply stands for *Salus*, equivalent to *Anno salutis* (in the year of grace), a form of dating frequently employed by Dürer in his writings.

Panofsky points out that the dog "Veritas" (Truth) pursuing the hare "Problema" (Problem) occurs in all editions of Gregor Reisch's popular *Margaritha Philosophica* (Pearl of Philosophy; Freiburg, 1503; Strassburg, 1504, 1508, 1512). "In comparison with the engraving 'St. Jerome in His Study' [No. 77], this print represents the 'vita activa' as opposed to the 'vita contemplativa.' "[8] Tietze[9] notes a relationship to Jacopo Bellini's painting *St. Eustace*. The entire composition is based on the drawing W.176 and the preparatory drawings W.617 and W.618; the jumping dog on the drawing W.vol. III, pl. 19; the lizard on an unpublished drawing in the Institut Néerlandais, Paris; the quarry on the drawing W.111. According to Gombrich[10] this engraving is a restatement of Dürer's woodcut of 1510, "Lansquenet and Death" (B.132).

[1] In the chapter on Marcantonio Raimondi.
[2] 1778, No. 94.
[3] 1827, No. 1013.
[4] 1876, vol. II, p. 229.
[5] P. Weber, *Beiträge zu Dürers Weltanschauung*, Strassburg, 1900, p. 13.
[6] 1905, p. 241.
[7] D.70.
[8] 1943, vol. I, p. 152; 3rd ed., p. 170.
[9] T.574.
[10] E. H. Gombrich, "The Evidence of Images," *Interpretation, Theory, and Practice*, C. Singleton, ed., Baltimore, 1969, pp. 97-103.

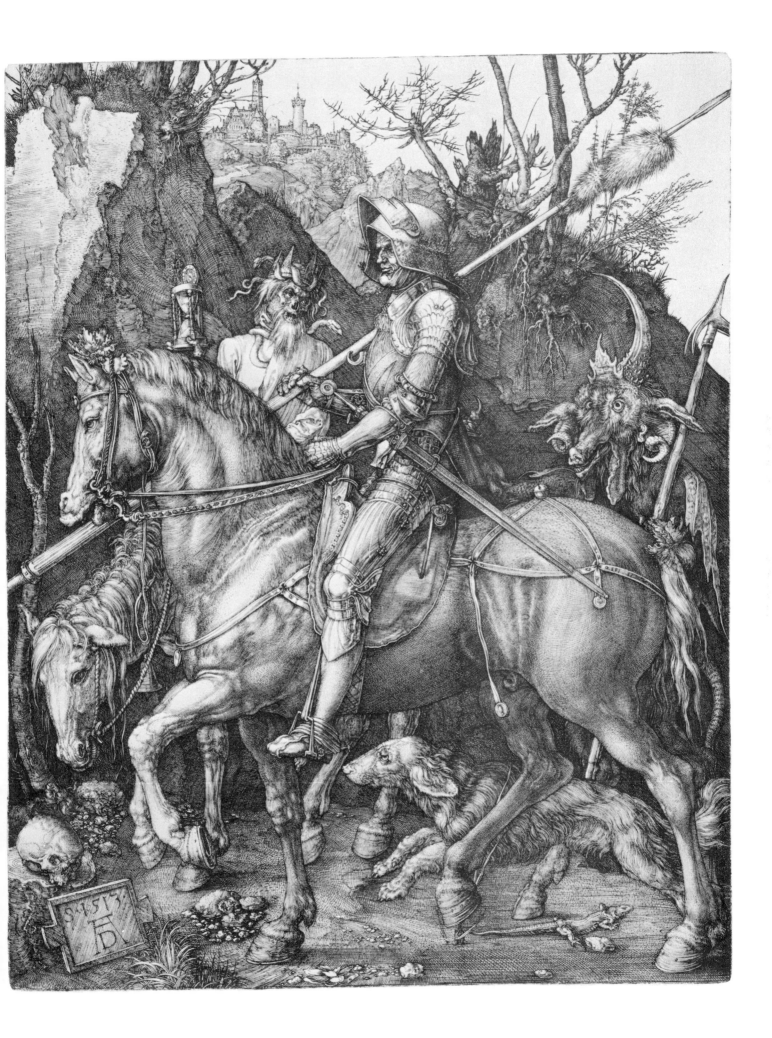

72. ST. THOMAS

Monogram and date, 1514. (The 5 of the date is corrected.)
117 × 75 mm; 4 1/2 × 2 7/8 in.
No border lines.
B.48; K.76; D.76; T.608; M.50; P.155.

The spear is the instrument of St. Thomas' martyrdom. The open book denotes "seeing is believing," the motto of this saint. Wölfflin[1] remarks that "in contrast to the companion piece, 'St. Paul' [No. 73], St. Thomas appears to burn with anger, his face clouded by the shade. One must pause to consider how radically this representation differs from the playful types of a few decades before [i.e., Schongauer]." Panofsky[2] calls it "small in size and unambitious in content." Winkler[3] notes that after a long interval Dürer here reverts to single figures on a white background. This print is one of two engraved in 1514 for a projected series of Apostles. Dürer continued the series in 1523 but never completed it.

[1] 1905, p. 271.
[2] 1943, vol. I, p. 151.

[3] 1957, p. 236.

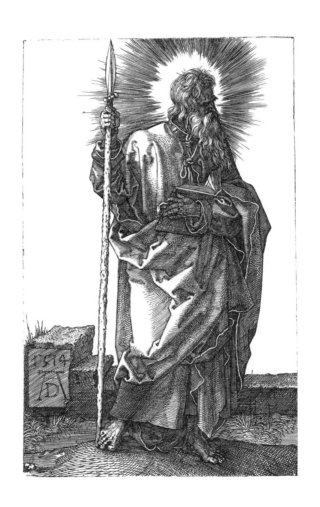

73. ST. PAUL

Monogram and date, 1514.
119 × 75 mm; 4 5/8 × 2 7/8 in.
No border lines.
B.50; K.77; D.77; T.612; M.47; P.157.

The sword of St. Paul was the instrument of his martyrdom. He was beheaded during the reign of the Emperor Nero. Wölfflin[1] points out that "the stance of the saint seems unrelated to his attributes. The sword lies on the ground; he seems like a preacher, as if dreaming, enlivened by light." Dodgson describes the two states of this engraving:[2] the first without the wall in the background, the second with the wall added. It is therefore possible that Dürer conceived this subject before "St. Thomas" (No. 72), i.e., originally standing in relief against the blank sky. Tietze[3] asserts that this is Dürer's new style in which he approaches the Italian Cinquecento, "Raphaelesque pathos exemplified by the philosopher king of the fresco of *The School of Athens*." Panofsky[4] calls this engraving also "small in size and unambitious in content." This print is related to the drawings W.591, W.592, and W.611.

[1] 1905, p.271.
[2] D.77; both states are illustrated.
[3] T.612.
[4] 1943, vol. I, p. 151.

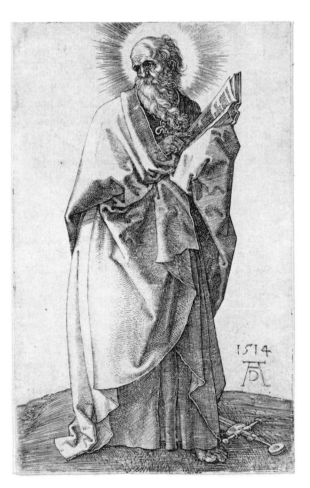 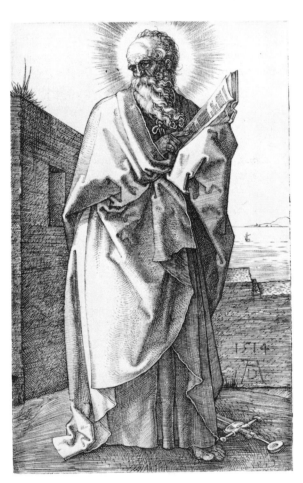

First state *Second state*

74. THE VIRGIN ON THE CRESCENT WITH A DIADEM

Monogram and date, 1514.
118 × 76 mm; 4 5/8 × 2 7/8 in.
No border lines.
B.33; K.74; D.75; T.594; M.35; P.140.

Thausing[1] calls attention to the "new silvery and mat technique which marks Dürer's later engravings." The "man in the moon" that appeared in earlier renderings of this subject (Nos. 27 and 51) is here omitted. Wölfflin[2] calls this "more sensitive than the version of 1508." Tietze[3] terms it "an indifferent restatement of the earlier representation of this subject." Panofsky[4] describes this engraving too as "unambitious in content." Even Winkler,[5] the least captious of the commentators, finds this print "decidedly modest and lethargic."

[1] 1876, vol. II, p. 70.
[2] 1905, p. 279.
[3] T.594.

[4] 1943, vol. I, p. 151.
[5] 1957, p. 235.

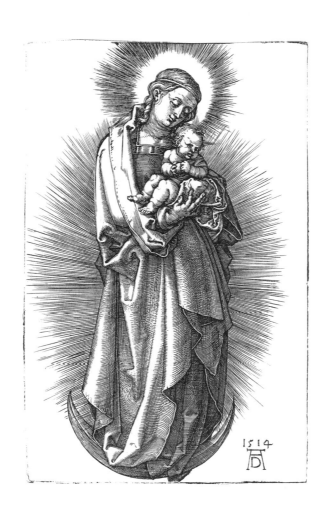

75. PEASANT COUPLE DANCING

Monogram and date, 1514.
118 × 75 mm; 4 5/8 × 2 7/8 in.
Border line only on the bottom.
B.90; K.73; D.79; T.614; M.88; P.197.

Koehler[1] describes this print succinctly as follows: "For individuality and for the happy expression of a transient mood in face as well as pose, these Dancing Peasants are quite as much without rivals in Dürer's oeuvre, as 'Knight, Death, and Devil,' 'Melencolia I,' and 'St. Jerome in His Study' are without rivals in the mood which finds expression in the lighting." Wölfflin[2] comments that "in spite of the elephantine stamping of their feet, the impression and the form are magnificent. The peasants are not shown sneeringly as earlier, but as a character study." Tietze[3] finds that "the group fills the picture area in a magnificent manner and, in spite of the massiveness, a feeling of their being swept off their feet is conveyed." But Panofsky,[4] in contrast, comments that it is "a spectacle of statuesque heaviness and immobility; unambitious in content."

[1] K.73.
[2] 1905, p. 262.
[3] T.614.
[4] 1943, vol. I, pp. 151, 200.

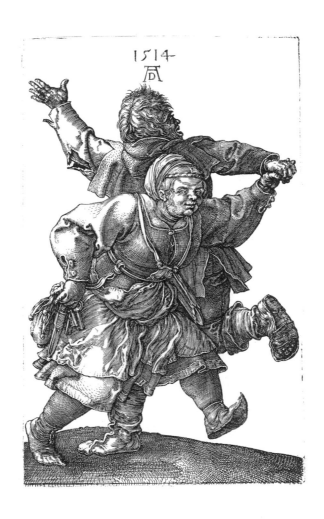

76. THE BAGPIPER

Monogram and date, 1514.
115 × 74 mm; 4 1/8 × 2 7/8 in.
No border lines.
B.91; K.72; D.78; T.613; M.90; P.198.

Bartsch[1] considered this one of the best finished works of the artist. Like the "Peasant Couple Dancing" (No. 75), the figure is depicted without any background or indication of the festivity for which he is playing. Perhaps based on the drawing W.vol. III, pl.16.

[1] B.91.

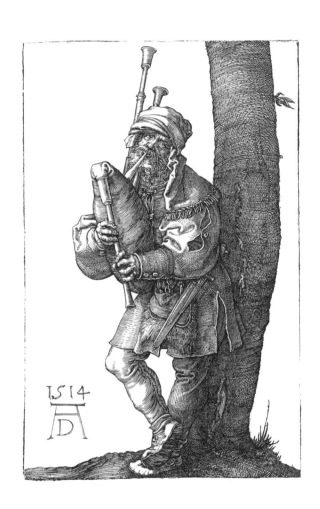

77. ST. JEROME IN HIS STUDY

Monogram and date, 1514, on a tablet.
247 × 188 mm; 9 5/8 × 7 3/8 in.
With border lines.
B.60; K.71; D.74; T.593; M.59; P.167.

Dürer, according to the diary of his trip to the Netherlands during 1520/21, sold or gave away copies of this print more frequently than any of his others.[1]

It has been repeatedly asserted[2] that this engraving was to be part of a projected series representing the four human temperaments. Only two others have been so identified, "Melencolia I" (No. 79) and "Knight, Death and Devil" (No. 71). Although they correspond in size, Dürer never gave away all three as a set. Occasionally he gave away "St. Jerome" and "Melencolia I" as a pair.[3] This fact would also seem to eliminate Lippmann's theory that these three engravings represent the human virtues, "Virtutes intellectuales, morales and theologicales," respectively, as described in Gregor Reisch's *Margaritha Philosophica* (cf. No. 71).[4] Weber[5] recalls a vision of St. Jerome in the year 374 which caused him to abandon "litterae seculares" for "litterae divinae." But Dodgson[6] warns that this theory should be received with caution. Panofsky[7] proposes instead that "life in the service of God" (i.e., "St. Jerome") is contrasted with what may be called "life in competition with God" (i.e., "Melencolia I").

Koehler[6] comments that "it is a relief to come upon a subject among Dürer's works which is so sufficient in itself that it needs no explanation." Wölfflin[9] points out that the mood of order and contentment, quite in contrast to "Melencolia I" (No. 79), is emphasized by the predominantly horizontal line of the composition. It is decidedly not in the "minor key" that pervades "Melencolia I." He goes on to say that "it would seem to be on the threshold of the period when interiors dominated painting. But the development does not continue along this line. Almost one hundred years were to elapse before Rembrandt was born." Winkler[10] adds that "the figure of the saint is reduced almost to the size of an accessory."

Schuritz[11] already noted that the design is based on an exact plan of perspective. A certain degree of distortion is due to the fact that the vanishing point is placed close to the margin instead of near the center. This is a peculiarity that can be observed in other works by Dürer. Heller[12] observed, "One receives the impression of being inside the chamber." Ivins[13] is very critical of Dürer's use of the rules of perspective in this instance. He finds it lacking in internal cohesiveness. "If Dürer had followed the simple rules laid down by Alberti or Viator he would not have got himself involved in absurdity after absurdity, such as the top of the table, which is of the oddest trapezoidal shape—certainly not rectangular."

The year 1514 coincides with the publication of the translation of St. Jerome's biography by Dürer's friend Lazarus Spengler.

[1] 1520: August 19, 20, 31, September 3; 1521: January 2.
[2] 1876, Thausing, vol. II, p. 228.
[3] T.593.
[4] F. Lippmann, *Der Kupferstich*, 1893, p. 51.
[5] P. Weber, *Beiträge zu Dürers Weltanschauung*, Strassburg, 1900, p. 48.
[6] D.74.
[7] 1943, vol. I, p. 156.
[8] K.71.

[9] 1905, p. 253.
[10] 1957, p. 239.
[11] H. Schuritz, *Die Perspektive in der Kunst Dürers*, Frankfurt, 1919, p. 34.
[12] 1827, No. 756.
[13] W. M. Ivins, Jr., "On the Rationalization of Sight," *The Metropolitan Museum of Art Papers*, No. 8, New York, 1938, p. 42.

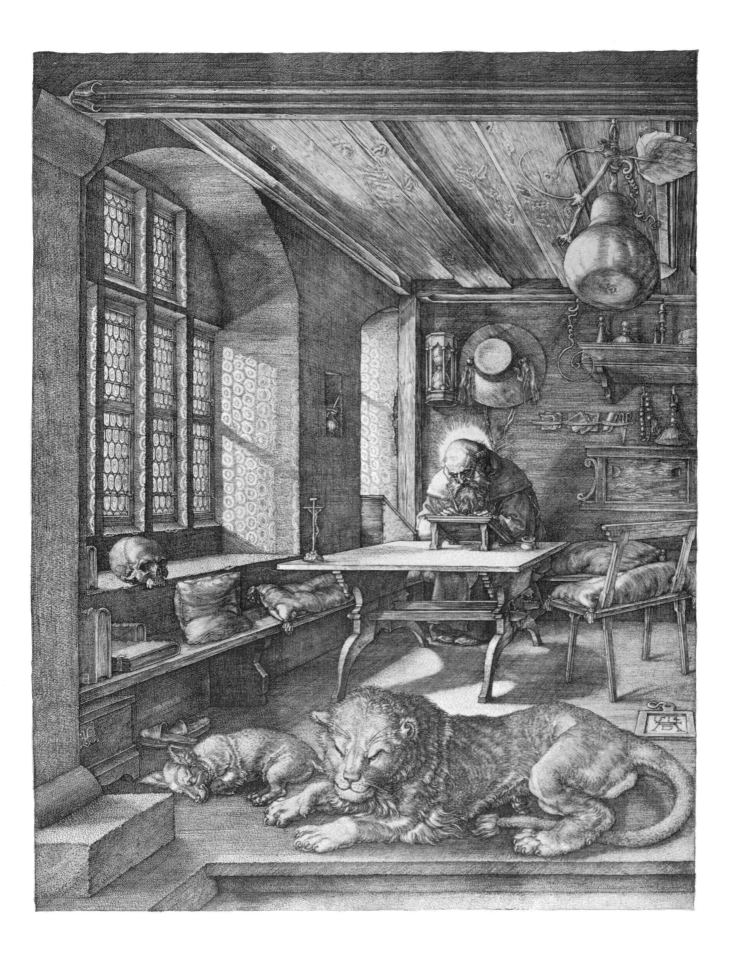

78. MADONNA BY THE WALL

Monogram and date, 1514, on a tablet (very similar to that of No. 72).
149 × 101 mm; 5 3/4 × 3 7/8 in.
No border lines.
B.40; K.75; D.72; T.607; M.36; P.147.

Heller[1] called this "the most perfect and rare of all of Dürer's engravings." Koehler[2] assigned to it "a special place among all of Dürer's plates." It is transitional from the technique of deep black lines to a more even-tempered, silvery mat texture.[3] Its mood is almost tragic, akin to that of "Melencolia I" (No. 79), perhaps because of the death of Dürer's mother, which occurred on May 14, 1514.[4] A similar relationship might be attributed to the woodcut featuring St. Joseph the provider (B.90), which probably dates from the year of the death of Dürer's father (September 19, 1502). Wölfflin[5] considered the "Madonna by the Wall" the ultimate of Dürer's Madonnas: "It need not be analyzed. The composition is so natural that everything falls into place. Nowhere is there a rupture of contours. The expression is achieved by forms within the silhouette. The harmony of tone is incomparable." Whereas the "Madonna with the Monkey" (No. 21) is pure black and white, the "Madonna by the Wall" shows a unique variety of texture resulting in a coloristic effect.[6] Panofsky[7] compares it "with the vivid 'Madonna with the Pear' [No. 54] on the one hand, and the stony 'Madonna with the Swaddled Infant' [No. 94] of 1520 on the other. The 'Madonna by the Wall' represents indeed a perfect coincidence of apparent opposites. Regal, virginal, yet humble and motherly. Its utmost precision of design is combined with incomparable softness of texture." The Infant Christ is here holding an apple (compare No. 70). In the background appears the castle of Nuremberg, which Dürer could see from the windows of his house.[8]

[1] 1827, No. 610.
[2] K.75.
[3] Thausing, 1876, vol. II, p. 70.
[4] T.607.

[5] 1905, p. 273.
[6] Koehler, 1897, Introduction, p. xvi.
[7] 1943, vol. I, p. 150.
[8] T.607.

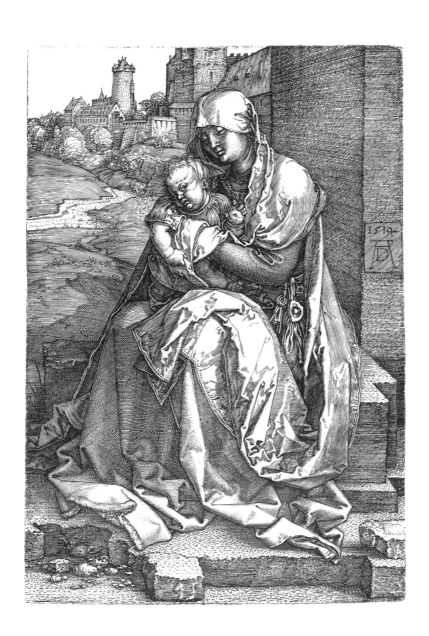

79. MELENCOLIA I

Monogram and date, 1514.
239 × 189 mm; 9 3/8 × 7 1/2 in.
With border lines.
B.74; K.70; D.73; T.588; M.75; P.181.

"It has usually been thought that Dürer meant this print to typify the insufficiency of human knowledge to attain heavenly wisdom, or to penetrate the secrets of nature. The old craving for the forbidden fruit is strong in her breast." To this remark, made by Mrs. Heaton[1] in 1869, Wölfflin[2] added: "She is a winged woman sitting on a stoop near the wall, quite low, close to the ground; leaden, as if she had no intention of soon getting up again; morbid, displeased, almost frozen; only her eyes wander; but everything else is alive; a chaos of objects, all in disarray. It is based on the writings of Marsilio Ficino, who said that all men who excel in the arts are melancholics."

Willibald Pirckheimer, Dürer's closest friend, had sent a copy of Ficino's *Libri de Vita Triplici* (On the Threefold Life; Florence, 1489) back home to his father while studying at the University of Pavia in Italy. Anton Koberger, Dürer's godfather, had published Ficino's letters in 1497. Apart from rules of health and diet for scholars, Ficino describes in detail the symptoms and therapy of the saturnine character. He attempts to relate the melancholy man of genius to the framework of Christian Neo-Platonic mysticism. Ficino distinguishes between "Melancolia candida bilis" (white-bile melancholy), which causes brilliancy, and "Melancolia atra bilis" (black-bile melancholy), which causes mania. The etching "The Desperate Man" (No. 80), according to some scholars, may have been intended to represent this second variety.[3] The iconography of "Melencolia I" does not, however, fully satisfy Ficino's specifications. Dürer obviously stresses the geometrical and imaginative aspects of the melancholic temperament. These coincide more closely with the first of three types of melancholy described in Agrippa von Nettersheim's *De Occulta Philosophia*.[4] Although strongly influenced by Ficino, he divides melancholia into "Melancholia imaginativa," a condition particularly affecting artists, architects and artisans; "Melancolia rationalis," encompassing medicine, the natural sciences and politics; and "Melancolia mentalis," covering theology and the divine secrets. Viewed in this light, many details of Dürer's engraving fall into place. It is obviously a representation of "Melancolia imaginativa."

The strong, bright-eyed woman, sitting in contemplation, her wings locked in by the hourglass, her face darkened by melancholia (literally, in Greek, black bile), personifies mature, artful, the-

[1] P. 206.
[2] 1905, p. 247.
[3] E. Panofsky and F. Saxl, *Dürers Melencolia I, eine quel-len- und typengeschichtliche Untersuchung*, Leipzig, 1923.
[4] Circulated in manuscript about 1510; the complete edition appeared in 1531. Panofsky, 1943, vol. I, p. 168.

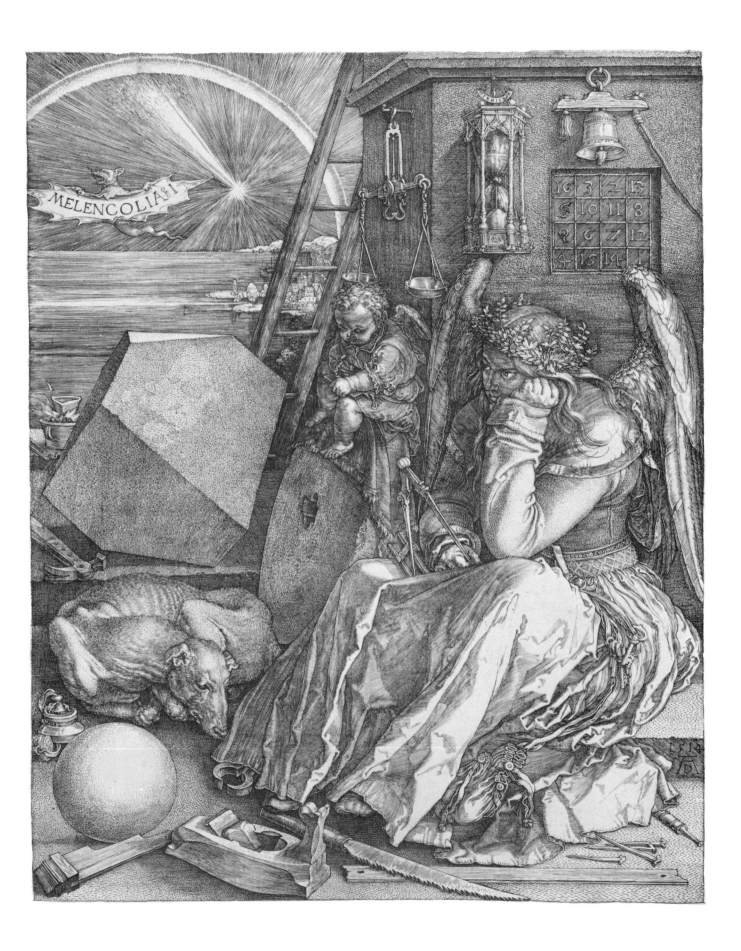

oretical imagination. Her counterpart is the young putto, eyes closed, dozing after a grammatical exercise—which traditionally is a melancholic activity. Dürer himself noted the significance of some of the accessories next to one of his preparatory sketches for this print: "Keys mean power, purse means wealth."[5]

The finely textured stone block, emphasizing solidity as compared with the instability of the sphere below, at first glance appears to be a crystal with triangular and pentagonal surfaces. Upon closer examination, however, it will be found to be a cube, pictured in Dürer's peculiar foreshortened perspective, its two opposite corners cut off.[6] Resting on one of these truncated surfaces, not quite as solidly as first imagined, it stands for perspective and erudition.

The woman's wreath is braided from two watery plants, watercress and water ranunculus, which reputedly serve as a remedy for body dryness caused by melancholy.[7] The magic square[8] is a Jovian device used to counteract the unfavorable influence of Saturn. Another counteragent especially recommended by Ficino is, however, omitted. Dürer had recorded it in his papers[9] as follows: "A boy who practices painting too much may be overcome by melancholy. He should learn to play string instruments and thus be distracted to cheer his blood." The omission of this pertinent symbol suggests that Dürer reserved it for a "Melencolia II."

Panofsky[10] points out that the contrast offered by "St. Jerome in His Study" (No. 77) and "Melencolia I" is "too perfect to be accidental. St. Jerome is comfortably installed at his desk, secluded in his sunlit study. The winged Melancholia sits in a crouched position in a chilly and lonely spot, not far from the sea, dimly illuminated by the moon. Life in the service of God is here opposed to what may be called life in competition with God; peaceful bliss of divine wisdom, as opposed to the tragic unrest of human creation." It is therefore no mere coincidence that Dürer, as recorded in his diary, gave away both prints simultaneously on many occasions during his journey to the Low Countries, 1520/21.[11] This engraving is based on the preparatory drawings W.619-621; Winkler, vol.III, pl.15; T.586.

[5] London, British Museum, Sloane 5229, fol. 60; Winkler, vol. III, pl.15.

[6] H. Schuritz, *Die Perspektive in der Kunst Dürers*, Frankfurt, 1919; W. M. Ivins, "On the Rationalization of Sight," *The Metropolitan Museum of Art Papers*, No. 8, New York, 1938, p. 42; R. Klibansky, E. Panofsky and F. Saxl, *Saturn and Melancholy*, London, 1964, p. 401.

[7] Panofsky, vol. I, p. 163; L. Behling, "Betrachtungen zu einigen Dürer Pflanzen," *Pantheon*, vol. XXIII, 1965, p. 282: The wreath actually is braided from a plant known as *Levisticum Officinalis* Koch. This plant was specifically recommended as a cure for melancholy in Hieronymus Bock's *Kreutterbuch*, Strassburg, 1580; *Saturn and Melancholy*, p. 325.

[8] K. Giehlow, "Dürers Stich Melencolia I und der Maximilianische Humanistenkreis," *Mitteilungen der Gesellschaft für vervielfältigende Kunst*, Vienna, 1904. C. Dodgson, "A New State of Melencolia I," *Burlington Magazine*, vol. XXII, 1913, p. 316. *Saturn and Melancholy*, p. 327: The square is identical to the one illustrated by Pacioli in Bologna, Bibl. Cod. Univ. 250, fols. 118-122.

[9] London, British Museum, Sloane 5230, fol. 5.

[10] 1943, vol. I, p. 156.

[11] 1520: August 19, 20, September 3, November 4.

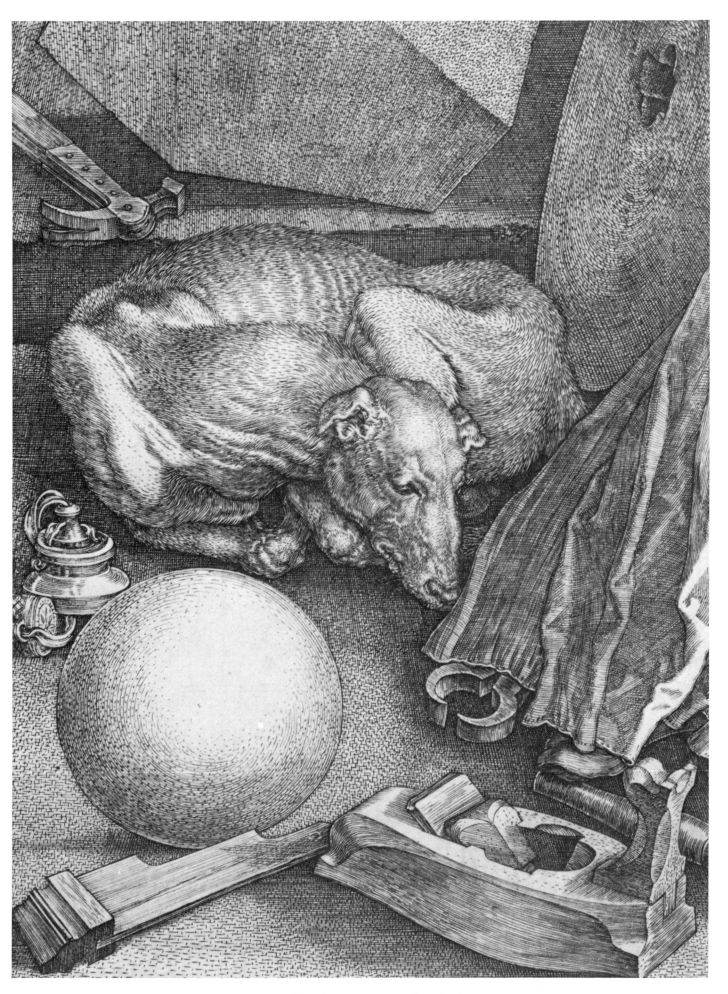

Detail from the engraving *Melencolia I.*

80. THE DESPERATE MAN (*Etching*)

Without monogram or date [1515].
186 × 135 mm; 7 1/4 × 5 1/4 in.
With border lines; rounded corners.
B.70; K.85; D.80; T.671; M.95; P.177.

Older commentators referred to this etching as "The Dismayed Husband"[1] or "The Bath."[2] Since Retberg[3] it has been known as "The Desperate Man," although its true meaning is still a subject of controversy. Thausing[4] noticed that the man wearing a beret is based on Dürer's portrait sketch of his brother Endres (W.557). Because of the added beard others[5] thought it might represent Michelangelo. There is today general agreement[6] that this is Dürer's first experimental etching. It is unsigned, undated and probably drawn directly on the plate without a definite program.

Bartsch,[7] who himself was an etcher, considered it merely a study of nudes. Panofsky[6] suggested that it relates to Dürer's preoccupation with the four human temperaments, and is specifically an attempt to picture a second type of melancholy in contrast to "Melencolia I" (No. 79). This theory is expanded tentatively in later comments[9] connecting this etching with the four forms of "melancholia adusta." Admittedly this is highly conjectural. This print was etched on iron, as were all of Dürer's six works in this medium, and impressions without rust spots are rare.

[1] Hüsgen manuscript, Bamberg, Staatsbibliothek, J.H. Msc. 80a (318), 1798.
[2] Heller, 1827, No. 882.
[3] 1871, No. 225.
[4] 1876, vol. II, p. 66.
[5] T.671; G. Gronau, "Dürer und Michelangelo," *Belvedere*, vol. III, No. 7, 1923, p. 3.

[6] Except for Koehler and Tietze, who assign this place to "The Man of Sorrows" (No. 81).
[7] B.70.
[8] P.177.
[9] R. Klibansky, E. Panofsky and E. Saxl, *Saturn and Melancholy*, London, 1964, pp. 403-405.

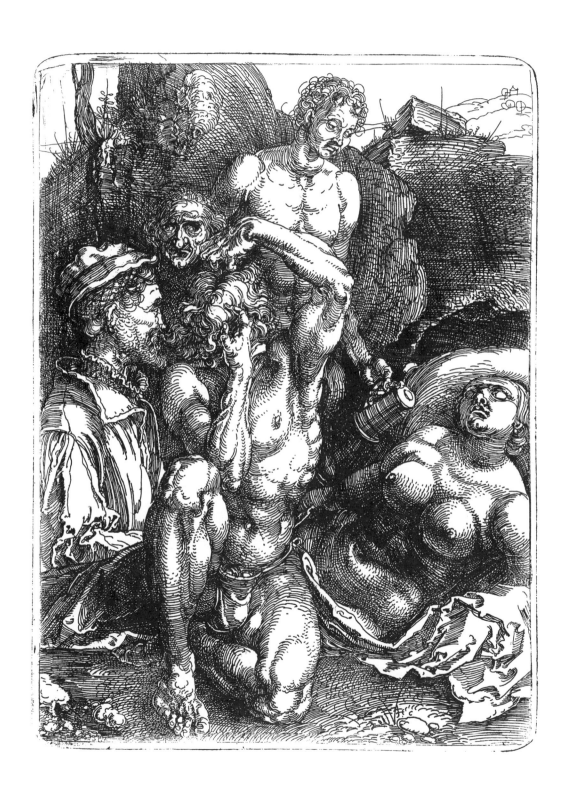

81. MAN OF SORROWS, SEATED (*Etching*)

Without monogram; dated 1515.
112 × 66 mm; 4 3/8 × 2 1/2 in.
B.22; K.81; D.81; T.644; M.22; P.129.

Early impressions of this etching are of the greatest rarity and of such purity that they look like a pen drawing.[1] This is quite in contrast with the still somewhat laborious technique, reminiscent of burin work, of "The Desperate Man" (No. 80).[2] Panofsky[3] points out that Dürer here exploits more fully the virtues of this medium. It is for these reasons that the "Man of Sorrows" is probably Dürer's second experimental etching, still without his monogram (cf. No. 80). Winkler calls it "artistically ineffective."[4]

[1] Hausmann, 1861, p. 14.
[2] Thausing, 1876, vol. II, p. 67.
[3] 1943, vol. I, p. 196.
[4] Winkler, 1957, p. 256.

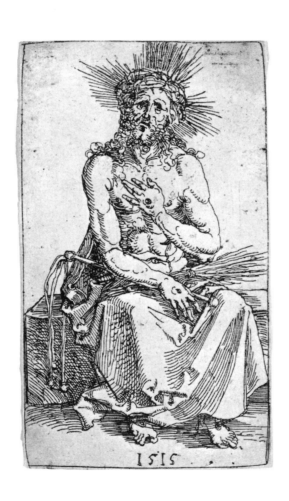

82. AGONY IN THE GARDEN (*Etching*)

With monogram and date, 1515. Rounded corners.
221 × 156 mm; 8 5/8 × 6 1/8 in.
B.19; K.82; D.82; T.648; M.19; P.26.

This etching differs considerably from the remaining preparatory studies. Christ's struggle is already over. He seems to be staring at the cup. The disciples are far in the background.[1] The Savior kneels, untouched by the raging storm; only His hands, ready to receive the chalice, reveal emotion. Dürer is as inventive as ever.[2] Panofsky[3] points out that this drawing too gives the impression of a "tough and impetuous pen drawing rather than an engraving and already takes advantage of the etching technique in order to blend the clair-obscur effects of the preceding phase with the expressive literalism and grand pathos of the Large Passion." The plate of this etching is preserved at the Staatsbibliothek in Bamberg.

Preparatory drawings: W.584, W.585.

[1] Wölfflin, 1905, p. 228.
[2] Winkler, 1957, p. 256.
[3] 1943, vol. I, p. 196.

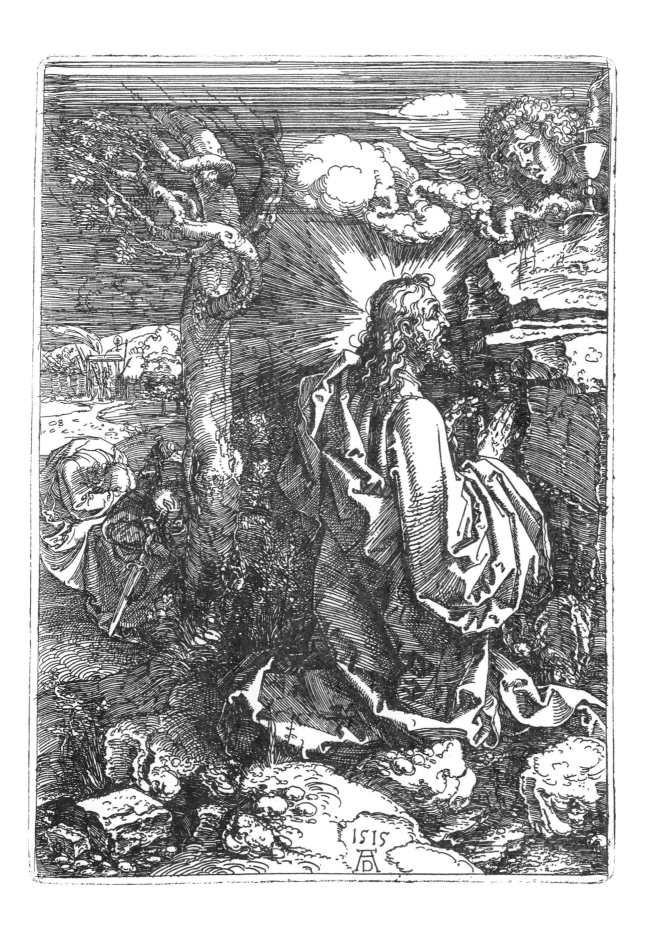

83. SUDARIUM SPREAD OUT BY AN ANGEL (*Etching*)

Monogram and date, 1516, on a tablet.
185 × 134 mm; 7 1/4 × 5 1/4 in.
B.26; K.83; D.84; T.665; M.27; P.133.

One can almost hear the outcry of the angel soaring out of the dark with the Sudarium.[1] Christ's face is shown distorted on the windblown kerchief in contrast to the solemn rendering in the engraving No. 69. It seems that the less severe technique has also led to a relaxation of the spiritual expression.[2] Panofsky[3] calls this "a feverish vision, with the pace of the needle accelerated to an allegro furioso. Instead of solemn frontality, Veronica's kerchief is here held aloft by a great angel and billows like the sail of a ship in a stormy night. Sharply foreshortened, the Holy face is barely recognizable. Space seems to have dissolved into darkness pervaded by a long wail of lament. It marks the climax and the end of a somber excitement which are the attributes of Dürer's decorative style. The storm subsided as suddenly as it had broken, and with it Dürer's enthusiasm for etching." Winkler describes the print as "a concept without precedent."

The upper corner of the kerchief crosses the border line. A preparatory drawing, dated 1515, was recently discovered in England.[4]

[1] Wölfflin, 1905, p. 260.
[2] T.665.
[3] 1943, vol. I, p. 196.
[4] Winkler, 1957, p. 257. Now at the British Museum.

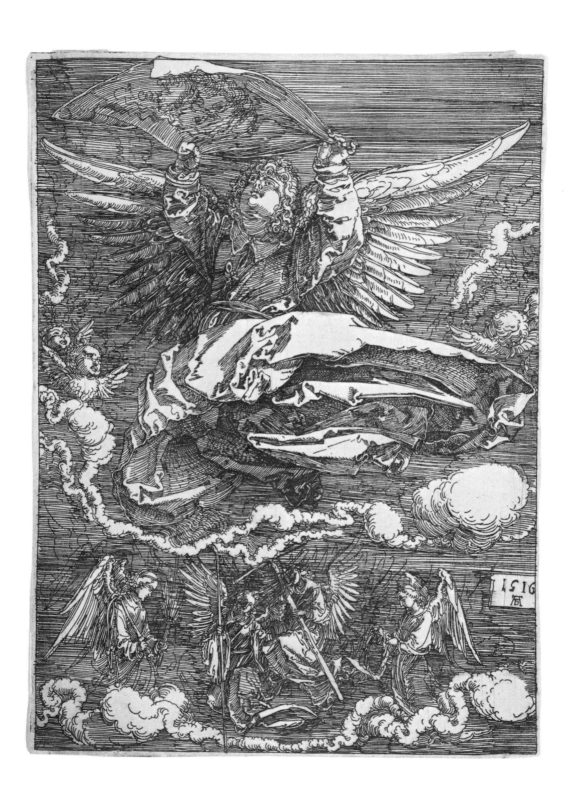

84. ABDUCTION OF PROSERPINE ON A UNICORN (*Etching*)

With monogram and date, 1516.
308 × 213 mm; 12 × 8 3/8 in.
With border lines.
B.72; K.84; D.83; T.670; M.67; P.179.

Mrs. Heaton, the first English biographer of Albrecht Dürer, describes this etching as "a wild, weird conception that produces a most uncomfortable, shuddering impression on the beholder."[1] Panofsky[2] echoed this reaction: "By eliminating accessory figures and by arranging the terrain so as to suggest a leap into the void, by diffusing the scenery with a lurid, flickering light, and by transforming the horse [of the preparatory drawing W.669] into a fabulous unicorn evocative of the ideas of night, death and destruction, Dürer invested a violent but perfectly natural scene with an infernal character unparalleled in representations of the subject except for Rembrandt's early picture in Berlin." Wölfflin[3] remarks that the invention is so excellent that the impression cannot be spoiled by the weaknesses in the rendering of the woman. The "decrepit nude body under the horse" of the preparatory drawing has been left out of the etched version.[4] The head of the unicorn was sketched separately by Dürer.[5] According to Bernheimer,[6] Pluto here appears as the leader of the wild hunt, riding a unicorn. Wild men, according to ancient belief, were the only creatures capable of overcoming the unicorn's ferocity. Poesch proposes that the idea probably derives from an illustration in the *Nuremberg Chronicle* (folio CLXXXIX) relating to an event during the reign of Emperor Henry III (1017-1056). According to report a wicked English sorceress, the "Berkeley Witch," was hauled off by the devil on a hideous horse. Her fearful and terrifying cry was heard four miles around.[7]

[1] 1869, p. 202.
[2] 1943, vol. I, p. 196.
[3] 1905, p. 260.
[4] Winkler, 1957, p. 257.
[5] Winkler, vol. III, pl. XIX.

[6] R. Bernheimer, *Wild Men in the Middle Ages*, Cambridge, Mass, 1952, p. 134.
[7] J. Poesch, "Sources for Two Dürer Enigmas," *Art Bulletin*, vol. XLVI, 1964, p. 70.

178

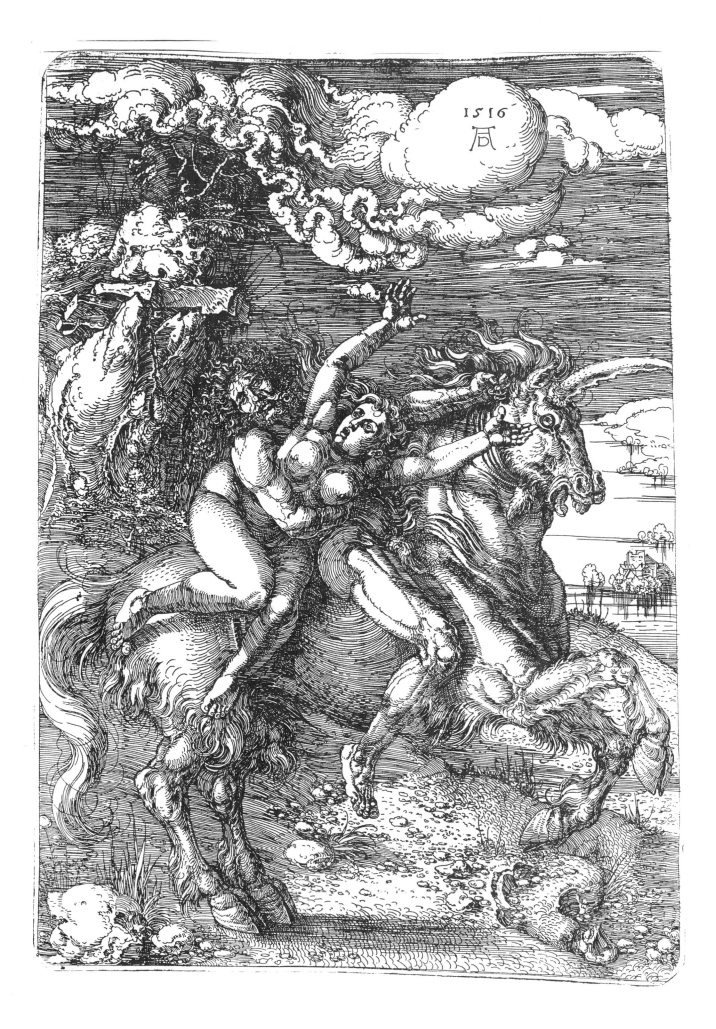

85. THE VIRGIN ON A CRESCENT
WITH A CROWN OF STARS AND A SCEPTER

With monogram and date, 1516.
118 × 74 mm; 4 5/8 × 2 7/8 in.
No border lines.
B.32; K.86; D.85; T.664; M.37; P.139.

This is the fourth and last of Dürer's representations of this subject. Winkler[1] calls it the most magnificent and tender one. Thausing[2] thought that some etching was employed to further the effect of the engraving. This effect may, however, be due to inking rather than the character of the lines.[3]

After the intense productivity of the preceding period, the years 1516/1517 show a sudden decline both in the number of remaining works and in recorded activity by Dürer. The year 1516 marks the end of his experimentation with etching, except for the "Landscape with Cannon" (No. 86) of 1518. There are no engravings from the year 1517.

(Compare Nos. 27, 51 and 74.)

[1] 1957, p. 235.
[2] 1876, vol. II, p. 71.

[3] K.86.

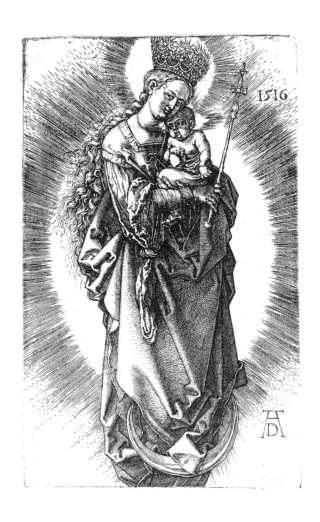

86. LANDSCAPE WITH CANNON (*Etching*)

With monogram and date, 1518.
217 × 322 mm; 8 1/2 × 12 1/2 in.
With border lines; rounded corners.
B.99; K.89; D.86; T.699; M.96; P.206.

This cannon, decorated with the coat-of-arms of the city of Nuremberg, is the weapon which gave superiority of firepower to Emperor Maximilian I in his fight against the infidels (the Turks were then threatening the borders of the Empire). For many years, and again during the Diet of Augsburg in 1518, the Emperor had urged a new crusade, only to be denied the necessary funds by the princes and estates. It is not quite clear whether the Turk in the etching is an ambassador or a prisoner.[1] According to Bechtold,[2] Dürer pictured a cannon of older vintage, which by then had been replaced by newer models cast in the Emperor's new foundry near Innsbruck. The landscape is based on an earlier drawing (W.479) of Reuth near Bamberg.[3] For the Turk, Dürer made use of a drawing dating back some twenty years (W.78), but replaced the head with a likeness of himself. Panofsky[4] calls this etching "a masterpiece of panoramic breadth, perspective coherence and clarity, announcing a new and final phase in Dürer's development, and reinstating the predominance of painting and orthodox burin work." It is the largest of Dürer's etchings.

[1] M. J. Friedländer, *Albrecht Dürer*, Leipzig, 1921, p. 210.
[2] A. Bechtold, "Zu Dürers Radierung Die Grosse Kanone," *Festschrift für Georg Habich*, Munich, 1928, p. 102.
[3] Winkler, 1957, pp. 247, 258.
[4] 1943, vol. I, p. 197.

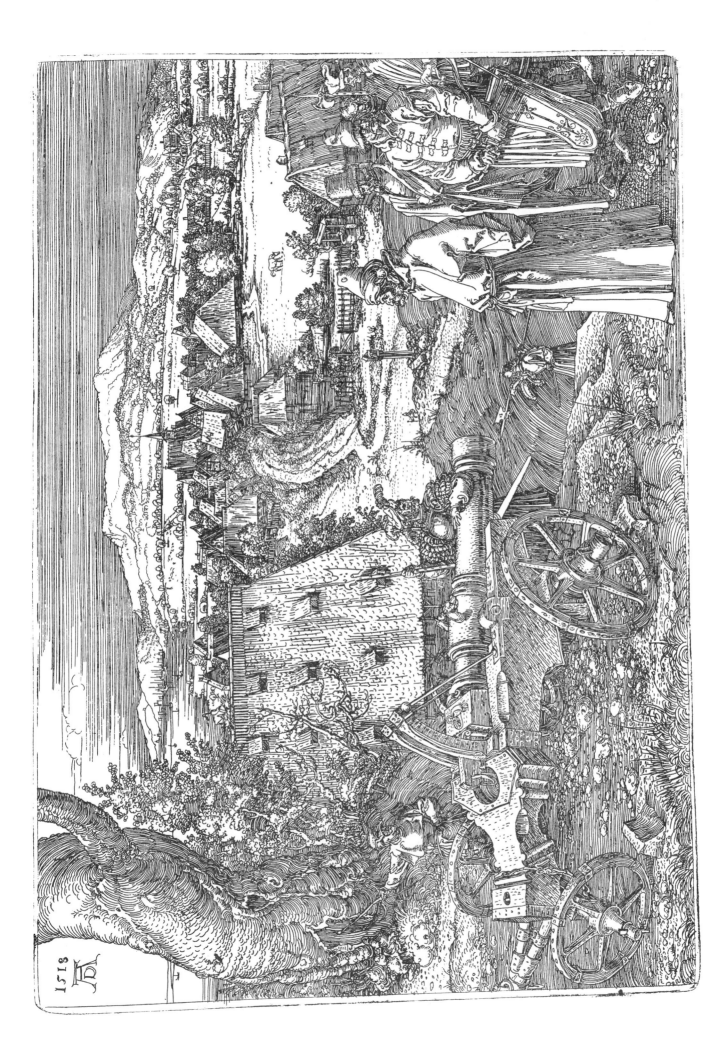

87. MADONNA CROWNED BY TWO ANGELS

With monogram and date, 1518, on a stone.
148 × 100 mm; 5 3/4 × 3 7/8 in.
No border lines.
B.39; K.87; D.87; T.706; M.38; P.146.

This is one of only two engravings of the period between 1514 and 1519. The Virgin is crowned with a wreath of roses and is holding an apple. Wölfflin[1] comments that "in spite of its admirable style, it lacks warmth compared to earlier versions. The background is no longer picturesque but rather dry in its reality." Panofsky, however,[2] finds that this engraving "conveys a feeling of perfect balance and serenity, a Raphaelesque equilibrium of loveliness and solemnity, neither too large nor too small in relation to its frame." Dürer made use of a much older preparatory study (W.457), originally sketched for the *Heller Altarpiece*, for the drapery of this engraving.

[1] 1905, p. 276.

[2] 1943, vol. I, p. 193.

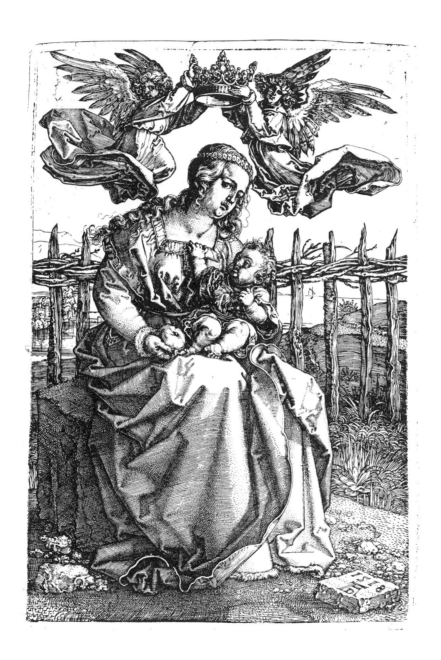

88. CARDINAL ALBRECHT OF BRANDENBURG; *or,* THE SMALL CARDINAL

Monogram and date, 1519.
148 × 97 mm; 5 3/4 × 3 3/4 in.
With border lines.
B. 102; K.93; D.92; T.712; M.100; P.209.

This portrait is based on a preparatory drawing[1] which presumably dates from the time of Dürer's stay at Augsburg during the Imperial Diet of 1518. In a letter to Georg Spalatin, an adviser of Frederick the Wise, Dürer reports the circumstances:[2] "I am enclosing three prints of an engraving for my gracious lord. It was engraved upon the request of my gracious lord of Mainz. I sent the copper plate to him together with two hundred impressions as a present. He then sent me most kindly two hundred gold guilders in return and twenty ells of damask for a coat." The plate was used subsequently to illustrate the book *Das Heiligtum zu Sachsen,* Halle, 1524.

Koehler[3] considers this portrait "preeminent for delicacy and noble simplicity among those engraved by Dürer, to be ranked among the best portraits engraved anywhere at any time." Wölfflin[4] notes that the head appears a little too small for the composition and finds the horizontal line of the wall hanging "revolting." Panofsky[5] considers the treatment of the body "impressive, as it tightly fills the interval between the two planes formed by the dark curtain behind and the parapet-like strip in front." Ruskin[6] is critical of the reflection of windows in the eyes of most of Dürer's late portraits, as in this one, considering it an affectation.

The inscription above the portrait reads: "Albrecht by Divine Mercy Presbyter Cardinal of the Holy Roman Church, Titular of St. Chrysogonus, Archbishop of Mainz and Magdeburg, Primate Elector of the Empire, Administrator of Halberstadt, Margrave of Brandenburg." The legend on the bottom states: "Thus were his eyes, his cheeks, his features at the age of 29."

Cardinal Albrecht of Brandenburg was born on June 28, 1490. He became Archbishop of Magdeburg in 1513, Archbishop of Mainz in 1514 and Cardinal in 1518. In 1514 Jacob Fugger of the wealthy trading house of Augsburg had advanced 21,000 ducats to Albrecht in order to secure for him the Archbishopric of Mainz, which entailed the electorship. The Pope authorized the sale of indulgences to reimburse the Fuggers, provided one half of the proceeds was turned over to the Papal treasury. An agent of the Fuggers subsequently traveled in the Cardinal's retinue in charge of the cashbox. It was Albrecht who appointed the Dominican Tetzel and thus indirectly caused Luther to post his 95 theses on the church doors at Wittenberg.

[1] W.568 and Winkler,vol.III,pl.V.
[2] Rupprich, Hans, *Dürers schriftlicher Nachlass,* Berlin, 1956, vol. I, p. 85. Probably January or February 1520.
[3] K.93.

[4] 1905, p. 330.
[5] 1943, vol. I, p. 200.
[6] Quoted by Koehler, K.93.

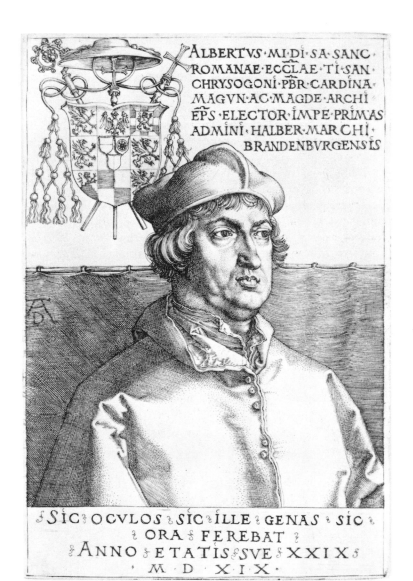

ALBERTVS · MI · DI · SA · SANC ·
ROMANAE · ECCLAE · TI · SAN ·
CHRYSOGONI · PBR · CARDINA ·
MAGVN · AC · MAGDE · ARCHI ·
EPS · ELECTOR · IMPE · PRIMAS ·
ADMINI · HALBER · MARCHI ·
BRANDENBVRGENSIS ·

SIC · OCVLOS · SIC · ILLE · GENAS · SIC ·
ORA · FEREBAT ·
ANNO · ETATIS · SVE · XXIX ·
· M · D · XIX ·

89. ST. ANTHONY

Monogram and date, 1519.
96 × 143 mm; 3 3/4 × 5 5/8 in.
Incomplete border lines; rounded corners except the upper right.
B.58; K.91; D.91; T.730; M.51; P.165.

Dürer recorded in his diary of the trip to the Low Countries, 1520/21, that he gave away "St. Anthony" as a present on six occasions.[1] It is one of the very few Dürer engravings in horizontal format. St. Anthony (ca. 250–350 A.D.) was the first Christian monk. He lived in Egypt and loved poverty, piety and scholarship. The traditional rendering of this saint shows him in the desert beset by fantastic creatures, a scene which allows the freest reign to an artist's imagination. But Dürer chose to picture him in a melancholy mood, in a setting where the scenery dominates the composition. The background is a cityscape[2] taken over from an entirely different subject, the drawing "Pupila Augusta" which Dürer had laid aside many years before.[3] The composition is almost cubistic in concept. The contours of saint and scene correspond. During this year Dürer experimented with "cubistic" figures and faceted faces, which like "St. Anthony" seem to have been put together block by block.[4]

[1] 1520: August 19, August 20, September 3.
[2] Panofsky, 1943, vol. I, p. 201.
[3] W.153.

[4] P.839; Bruck, plate 125b (*Dresden Sketchbook*, ed. by Strauss, pl. 116).

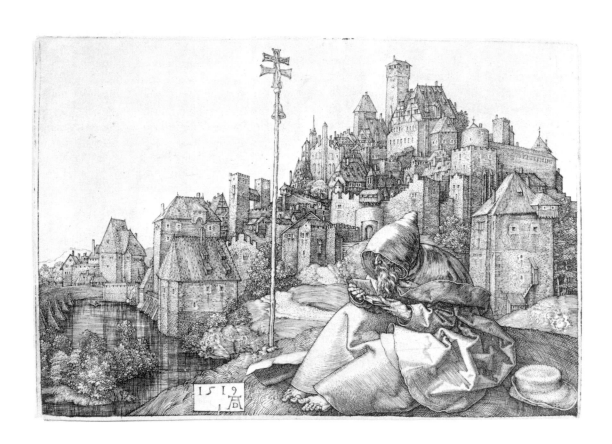

90. THE PEASANT AND HIS WIFE AT MARKET

Monogram and date, 1519.
116 × 73 mm; 4 1/2 × 2 3/4 in.
No border lines except on top.
B.89; K.92; D.90; T.733; M.89; P.196.

Dürer gave away only two impressions of this engraving during his trip to the Low Countries in 1520/21[1] Allihn[2] asserted that "the faces reflect exceptional stupidity." Thausing[3] noted the "delightful hinterland simplicity and earthy humor which were yet to play a great role in German Netherlandish art." According to Flechsig,[4] the woman is no relation of the peasant's but is only curious about what he has to sell, although she has already made several purchases. Panofsky[5] described this engraving as "a spectacle of statuesque heaviness and immobility." Winkler[6] says that "like almost all engravings after 1514, it is devoid of any landscape in the background. Everything, even the chickens, is shown with an intensity that prompts the question whether this is not too much of a good thing." Dürer classified this size of print as a "quarter-sheet" which he sold forty-five for one guilder, according to his diary.

[1] Both on September 3, 1520.
[2] M. Allihn, *Dürer Studien*, Leipzig, 1871, p. 90.
[3] 1876, vol. II, p. 137.
[4] 1928, vol. I, p. 246.
[5] 1943, vol. I, p. 200.
[6] 1957, p. 263.

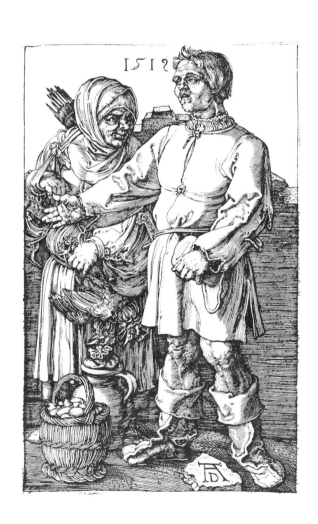

91. MADONNA NURSING

Monogram and date, 1519, on a stone.
115 × 73 mm; 4 1/2 × 2 3/4 in.
No border lines.
B.36; K.90; D.89; T.729; M.39; P.143.

Thausing[1] described this Madonna as "without any particular charm or dignity; taken from everyday life; notable only on account of its soft grey tone." Wölfflin points out the "incredible contrast to the Madonna of 1503 [No. 39]. Fastidious picturesqueness has here given way to straightness of line and unembellished surface areas. Every detail is of the greatest exactitude. No wonder that the warmth of the earlier work has not been entirely retained."[2] Panofsky[3] remarks that "Michelangelesque monumentality and gloom here replace the Raphaelesque equilibrium of loveliness and solemnity of the 'Madonna Crowned by Two Angels' [No. 87]. The group detaches itself from the solid background like sculpture projecting from a wall. The figure of the Virgin is composed of two block-like units, the lower one resembling an enormous cube. The emphasis is here shifted from linear values and dynamic movement to schematized volume." Based on or related to the drawings W.512, W.542, W.538, W.539.

[1] 1876, vol. II, p. 136.
[2] 1905, p. 278.
[3] 1943, vol. I, p. 200.

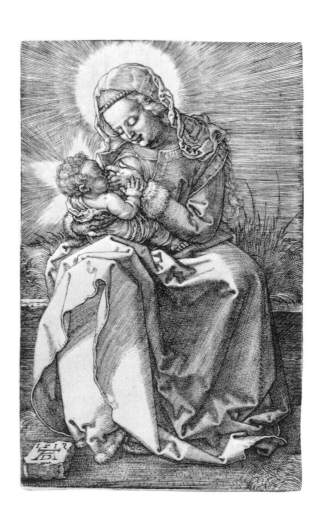

92. CRUCIFIXION (*Round*)

Without monogram or date [1519].
Diameter: 37 mm; 1 1/4 in.
B.23; K.88; D.88; T.A205; M.24; P.130.

In the same letter mentioned in connection with the engraved portrait of Cardinal Albrecht of Brandenburg (No. 88), Dürer notified Spalatin that he was "also sending him two impressions of a small Crucifixion engraved on gold."[1] It is the smallest and one of the most celebrated engravings by Dürer.[2] Because the letters INRI are reversed in the printing, and because the Virgin and St. John are not standing on the customary sides of the Cross, it has been assumed that this plate was engraved for decorative purposes.[3] Opinions have differed as to whether it was intended as a hat decoration[4] or else as a sword ornament.[5] Tietze[6] denies the authenticity, but is refuted by both Panofsky and Winkler.[7] There is a very deceptive copy of this engraving which can be distinguished by the happy expression of both Christ and the Virgin. Based on the drawing W.602. An enlargement is also illustrated.

[1] Rupprich, Hans, *Dürers schriftlicher Nachlass*, Berlin, 1956, vol. I, p. 85.
[2] K.88.
[3] D.88.
[4] Thausing, 1876, vol. II, p. 72; Flechsig, 1928, vol. I, p. 246; M.24.
[5] Hausmann, 1861, p. 14
[6] T.A205.
[7] P.130; Winkler, 1957, p. 285.

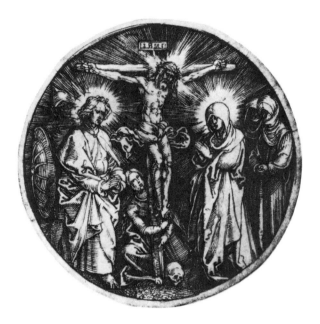

Enlarged

Actual size

93. MADONNA CROWNED BY AN ANGEL

Monogram and date, 1520, on a tablet.
139 × 100 mm; 5 3/8 × 3 7/8 in.
No border lines; rounded corners.
B.37; K.94; D.94; T.751; M.41; P.144.

According to Dürer's diary he gave away this Virgin as a present on four occasions.[1] Thausing[2] described it as stiff and lacking in spirit. Wölfflin[3] considered it "not as decidedly in the new style, but nevertheless distinguished by the new accent on frontality, exemplified by the youthful, idealized head. A peculiar impression is created by the white face and the concentration of the light on the skirt. It seems almost as if the scene were illuminated by lightning—the wind-blown hair, the creeping clouds, the upswept drapery of the angel—and in these surroundings sits the Virgin, smiling even though empty of expression, quite serene and aristocratic, idealized in the style of ancient, mild beauty." Panofsky[4] notes "its abstract rigidity, exemplified by the stiffly erect posture and the angular drapery, in all of which it surpasses the 'Madonna Crowned by Two Angels' [No. 87]." Winkler, however,[5] considers the vestment almost "unduly busy, supplemented by great attention to detail in the rest of the composition. These details, offset by the oval, doll-like, beautiful face, are all so interesting in themselves that they threaten the unity of the whole." Based on or related to the drawings W.544, W.538, W.539.

[1] August 20, September 3, end of September 1520.
[2] 1876. vol. I, p. 136.
[3] 1905, p. 278.

[4] 1943, vol. I, p. 150.
[5] 1957, p. 260.

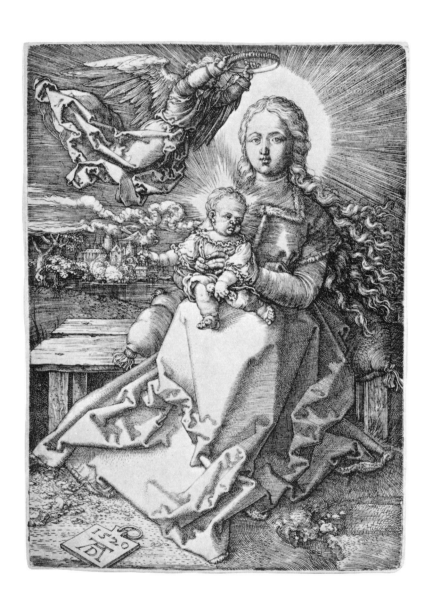

94. MADONNA WITH THE SWADDLED INFANT

Monogram and date, 1520.

144 × 97 mm; 5 5/8 × 3 3/4 in.

No border lines.

B.38; K.95; D.93; T.746; M.40; P.145.

Dürer recorded in his diary of the trip to the Low Countries that he gave away this print together with the "Madonna Crowned by an Angel" [No. 93] on four occasions (August 20, September 3, and late September 1520). Opinions of commentators vary greatly concerning this engraving. Hausmann[1] found it to have more warmth than the "Madonna Crowned by an Angel" of the same year. Thausing[2] considered it to be "without particular charm or dignity, although the softness of tone is remarkable." Wölfflin[3] felt that it was "hardly more than a geometrical outline." Panofsky[4] calls it "stony in comparison with the vivid 'Madonna with the Pear' [No. 54]. The abstract rigidity, exemplified by the schematization of organic forms, which bring to mind the polyhedron of 'Melencolia I' [No. 79], exceeds that of the 'Madonna Crowned by Two Angels' [No. 87]." Winkler[5] notes that particularly great care was taken in the rendering of the hands of the Virgin and the head of Christ. Based or related to the drawings W.543; W.636; W.vol.III.pl.IV.

[1] 1861, p. 19.
[2] 1876, vol. I, p. 136.
[3] 1905, p. 278.

[4] 1943, vol. I, p. 150.
[5] 1957, p. 260.

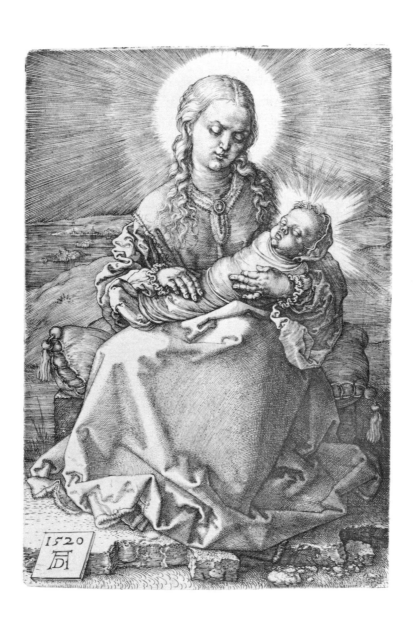

95. ST. CHRISTOPHER FACING TO THE RIGHT

Monogram and date, 1521, on a stone in the left foreground.
117 × 75 mm; 4 5/8 × 2 7/8 in.
No border lines.
B.52; K.97; D.96; T.878; M.52; P.159.

This is the first engraving after Dürer's return from his long stay in the Netherlands. He had left on July 12, 1520, together with his wife and a maid, in order to appeal to the new Emperor, Charles V, to confirm his annuity. No engravings were executed during this trip. Dürer returned to Nuremberg toward the end of July 1521, having been greatly honored, yet also a sick man suffering from malaria.

This engraving is presumably based on one of the several drawings Dürer made at Antwerp for the Dutch landscape painter Joachim Patinir in May 1521.[1] The hermit in the background is carrying a torch. Winkler[2] comments that "one would have expected a more interesting solution, although no one could deny the earnestness and radiance of both this engraving and the one that follows" (cf. No. 96).

[1] W.800; mentioned in Dürer's diary on May 20, 1521.

[2] 1957, p. 327.

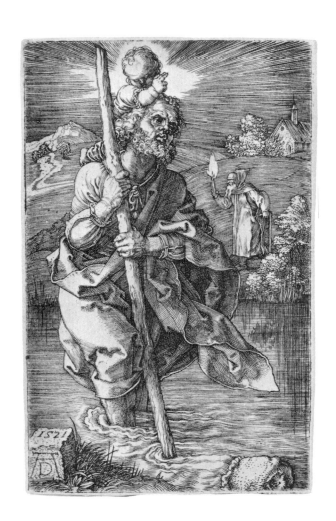

96. ST. CHRISTOPHER FACING TO THE LEFT

Monogram and date, 1521, on a stone in the right foreground.
119 × 75 mm; 4 5/8 × 2 7/8 in.
No border lines.
B.51; K.96; D.95; T.879; M.53; P.158.

According to Wölfflin,[1] this engraving is obviously the later of the two versions of 1521. "The meaning is here conveyed more poignantly, as the saint, instead of looking straight ahead, turns his head toward the Infant Christ." The hermit, in this case, is moved further into the background. This engraving is probably also based on the drawings prepared for Joachim Patinir (cf. No. 95). Panofsky[2] notes in this connection that Patinir's painting at the Escorial shows a quite similar group, only in mirror image. Both engravings are based on the account of St. Christopher in *Passional oder der Heiligen Leben*, Nuremberg, 1488, published by Anton Koberger, Dürer's godfather.

There are no engravings dated 1522.

[1] 1905, p. 337.

[2] 1943, vol. I, p. 230.

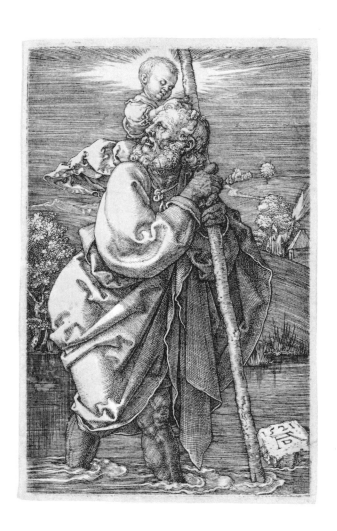

97. CARDINAL ALBRECHT OF BRANDENBURG; *or,* THE GREAT CARDINAL

Monogram and date, 1523.
174 × 127 mm; 6 3/4 × 4 5/8 in.
With border lines; irregular corners.
B.103; K.98, D.99; T.897; M.101; P.210.

"Before I became ill this year I sent an engraved copper plate to Your Elector?! Grace with your portrait together with five hundred impressions thereof. Finding no acknowledgment of this in Your Grace's letter, I fear that either the portrait did not please Your Grace—this would sadden me, as my diligence would have had poor results—or else, I fear that it may not have reached Your Grace at all. I beg Your Grace for a gracious reply." Thus we have in Dürer's own words the history of this engraving.[1] According to Hausmann,[2] "the fact that Dürer sent five hundred copies to the Cardinal, all produced at the same time, explains the uniform quality of so many impressions found in various collections. All these have the identical watermark, a small jug." This engraving is based on a new preparatory drawing[3] that probably dates from the Diet of Nuremberg, 1522/23. The Cardinal had gained weight since the earlier portrait (No. 88). According to Wölfflin,[4] "the Cardinal had wild, protruding eyes, a bulbous mouth and layers of fat on chin and cheeks. Dürer offset the predominant lower part of the face with a large cap. It suggests that beneath it a large impressive head is to be found. In actuality that was not the case. Dürer used utmost discretion in the treatment of the physiological details without denying the monstrous reality. It is Dürer's most interesting utilization of a profile." Panofsky[5] notes that "in contrast with the 'Small Cardinal,' and in accordance with other late portrait engravings, this panel has depth and substance. It is treated as a real tablet, carved and framed after the fashion of Roman tombstones, which were common in Germany, as in Italy and France." Such tombstones were described in Konrad Peutinger's *Inscriptiones vetustae roman[ae] et earum fragmenta in Augusta Vindelicorum et eius diocesi Mogunciaci,* 1520, published by Johann Schöffer.[6]

[1] Rupprich, vol. I, p. 95.
[2] 1861, p. 37.
[3] W.896.
[4] 1905, p. 330.

[5] 1943, vol. I, p. 238.
[6] Per kind communication of Dr. Peter Strieder, Nuremberg.

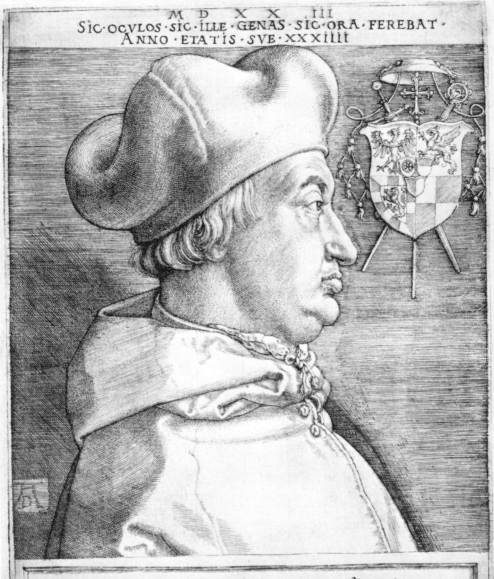

MDXX.III
·SIC·OCVLOS·SIC·ILLE·GENAS·SIC·ORA·FEREBAT·
ANNO·ETATIS·SVE·XXXIIII

·ALBERTVS·MI·DI·SA·SANC·ROMANAE·ECCLAE·TI·SAN·
CHRYSOGONI·PBR·CARDINA·MAGVN·AC·MAGDE·
ARCHIEPS·ELECTOR·IMPE·PRIMAS·ADMINI·
HALBER·MARCHI·BRANDENBVRGENSIS·

98. ST. BARTHOLOMEW

Monogram and date, 1523, on a tablet.
122 × 76 mm; 4 3/4 × 2 7/8 in.
No border lines.
B.47; K.79; D.97; T.908; M.45; P.154.

The knife in the hand of the saint is the instrument of his martyrdom. According to Wölfflin,[1] "the engravings of the Apostles of this last period are quite subdued and unemotional. The stance requires the viewer to look at the head of the saint and to seek out what characterizes his greatness." Dodgson[2] points out the absence of a halo, which distinguishes this plate and "St. Simon" (No. 99) from the earlier members of the set of Apostles. Tietze[3] remarks upon the "Raphaelesque pathos, similar to that of 'St. Paul' [No. 73]." Winkler[4] terms it "more down-to-earth than the lofty type of 1514. These men are more modest, like artisans; their bodies disappear beneath the draperies. They fill the picture area from top to bottom and have a metallic quality, almost like bronze statues." The preparatory drawing[5] is, in this case, much larger than the print.

[1] 1905, p. 338.
[2] D.97.
[3] T.908.
[4] 1957, p. 327.
[5] W.876.

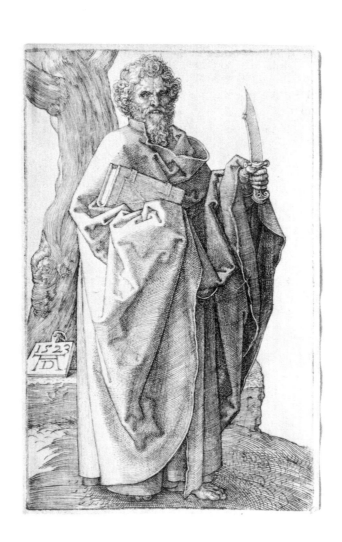

99. ST. SIMON

With monogram and date, 1523.
118 × 75 mm; 4 5/8 × 2 7/8 in.
No border lines.
B.49; K.78; D.98; T.911; M.49; P.156.

The saw was St. Simon's instrument of torture. Wölfflin[1] says of this print "although on the surface it appears to be in a more popular vein, this is a misconception. It is as serene as the other representations of the Apostles of this series." Panofsky[2] asserts that this engraving and the "St. Bartholomew" (No. 98) are "done in the 'corrugated style' where stereometrically simplified forms are contrasted with complicated systems of prominences and indentations so that the whole gives the impression of a compact massif broken up into big tablelands, craggy rocks and deep ravines." The preparatory drawing[3] had been intended for the St. John of the "Great Crucifixion" (No. 100) but was revised and used for this print.

[1] 1905, p. 338.
[2] 1943, vol. I, p. 205.

[3] W.875.

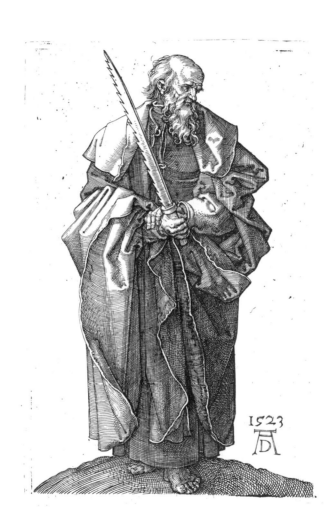

100. CRUCIFIXION WITH MANY FIGURES

Without monogram or date [1523].
320 × 225 mm; 12 1/2 × 8 3/4 in.
K.109; D.107; T.913; M.25; P.216.

The authenticity of this incomplete engraving was questioned until Passavant's catalog in 1862.[1] Retberg[2] states emphatically that "had Dürer completed it, it would have been his most exquisite engraving. It was begun after Dürer's return from the Netherlands, influenced by new and uncommon impressions. He came back from his trip physically and spiritually a changed man. His contours are less precise and less delicate than before." Ephrussi[3] stressed that the numerous extant preparatory studies clearly indicate that this engraving is by Dürer. Panofsky[4] calls the composition superb although most complex. Ehrenfest,[5] noting the development of a slight crack in the plate growing progessively larger from the impression at St. Louis to that at Berlin, suggests that this was the reason Dürer discontinued work on the engraving. A second plate exists, according to Meder,[6] which can be distinguished by the complete double circle around the tower clock and the lack of the dot in the center of its dial. The impression at St. Louis is still less complete than that at Berlin, as can be noticed particularly in the foot rest of the Cross.

Preparatory drawings: W.880, W.858–869, W.875.

[1] No. 109.
[2] 1871, No. 253.
[3] *Durer et ses Dessins*, Paris, 1882, p. 318.
[4] 1943, vol. I, p. 223.
[5] F. Ehrenfest, "Albrecht Dürer's Crucifixion in Outline," *Print Collector's Quarterly*, vol. XXX, No. 2, 1950, p. 48.
[6] M.25.

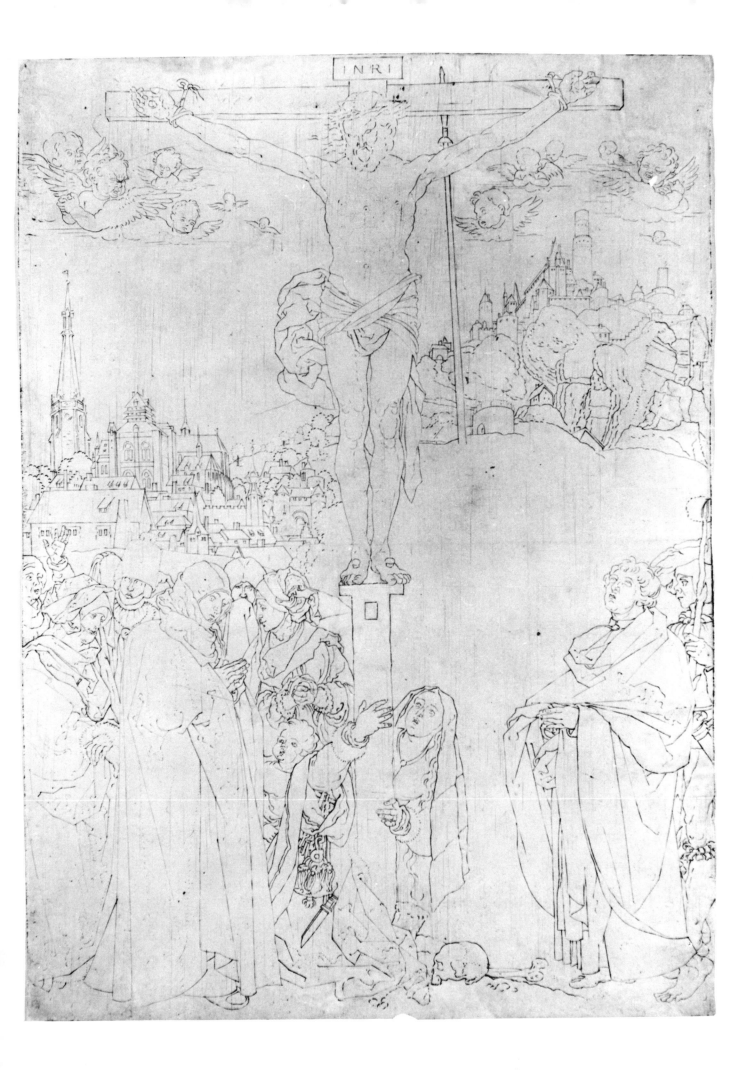

101. FREDERICK THE WISE, ELECTOR OF SAXONY

Monogram (the D reversed) and date, 1524.
188 × 122 mm; 7 3/8 × 4 3/4 in.
With border lines.
B.104; K.99; D.100; T.927; M.102; P.211.

Frederick III, called the Wise, Elector of the Empire and Duke of Saxony (1463–1525), was a patron of art and science, the founder of the University of Wittenberg and a supporter of the Reformation, although he never openly espoused the doctrines of Martin Luther. He could easily have been elected Emperor but wisely declined the honor. One of the earliest patrons of Dürer, he commissioned a portrait (in 1496) and many other works. The inscription beneath this engraved portrait reads: "Sacred to Christ. He favored the word of God with great piety, worthy to be revered by posterity forever. Albrecht Dürer made this for Duke Frederick of Saxony, Arch-Marshal, Elector of the Holy Roman Empire; B[ene] M[erenti] F[ecit] V[ivus] V[ivo], MDXXIIII."[1] Wölfflin[2] points out that "Dürer must have had a remarkable memory in order to add so much form and detail in the engraving that does not appear in the sketch from life, particularly the details of the eyes, the higher eyebrows and the revision of the cap." According to Panofsky[3] "it shows the fat but somehow tragic face of Frederick the Wise, one year before his death, in three-quarter profile, in contrast to the strict profile of Cardinal Albrecht of Brandenburg [No. 97]." Based on the preparatory drawing W.897, probably prepared during Frederick's stay at Nuremberg from November 1522 to February 1523.[4]

[1] The meaning of the letters "BMFVV" per kind communication of Dr. Peter Strieder, Nuremberg. The phrase connotes: "worthy of high praise even while still alive."

[2] 1905, p. 332.
[3] 1943, vol. I, p. 239.
[4] Winkler, 1957, p. 339.

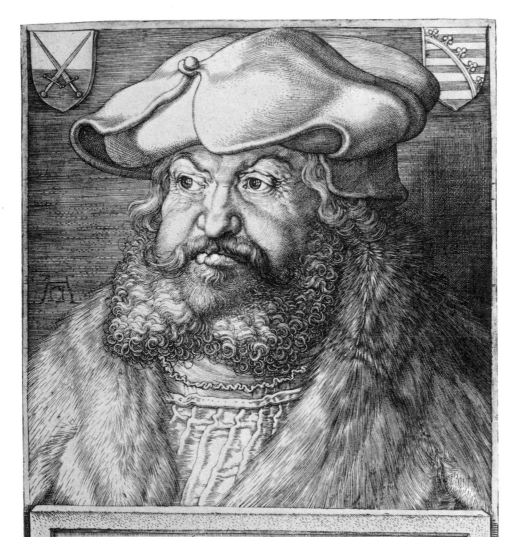

· CHRISTO · SACRVM ·

ILLe · Dei · VERBO · MAGNA · PIETATE · FAVEBAT ·
· PERPETVA · DIGNVS · POSTERITATE · COLI ·

· D · FRIDR · DVCI · SAXON · S · R · IMP
ARCHIM · ELECTORI ·
· ALBERTVS · DVRER · NVR · FACIEBAT ·
B · M · F · V · V ·
· M · D · XXIIII ·

102. WILLIBALD PIRCKHEIMER

Monogram and date, 1524.
181 × 115 mm; 7 1/8 × 4 1/2 in.
Border lines on bottom and the lower half of the sides.
B.106; K.100; D.101; T.928; M.103; P.213.

The celebrated humanist Willibald Pirckheimer, counselor to the Emperor, friend of Erasmus of Rotterdam, member of the Nuremberg city council, translator of Greek and Latin classics, commander of the Nuremberg contingent of troops in the Swiss War, was Albrecht Dürer's closest friend and mentor. Suffering from severe gout, Pirckheimer had retired from the city council shortly before Dürer engraved this portrait.[1] The inscription beneath the portrait reads: "Image of Willibald Pirckheimer at age 53. Man lives through his intellect; all else will belong to death. 1524" (based on Livy III, 36). In this likeness, too, Dürer could not resist the temptation to show the reflection of windows in the eyes.[2] Panofsky[3] comments that "the magnificent bulldog head of Dürer's best friend is not so much embellished as transfigured. Mass is converted into energy, and the heavy features of the learned irascible giant appear illumined, as it were, by the enormous eyes which flare from their sockets like powerful searchlights." This engraving was used as a bookplate by Pirckheimer. Many volumes containing it, formerly in the possession of the Royal Society, were sold at auction in London in 1925.[4] Until 1945 there was an impression on white satin, probably posthumous, at Bremen.

[1] Thausing, 1876, vol. II, p. 254. Pirckheimer retired from the council on April 8, 1523.
[2] K.100.
[3] 1943, vol. I, p. 239.
[4] D.101.

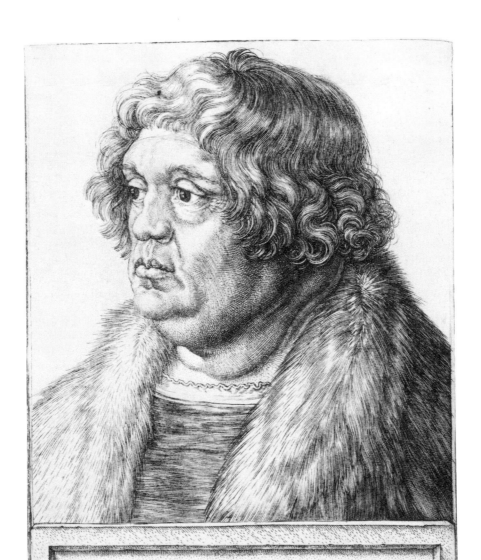

BILIBALDI · PIRKEYMHERI · EFFIGIES
· AETATIS · SVAE · ANNO · L · III ·
VIVITVR · INGENIO · CAETERA · MORTIS ·
· ERVNT ·
· M · D · X X · IV ·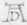

103. ST. PHILIP

Monogram and date, 1526 (corrected from 1523).
122 × 76 mm; 4 3/4 × 2 7/8 in.
No border lines.
B.46; K.80; D.103; T.907; M.48; P.153.

St. Philip was crucified in the reign of Emperor Domitian. This is the fifth and last sheet of the unfinished series of Apostles. The great white mantle pleased Dürer so much that he used it again in his painted panels of *Four Apostles* in 1526.[1] Koehler[2] notes that "the handling is very bold and shows the skill due to the absolute command of the graver. The long sweeping lines which marked Dürer's earlier work, as 'St. Je-rome in Penitence' [No. 8], reappear, especially in the background." This work was apparently finished in 1523, based on the preparatory drawing bearing that date (W.878). Panofsky[3] thought that the preparatory drawing indicates that Dürer intended to change the St. Philip into a St. Paul for the painted panels. This has, however, been disproved by a recent thorough x-ray analysis of the painting.[4]

[1] Thausing, 1876, vol. II, p. 278.
[2] K.80.
[3] *Münchener Jahrbuch*, NF, vol. VIII, 1938, p. 39; 1943, vol. I, p. 230.
[4] At the Dörner Institute in Munich.

104. PHILIP MELANCHTHON

Monogram and date, 1526.
174 × 127 mm; 6 3/4 × 5 in.
No border lines.
B.105; K.101; D.102; T.960; M.104; P.212.

The inscription beneath the portrait reads: "Dürer was able to picture the features of the living Philip, but his skilled hand was unable to picture his mind." Melanchthon (1497–1560) was celebrated for his learning and his knowledge of the ancient languages. At the early age of 21 he was appointed to a professorship at the University of Wittenberg, where he became the friend of Martin Luther. In November 1525 and May 1526 he visited Nuremberg at the invitation of the city council in order to establish the first public school. Thausing[1] terms this the best portrait of Melanchthon, or "Praeceptor Germaniae" (Germany's schoolmaster), as he was called. Koehler[2] points out that "the reflection of a window in the eyes verges on the ridiculous in this case, as the indication of clouds in the background show that Melanchthon is supposed to be standing in the open air. Nevertheless, the portrait hardly deserves the unmeasured condemnation of Mr. Ruskin, who in his *Ariadne Florentina*, Lecture V, says that it is not like Melanchthon nor of any person in his senses, but like a madman looking at someone who disputes his hobby." Wölfflin[3] describes this engraving as "certainly drawn with sincerity, but nevertheless in a somewhat hasty manner." Based on the preparatory drawing W.901. A counterproof of this engraving is at the Kupferstichkabinett in Berlin.

[1] 1876, vol. II, p. 266.
[2] K.101.

[3] 1905, p. 334.

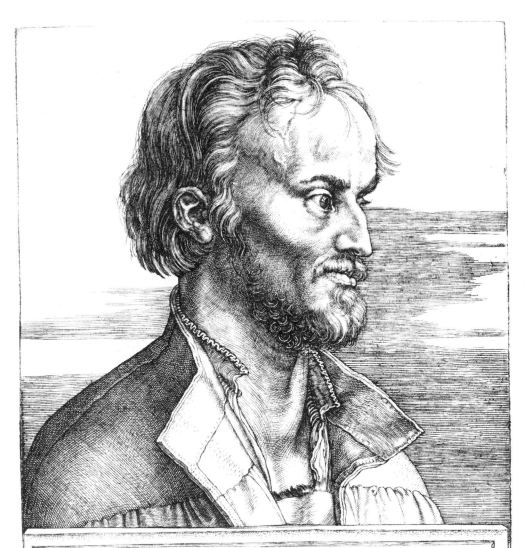

1526
VIVENTIS·POTVIT·DVRERIVS·ORA·PHILIPPI
MENTEM·NON·POTVIT·PINGERE·DOCTA
MANVS

105. ERASMUS OF ROTTERDAM

Monogram and date, 1526.
249 × 193 mm; 9 3/4 × 7 1/2 in.
Border line on the bottom only.
B.107; K.102; D.104; T.961; M.105; P.214.

On August 31, 1520, Dürer noted in his diary at Brussels: "I have given an Engraved Passion to Erasmus of Rotterdam and sketched his likeness once more." In a letter to Pirckheimer, dated from Basel, January 8, 1525, Erasmus writes: "I have received your portrait. I wish I could also be portrayed by Dürer. Why not by such an artist? But how could it be accomplished? He began my portrait in charcoal at Brussels, but he has probably put it aside long ago. If he could do it from my medal or from memory, let him do what he has done for you, that is, add some fat." (Erasmus was notoriously lean.) Dürer complied with Erasmus' wish. In another letter, dated July 30, 1526, Erasmus writes to Pirckheimer: "I wonder how I can show Dürer my gratitude, which he deserves eternally. It is not surprising that this picture does not correspond exactly with my appearance. I no longer look as I did five years ago."

Thausing[1] calls this engraving "technically superior to the portrait of Melanchthon, but in corresponding measure less true to life. As the [Greek] inscription states, his writings present a better picture of the man than this portrait." Wölfflin[2] asserts that this is "the only instance in which Dürer was notably unfortunate in attempting a portrait. Much attention has been given to the accessories, but the representation has a lifeless quality." Dürer presumably made use of the medal of Erasmus designed by Quentin Massys.[3]

Desiderius Erasmus (1467-1536) was the most celebrated humanist north of the Alps and in certain ways a pioneer of the Reformation. He visited England in 1499 and again in 1505, when he stayed at the house of Sir Thomas More. He met Dürer on at least two occasions in 1520 at Brussels. In November 1521 he settled permanently at Basel as a literary adviser to Froben's press. According to Panofsky,[4] "Dürer with all his efforts produced merely an excellent portrait of a cultured, learned and God-fearing humanist. He failed to capture that elusive blend of charm, serenity, ironic wit, complacency and formidable strength that was Erasmus of Rotterdam." Before World War II the plate of this engraving was in the Gotha Print Room at Friedenstein Castle. There are posthumous impressions on satin at Berlin and Vienna. The engraving is based on the drawing W.805.

"Erasmus of Rotterdam" was Dürer's last engraving. If these engraved portraits of his friends and patrons are indeed memorial tablets, it is remarkable that Dürer should not have prepared a self-portrait of this type. Throughout his life he

[1] 1876, vol. II, p. 267.
[2] 1905, p. 334.
[3] Wölfflin, 1905, p. 334; T.961; P.214.
[4] 1943, vol. I, p. 239.

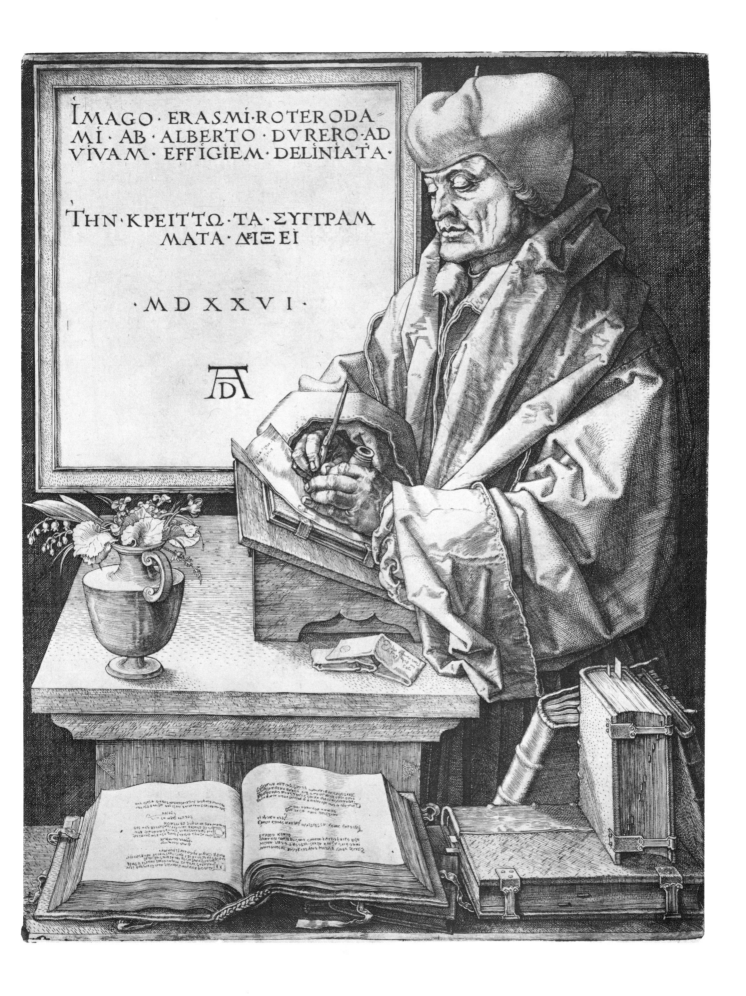

had sketched his likeness to the point of having been accused of vanity by some later commentators.

There is, in fact, some reason to believe that a drawing existed at the time of Dürer's death which may have been intended for this very purpose.[5] This sketch may have been the basis of a woodcut now attributed to Erhard Schön. Some of the early impressions of that woodcut bear the legend: "Albrecht Dürers Conterfeyt in seinem alter Des LVI Jahres, 1527" (Albrecht Dürer's likeness at the age of 56, in 1527). This is reminiscent of the type of inscription Dürer was in the habit of placing on his drawings.[6] Although this is highly conjectural, it seems quite possible that Dürer's widow handed the drawing to an artist in order to prepare a memorial portrait. The resultant woodcut is larger in format than Dürer's engraved portraits, but when it is seen reduced to their size, the relationship is surprising (see opposite, where a tablet has been added for easier visualisation).

[5] Similar to the portrait drawing of Eobanus Hesse (W.905) of 1526, which was used for the woodcut K.342 (Willi Kurth, *The Complete Woodcuts of Albrecht Dürer,* Dover Publications, New York, 1963).

[6] References for the woodcut: B.156; Heller, 1827, No. 1953; M., p. 240; P.370. Actual size: 285 × 247 mm; 11 1/8 × 9 5/8 in.

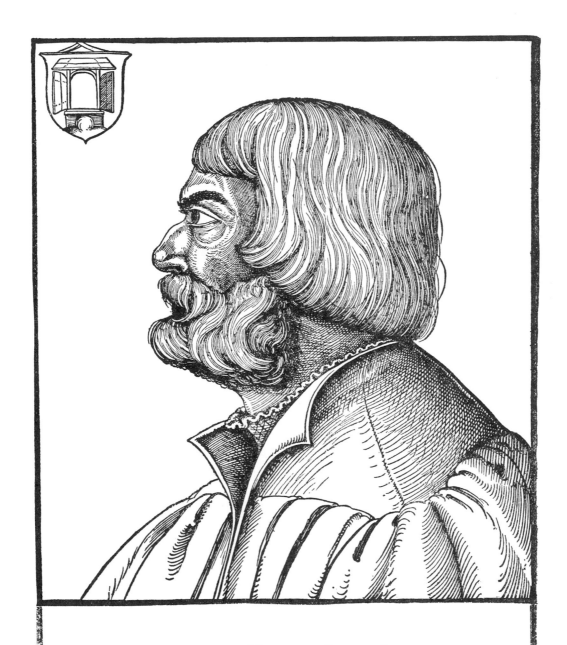

Albrecht Dürers Conterfeyt.

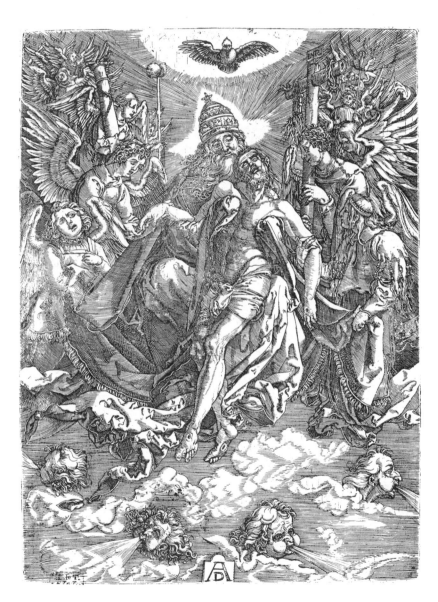

X-1 The Trinity. B.27; K.105; D., p. 142; P.134.

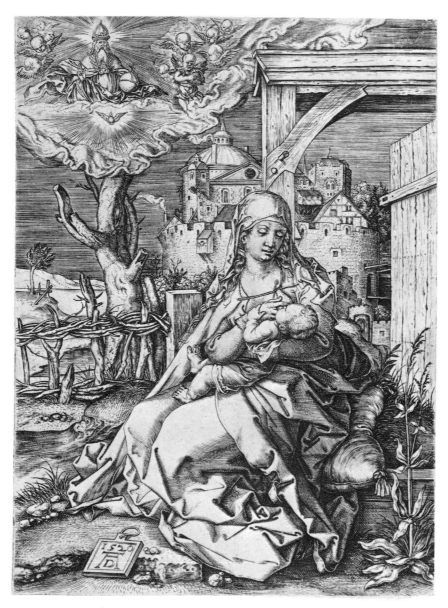

X-2 The Virgin by the Gate. B.45; K.104; D., p. 142; P.152.

X-3 St. Jerome in Penitence. B.62; K.106; D.105; T.A206; P.169.

X-4 St. Veronica. (Drypoint) B.64; K.62; D., p. 142; P.171.

X-5 The Judgment of Paris. B.65; K.107; D.106; T.A207; P.172.

X-6 Joachim Patinir. B.108; K.108; D., p. 142; T.W123; P.215.
Probably by C. Cort.

X-7 St. Sebastian. (Etching) T.A208; P.220.

Winkler, 1957, p. 256, asserts that this etching might be
Dürer's first experiment in etching.

BIBLIOGRAPHY

A. Chronological List of Prior Catalogs and Commentaries

1568 Vasari, Giorgio, *Delle Vite de' più eccellenti pittori, scultori ed architettori,* Florence (second edition). Some of Dürer's engravings are mentioned in the chapter on Marcantonio Raimondi.

1604 Van Mander, Carel, *Het Schilder-Boeck,* Alkmaar. It refers to Dürer's engravings as "being sufficiently known, therefore unnecessary to itemize."

1609 Quad von Kinkelbach, *Teutscher Nation Herrlichkeit,* Cologne.

1650 Hauer, Johann. A list of Dürer's works which was not published until 1787, in C. Murr's *Journal zur Kunstwissenschaft,* vol. XIV.

1675 Sandrart, Joachim von, *Teutsche Academie der Edlen Bau- Bild- und Mahlerey Künste,* Nuremberg.

1686 Baldinucci, Filippo, *Cominciamento e progresso dell'arte dell'intagliare in rame,* Florence.

1728 Ahrend, H. C., *Das Gedächtnis der Ehren, etc. Albrecht Dürers, um eben die Zeit als er vor 200 Jahren die Welt verlassen,* Goslar. Published upon the 200th anniversary of Dürer's death, it is the first book entirely devoted to him. A number of his prints are described, but then the author states: "Who in the world would have the patience to read the descriptions of some 300 sheets which I could provide?"

1759 Knorr, G. W., *Allgemeine Künstlerhistorie,*

Nuremberg. Bartsch characterizes Knorr's list as "fait sans ordre, sans connaissance, et sans goût."

1769 Schöber, D. G., *Albrecht Dürers Leben, Schriften und Kunstwerke,* Leipzig. Heller criticizes this work as follows: "If this book had appeared fifty years before Knorr's the many errors could have been more easily excused."

1778 Hüsgen, H. S., *Raisonierendes Verzeichnis aller Kupfer- und Eisenstiche von Albrecht Dürer,* Frankfurt and Leipzig. The first systematic and critical catalog, listing one hundred engravings.

1805 Lepel, Graf von, *Catalogue de l'OEuvre d'Albert Durer par un amateur,* Dessau. Heller calls this catalog "hurriedly assembled, full of errors, duplications and improper attributions."

1808 Bartsch, Adam von, *Le Peintre-Graveur,* vol. VII, Vienna. Bartsch was the director of the Imperial Gallery at Vienna. His catalog is based on Hüsgen and arranged according to subject. Each engraving is accurately described.

1816 Ottley, William Young, *An Inquiry into the Origin and the Early History of Engraving upon Copper and Wood,* London, chapter 8, pp. 710-736. Based on Bartsch but arranged in chronological order.

1827 Heller, Joseph, *Das Leben und die Werke Albrecht Dürers,* Bamberg. All spurious copies are described in detail with much supplementary information.

1837 Nagler, G. C., *Albrecht Dürer und seine Kunst,* Munich.

1861 Hausmann, B., *Dürers Kupferstiche, Radirungen, Holzschnitte und Zeichnungen unter besonderer Berücksichtigung der dazu verwendten Papiere und deren Wasserzeichen,* Hannover. The first catalog that takes into account the types of papers and watermarks used by Dürer as a criterion of authenticity and chronology. Sequence according to Bartsch.

1862 Passavant, J. D., *Un Catalogue supplémentaire aux estampes du XV et XVI Siècle du Peintre-Graveur de Adam Bartsch,* Leipzig.

1866 Zahn, A. V., *Dürers Kunstlehre und sein Verhältnis zur Renaissance,* Leipzig.

1869 Heaton, Mrs., *The Life of Albrecht Dürer with a Translation of His Letters and Journal and an Account of His Works,* London.

1871 Retberg, R. von, *Dürers Kupferstiche und Holzschnitte, ein Kritisches Verzeichnis,* Munich. The first systematic and critical catalog in chronological order, including criteria of authenticity. Engravings and woodcuts are intermingled in the numerical sequence.

1876 Thausing, Moriz, *Dürer, Geschichte seines Lebens und seiner Kunst,* Leipzig. Second edition, expanded to two volumes, 1884. English edition, London, 1882. References cited are from the revised edition of 1884. Thausing was a professor at the University of Vienna and director of the Albertina.

1877 Duplessis, G., *OEuvre de A. Durer,* with heliogravures by Amand-Durand, Paris. The first catalog that includes illustrations of all of Dürer's engravings.

1888 Koehler, S. R., *Catalogue of the Exhibition of Albert Dürer's Engravings, Etchings, and Dry-Points, and most of the Woodcuts Executed from His Designs,* Boston Museum of Fine Arts, Boston. The first catalog of Dürer's works published in America. It is in chronological order with detailed critical comments.

1897 Koehler, S. R., *A Chronological Catalogue of the Engravings, Dry-Points and Etchings of Albert Dürer, as Exhibited at the Grolier Club,* New York. The comments of the 1888 edition are greatly expanded.

1904 Scherer, Valentin, *Dürer,* vol. IV of *Klassiker der Kunst,* Stuttgart. Includes illustrations of all of Dürer's paintings, engravings and woodcuts with brief footnotes.

1905 Wölfflin, Heinrich, *Die Kunst Albrecht*

Dürers, Munich. The first major biography of Dürer since Thausing's. References are cited from the 6th edition, edited by K. Gerstenberg, Munich, 1943.

1926 Dodgson, Campbell, *Albrecht Dürer, Numbered Catalogue of Engravings, Dry-Points and Etchings with Technical Details,* London. The author was for many years Keeper of Prints at the British Museum in London.

1928 Flechsig, Eduard, *Albrecht Dürer, sein Leben und seine künstlerische Entwicklung,* Berlin. Chronological and critical catalog with emphasis on the calligraphy of Dürer's monogram and dates. A second volume was published in 1931, describing Dürer's drawings.

1928 Winkler, Friedrich, *Dürer, Klassiker der Kunst,* fourth and completely revised version of Scherer's edition of 1904.

1928 Tietze, Hans, and E. Tietze-Conrat, *Kritisches Verzeichnis der Werke Albrecht Dürers,* Augsburg, vol. I (1484–1505); 1937: Basel and Leipzig, vol. II (1505–1520); 1938: Basel and Leipzig, vol. III (1520–1528). In chronological sequence, but severely divided into sections of accepted, spurious and doubtful works.

1932 Meder, Joseph, *Dürer-Katalog; ein Handbuch über Albrecht Dürers Stiche, Radierungen, Holzschnitte, deren Zustände, Ausgaben und Wasserzeichen,* Vienna. Restricted to the analysis of the various states and qualities of the impressions of Dürer's engravings and woodcuts based on their watermarks.

1943 Panofsky, Erwin, *Albrecht Dürer,* Princeton, N.J., vol. I: Biography; vol. II: Hand-List. The hand-list is not intended to be a critical catalog, but an annotated list of Dürer's works according to subject. The engravings and woodcuts follow the sequence of Bartsch but are renumbered. 2nd edition, 1945; 3rd edition, 1948.

1957 Winkler, Friedrich, *Albrecht Dürer, Leben und Werk,* Berlin.

1962 Hollstein, F. W. H., *German Engravings, Etchings, and Woodcuts,* vol. VII, Amsterdam. Based on Meder, but his finer subdivisions are eliminated. Includes the locations of several of the prime impressions of each work. The illustrations are greatly reduced in size.

1965 Knappe, Karl-Adolf, *Dürer, the Complete Engravings, Etchings, and Woodcuts,* New York. Illustrations with introductory text.

B. Supplementary Titles

Allihn, M., *Dürer Studien,* Leipzig, 1871.

Barlow, T. D., *Woodcuts and Engravings by Dürer,* Cambridge, 1926.

Bruck, Robert, *Das Skizzenbuch von A. Dürer in der königlichen öffentlichen Bibliothek zu Dresden,* Strassburg, 1905.

Burckhardt, D., *Albrecht Dürers Aufenthalt in Basel 1492/94,* Munich and Leipzig, 1892.

Cust, L., *The Engravings of Albrecht Dürer,* London, 1894.

Ephrussi, C., *Durer et ses Dessins,* Paris, 1882.

Friedländer, Max J., *Albrecht Dürer,* Leipzig, 1921.

Ivins, W. M., *On the Rationalization of Sight, Metropolitan Museum of Art Papers,* No. 8, New York, 1938.

Kristeller, Paul, *Engravings and Woodcuts by Jacopo de Barbari,* Berlin, 1896.

Lehrs, Max, *Wenzel von Olmütz,* Dresden, 1889.

Lippmann, Friedrich, *Der Kupferstich,* Berlin, 1893.

Middleton-Wake, C. H., *Catalogue of the Engraved Work of Albert Dürer,* Cambridge, 1893.

Musper, H. Th., *Albrecht Dürer, der gegenwärtige Stand der Forschung,* Stuttgart, 1952.

BIBLIOGRAPHY

Oehler, Lisa, "Die Grüne Passion, ein Werk Dürers?," *Anzeiger des Germanischen Nationalmuseums*, Nuremberg, 1960, pp. 91-127.

Panofsky, Erwin; Raymond Klibansky and Fritz Saxl, *Saturn and Melancholy*, London, 1964.

Röttinger, H., *Dürers Doppelgänger*, Strasbourg, 1926.

Rupprich, Hans, *Dürers schriftlicher Nachlass*, 3 vols., Berlin, 1956-1969.

Ruskin, John, *Ariadne Florentina*, London, 1892.

Schramm, Albert, *Der Bilderschmuck der Frühdrucke*, Leipzig, 1929, vols. XVII and XVIII.

Springer, Anton, *Albrecht Dürer*, Berlin, 1892.

Stahlhelm, M., "Das Liebeskraut Eryngium auf den Bildern Albrecht Dürers," *Nürnberger Hefte*, Jahrgang I, no. 7, 1949.

Strauss, Walter L., ed., *Albrecht Dürer, Dresden Sketchbook*, New York, 1972.

Von Eye, A., *Leben und Wirken Dürers*, Nördlingen, 1860.

C. Dürer Anniversary Exhibition Catalogs

1970 Field, Richard S., *Albrecht Dürer, a Study Exhibition of Print Connoisseurship*, Philadelphia Museum of Art.

1971 Calvesi, Maurizio, *Albrecht Dürer, Opere Grafiche*, exhibition catalog, Museo di Roma, Palazzo Braschi, Rome.

1971 *Albrecht Dürer, das graphische Werk*, exhibition catalog, Städelsches Kunstinstitut, Frankfurt.

1971 Mesentseva, Charita, *Albrecht Dürer*, exhibition catalog, The Hermitage, Leningrad.

1971 Minott, Charles Ilsley, "Albrecht Dürer, Exhibition of His Early Graphic Works," *Record of the Princeton Art Museum*, vol. XXX, No. 2.

1971 Préaud, Maxime, *Albert Dürer*, exhibition catalog, Bibliothèque Nationale, Paris.

1971 Rowlands, John K., *The Graphic Work of Albrecht Dürer*, exhibition catalog, British Museum, London.

1971 Strieder, Peter, *Albrecht Dürer 1471-1971*, exhibition catalog, Germanisches Nationalmuseum, Nuremberg.

1971 Talbot, Charles W., *Dürer in America, His Graphic Work*, exhibition catalog, National Gallery of Art, Washington, D.C., with notes by Gaillard F. Ravenel and Jay A. Levenson.

INDEX OF PLATES

ACCORDING TO SUBJECT, AND CONCORDANCE OF NUMBERS

BETWEEN THE PRESENT EDITION AND

THE BARTSCH CATALOG

<table>
<tr><td></td><td>BARTSCH NO.</td><td>PLATE</td><td></td><td>BARTSCH NO.</td><td>PLATE</td></tr>
<tr><td>Old Testament Subjects:</td><td></td><td></td><td>Bearing of the Cross</td><td>12</td><td>64</td></tr>
<tr><td></td><td></td><td></td><td>Crucifixion</td><td>13</td><td>53</td></tr>
<tr><td>Adam and Eve</td><td>1</td><td>42</td><td>Crucifixion with Many Figures</td><td></td><td></td></tr>
<tr><td></td><td></td><td></td><td>(unfinished)</td><td>—</td><td>100</td></tr>
<tr><td>New Testament Subjects:</td><td></td><td></td><td>Lamentation over Christ</td><td>14</td><td>47</td></tr>
<tr><td></td><td></td><td></td><td>Deposition</td><td>15</td><td>65</td></tr>
<tr><td>Nativity (Weihnachten)</td><td>2</td><td>41</td><td>Harrowing of Hell</td><td>16</td><td>66</td></tr>
<tr><td>Man of Sorrows by the Column</td><td>3</td><td>52</td><td>Resurrection</td><td>17</td><td>67</td></tr>
<tr><td>Agony in the Garden</td><td>4</td><td>48</td><td>St. Peter and St. John</td><td></td><td></td></tr>
<tr><td>Betrayal of Christ</td><td>5</td><td>49</td><td>Healing the Cripple</td><td>18</td><td>68</td></tr>
<tr><td>Christ before Caiaphas</td><td>6</td><td>58</td><td>Agony in the Garden</td><td>19</td><td>82</td></tr>
<tr><td>Christ before Pilate</td><td>7</td><td>59</td><td>Man of Sorrows with Hands Raised</td><td>20</td><td>28</td></tr>
<tr><td>Flagellation</td><td>8</td><td>60</td><td>Man of Sorrows with Hands Bound</td><td>21</td><td>57</td></tr>
<tr><td>Christ Crowned with Thorns</td><td>9</td><td>61</td><td>Man of Sorrows, Seated</td><td>22</td><td>81</td></tr>
<tr><td>Ecce Homo</td><td>10</td><td>62</td><td>Crucifixion (round)</td><td>23</td><td>92</td></tr>
<tr><td>Pilate Washing His Hands</td><td>11</td><td>63</td><td>Crucifixion</td><td>24</td><td>50</td></tr>
</table>

INDEX OF PLATES

INDEX OF PLATES